T0383512

Give Me the Now

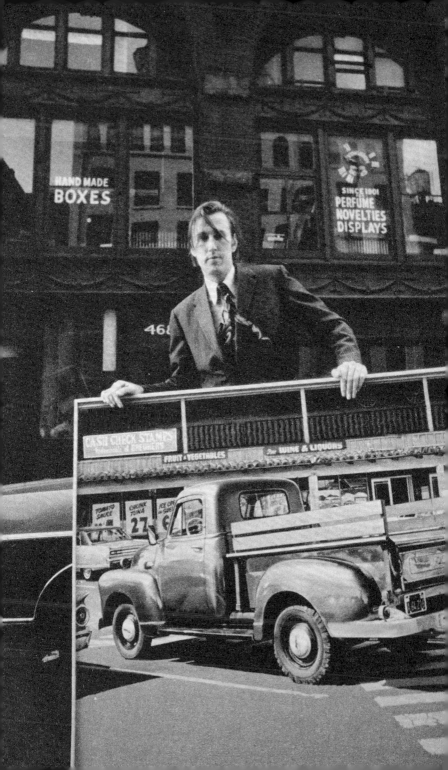

Give Me the Now

An Autobiography

Rudolf Zwirner
Written with Nicola Kuhn

Translated by
Gérard A. Goodrow

David Zwirner Books

For my children and grandchildren

Contents

Foreword

My grandfather Rudolf, who is eighty-seven on the occasion of his autobiography's publication in English, is one of those rare people whose passion for culture—a piano sonata by Mozart, a poem by Friedrich Schiller, a painting by Caspar David Friedrich, or a sculpture by Claes Oldenburg—is the cause of passion in others. A tour around his Berlin home or a walkthrough of Frederick the Great's vacation retreat, Sanssouci, just outside the neighborhood where Rudolf lives, prompts outpourings of energy, information, and excitement— his conviction that culture is infinitely significant in our lives.

This is a book about that conviction: its origins in post-war Germany, a place of radical possibility even though dev-astation was everywhere, and the development of Rudolf's dedication to contemporary art and its nascent market, which he helped shape. It shows him in action everywhere, a con-stant source of ideas and connections. In 1959, at the age of twenty-six, he was appointed as the secretary general for the second iteration of Documenta, the global art exhibition in Kassel, Germany, that takes place every five years and helped put contemporary art on the map. His job was to make it hap-pen. He did so to general acclaim, with some funny anecdotes along the way: He didn't check the dimensions of the paint-ings from the United States, assuming they would be the same size as your average Picasso. They were enormous, cannibal-izing the entire exhibition hall and banishing the European art that had been slotted for the main spaces to the previ-ously unused second floor. Thus, the Americans took Europe by storm. As Rudolf puts it, "The supremacy of the École de Paris, the European abstract artists, began to crumble, and American painting came into favor." Barnett Newman, Jackson Pollock, Mark Rothko, Franz Kline, and Robert Motherwell were the new masters, and large-scale American abstraction was on its way to capturing the world's imagination.

Rudolf's, too. As the title of this book proclaims, he was magnetically drawn to the present, to the new. His love for the great masterpieces of the Renaissance and earlier was less the result of schooling (he was mostly an autodidact

anyway and collected thousands of postcards of great art-
works as a child) and more of an appreciation for art that
lasts, since he has seen so many things come and go. His nose
for the now led him well. His small secretary's office during
Documenta ended up having Robert Rauschenberg's *Bed*
(1955) on the wall—the piece, which Leo Castelli later do-
nated to The Museum of Modern Art, in New York, where it
has been prominently on display for decades, was too rad-
ical for the curators to put on view. Rudolf's gallery in Co-
logne, which he opened a few years after the second Docu-
menta, became a hub for avant-garde culture, the art itself
but also the events, lectures, and Happenings he hosted. He
was the first German gallery to show Andy Warhol, and he
knew many of the pop artists personally. But perhaps most
significant of all, he and a former boss, Hein Stünke, cooked
up the first-ever art fair. It took place in Cologne and was
soon copied in cities throughout Europe, most notably Basel.
Little did Rudolf know that the fair model he helped invent
would dramatically change the course of the art world.

It can be difficult to imagine previous generations in
the throes of their era. The Rudolf I knew as a child, when we
went to visit him over Christmas in Berlin, represented estab-
lishment values, a sense of order and aesthetic correctness,
even if his indefatigable energy vastly outstripped that of
anyone else (he's still that way). But the Rudolf in this book is
much less predictable in his tastes. He hosts actors and provo-
cateurs in his space; he is the object of media sensations and
scandals as innovations in contemporary Western art—light
as sculpture, the body as object, money and advertising as
subject matter—tear through Europe and the United States,
shifting what the world was willing to take seriously as art.

Rudolf was a perfect protagonist for this changing land-
scape. With his sense for play—his self-professed interest in
the idea of *homo ludens* as a condition of all life—and his al-
lergy to the bourgeois, conservative values that led to the rise
of National Socialism when he was a boy, he fit in with the art-
ists he loved and venerated. He was guided by them and others

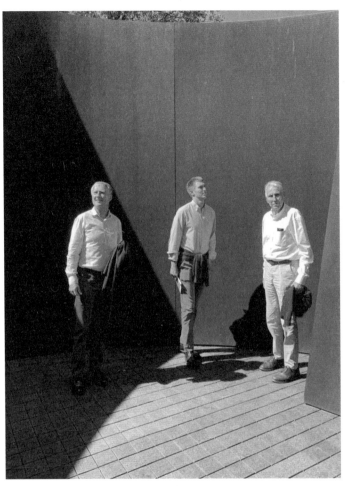

David, Lucas, and Rudolf Zwirner with *Sylvester* (2001) by Richard Serra, Glenstone, Potomac, Maryland, 2018

he encountered on his path; in a way, the art world in formation spoke through him. He let connections flow naturally and intuitively, made good (and sometimes bad) decisions, often following the creative advice of an innovator in his orbit. This led to trips to America, friendships with artists from Roy Lichtenstein and Joseph Beuys to Marcel Broodthaers and Konrad Klapheck, and his eventual overreliance on a single collector, Peter Ludwig, which hampered the growth of his business. Nonetheless, his relationship with Ludwig resulted in the most important pop art collection outside of America: the Museum Ludwig, in Cologne. Many of the masterpieces hanging there came through Rudolf's gallery.

Through all of his dealings and activities, it's the art fair that remains most prescient. The global explosion of contemporary art in the 2000s was driven to a large degree by the rise of mega-fairs and the proliferation of regional ones. The eighteen Cologne-based gallerists applauding Rudolf at the close of Art Cologne's first and very successful year were harbingers of a world to come: armies of fairgoers and galleries descending on Basel, Miami, London, and New York, buying and selling not millions but hundreds of millions of dollars' worth of art over the course of single weekends. Back in the 1960s, Castelli complained that the fairs brought too much price transparency (the argument sounds eerily familiar to complaints today against online initiatives in the art world). But the model stuck just as the shift into digital territory will certainly be with us for a long time to come.

In fact, Rudolf's experience starting Art Cologne, only to see it outdone by the larger and more ambitious fairs, is instructive: by initially barring international galleries from participating, in order to make the fair more about Germany's economy, Rudolf later recognized that he and his partners missed the actual potential of the art fair—engaging a truly global audience. Within three years of the first Art Cologne, Art Basel's inaugural edition invited galleries from all over the world to present works in Switzerland. There were more than one hundred participants.

These astonishing snapshots of a market in formation extend to the auction houses, too, which followed the fairs into the exciting world of contemporary art. Rudolf reminds us that before the expansion of the international fair circuit, the auction houses sold work from past centuries and hardly ever dabbled in the present. Once the galleries began to create an appetite for international contemporary art—with Germans collecting pop and the Americans following suit, driving prices up through the competition that emerged— the auction houses got in on the action. Again and again, Rudolf found himself at the center of a transformation we are still only beginning to understand: the commercial and cultural dominance of art made in the now.

And what about our now? What can we learn from Rudolf about what it has in store for us? For one thing, the latest rounds of innovation—digital presentations, replete with narrative components and artist-driven storytelling, things I've spent a good deal of time and energy on—have started to replace the art-fair model Rudolf helped invent. This is our now, whether we like it or not, and I happen to think it's not any more culturally impoverished than the times Rudolf experienced. If I were to take only one lesson from his book (and we have said this to each other), it is this: have faith. The technology is here for now; great art is here forever. There will always be new media, new methods of moving the market, different tools for reaching audiences. But the fundamentals are immutable: an experience that touches you; an object you would like in your life, in your home, because it does something special, colors your space with an artist's inner life and psychic energy. And if we use these new tools to amplify art, then we are moving in the right direction.

When I visit my grandfather in Berlin now, my stay involves at least one trip to the Gemäldegalerie to see Adolph Menzel, Petrus Christus, Hans Baldung Grien, Camille Corot, and many other masters whom Rudolf spends his time thinking about. It's no surprise that age has made his taste older, too, but his passion for the present, with all its creative openness,

can be applied to those artists who brought the same restlessness and fire to the matter of their times. When I walk through those galleries with Rudolf, I see Hans Baldung Grien alive in his moment, full of weirdness and mystery—not an established master passing down the wisdom he has learned, but an artist in formation, putting big pine trees in the middle of otherwise balanced compositions. Maybe that was always Rudolf's gift, to make it come alive for the viewer, to put so much of his own energy into an artwork that, for a moment, it reaches out to you. Art needs this kind of love and attention in order to speak to us in the language of our time.

Rudolf closed his gallery in 1992; David, his son and my father, opened his in 1993. Though they are entirely different businesses and gallery models, Rudolf's legacy lives on through David and my sister Marlene and me. It's a strange and wonderful feeling to be publishing his book in this topsy-turvy time, to reach back two generations and bring Rudolf's life smack into our present where it can serve as a model for others. To art enthusiasts and art professionals, the lessons and stories will inevitably be captivating. But even beyond the art world, his wisdom—be it political, emotional, or plain old practical—and his passion, after nearly a century of life, still feel electric.

Lucas Zwirner

1

Childhood
under National
Socialism

When I was a child, if someone asked me how old I was, I had fun answering, "A thousand years." I was born in 1933, the year the National Socialists took power in Germany and declared the beginning of their alleged thousand-year Reich. My parents tried to keep the political tensions away from my two older brothers, my younger sister, my younger brother, and me, but this was impossible. My father, Eberhard Zwirner, had been working as a linguistic researcher for the Kaiser Wilhelm Society (now the Max Planck Society) since 1928. The director at the time was the famous neurologist Oskar Vogt, whose neurobiological laboratory had led to the founding of the Kaiser Wilhelm Institute for Brain Research in 1914. In 1931, the institute was given its own home in the Buch district of Berlin. This is where I was born and where I spent the first years of my life.

The building that housed the institute, designed by the Munich-based architect Carl Sattler in the then popular style of new objectivity, is now home to the Max Delbrück

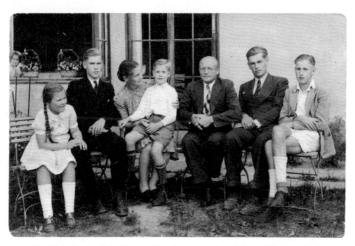

The Zwirner family in Braunschweig, 1947. *From left to right:* Elisabeth, Ruprecht, Irmgard, Ulrich, Eberhard, Kurt, and Rudolf

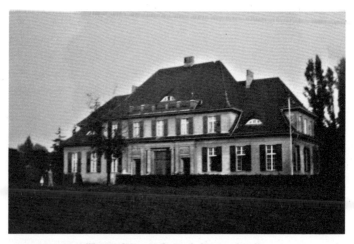

The gatehouse in the Buch district of Berlin

Center for Molecular Medicine. The institute was the largest and most modern research organization of its time, with departments for neurophysiology, neurochemistry, neuroanatomy, and genetics. Under one roof there were laboratories, an archive, a library, offices, and apartments for staff and their families. The campus also included a gatehouse, built by Ludwig Hoffmann between 1913 and 1922, which was situated in front of a park that was intended to become Berlin's central cemetery. (This plan was thwarted when it was discovered that the groundwater level was too high.) We lived in an apartment in the gatehouse, which now houses a café, next door to the families of other researchers, including the Russian geneticists Nikolay Timofeev-Ressovsky and Sergei Romanovich Tsarapkin, who were taken back to the Soviet Union in 1945 and imprisoned in a camp. As children, we all played together in the park. One day, when I brought a mushroom home from the park, my father sent me to Professor Timofeev, who knew a lot about mushrooms and immediately advised me against eating it: it was a Satan's bolete.

My father was able to pursue his research in Berlin-Buch for six years undisturbed. As a young physician—who was awarded a doctorate in medicine and philosophy for his dissertation, "On the Concept of History: A Study of the Relationships between Theoretical and Practical Philosophy"—he became interested in the control centers of language, largely as a result of his time as an assistant and later senior physician at the psychiatric clinics of the universities of Breslau and Münster. Through his work, he developed from a neuroscientist into a linguist and examined language mathematically according to the frequency of repeated sounds. He was instrumental in establishing the text block law, which later served as the basis for language translation programs. Today, he is considered the father of modern phonology. Vogt had hired him as a department head at his Institute for Brain Research in 1928, and four years later, my father founded the German Language Archive there. Today, the Archive for

Spoken German is based in Mannheim, where his hundreds of recordings of speech from all over Germany are preserved.

Our time in Berlin-Buch ended with Vogt's dismissal in 1938. Vogt had aroused the suspicion of the National Socialists as early as 1926, when the Soviet government commissioned him to examine Lenin's brain in Moscow, following his death in 1924. After being denounced for his openness toward Communists and Jews, he was forced to leave Berlin permanently. He later founded a private institute in the Black Forest together with his wife, the neuroscientist Cécile Vogt. Today, a plaque in Berlin-Buch commemorates the two scientists, and large busts of the Vogts greet visitors and staff on the campus of the Max Delbrück Center for Molecular Medicine. His successor at the Institute for Brain Research was Hugo Spatz, a card-carrying National Socialist. Under his directorship, research on the brains of victims of euthanasia began in 1940.

My father was forced to leave the institute along with Vogt. And as he failed the political screening test for his postdoctoral qualification, he was prevented from pursuing a university career. Thanks to financial support from my maternal grandmother, Lita Hammerschmidt, we were able to stay in Berlin-Buch for a while. She came from a wealthy, influential family and was in a position to help us, despite the fact that inflation had drastically decreased the value of the family's assets. Her grandfather, Peter August Bagel, had founded a large printing press and the Bagel publishing house in Düsseldorf. She was married to Wilhelm Hammerschmidt, who later became the mayor of Krefeld and was subsequently appointed governor of the province of Westphalia in Münster. Nevertheless, my grandmother's financial support—together with my father's unemployment allowance—was not enough to sustain a family of seven: we were forced to separate.

My mother, Irmgard Zwirner, took my brothers and sister to her parents' house in Münster, while I was sent to live with my father's mother in Podjuchy, near Stettin (now

Szczecin in Poland). There, my grandmother Elisabeth Zwirner managed the household of a widowed architect and his young son. At the age of six, I began my schooling in this foreign place, where I was bullied in the schoolyard as well as on my way home. It was a terrible time, which I still remember to this day, partly because I found no support in the home of the architect. My grandmother was a tough woman who ran the household with military stringency. She had led a strict regime at her own home in Löwenberg, near Breslau (now Lwówek Śląski, near Wrocław), where after the early death of my grandfather Max Zwirner she set up a boarding school in her house.

My grandfather, who worked as a pharmacist, was interested in archaeology, and he conducted excavations in Silesia and discovered urns from the Bronze Age during a campaign in Lusatia. I later inherited a particularly large specimen, which I handed over to the Museum of Prehistory and Early History in Berlin. My grandfather was also enthusiastic about modern architecture, and he commissioned Hans Poelzig to design a country house. My grandmother had met the architect by chance on a train while he was working on the renovation of the town hall in Löwenberg. The construction of the modernist house, which was much too large for the family, became too expansive and ultimately overtaxed and financially ruined my grandfather. In 1916, only six years after the house was completed, he died of cancer.

The designs for my grandparents' home (p. 22, top) are now in the Museum of Architecture at the Technical University of Berlin and the Academy of Arts in Berlin. In the 1920s, the Bober House, as it was later called because of its location above the Bober valley, once again gained recognition, as a meeting place for the Deutsche Freischar, a German youth organization associated with the scout movement. One of the instructors in 1928 was Adolf Reichwein, who became acquainted with several members of the future Kreisau Circle, a group of German dissidents active during the Second World War. Years later, he was a guest of our family in Braunschweig.

Design for the Zwirner villa in Löwenberg, near Breslau. Pencil drawing
by Hans Poelzig

The Institute for Phonometry in the Villa Salve Hospes, Braunschweig

In 1937, the National Socialists closed the Bober House and confiscated the property. It was destroyed during the war in 1945.

I stayed with my grandmother in Podjuchy for about a year and a half before I was finally allowed to return to my family in 1940. Our new home was in Braunschweig, where we rented a beautiful house with a garden on the outskirts of the city, at Stadtoldendorfer Strasse 9. That same year, my father established the Institute for Phonometry of the Kaiser Wilhelm Society, which was truly a coup. He had taken part in the German campaign against Poland as a medical officer and, on leave but in uniform, went to see Dietrich Klagges, the minister-president of the free state of Braunschweig. During their meeting, my father suggested that the Institute for Phonometry should be located in Braunschweig. Klagges—through whom the Austrian-born Adolf Hitler had obtained Braunschweigian citizenship in 1932, making him eligible for election in the German Reich—strove to make the city a model Nazi state, bringing various National Socialist institutions to the city, such as the Academy for Youth Leadership, the German Research Institute for Aviation, the Führer School for German Trades and Crafts, and the SS-Junker School.

He reacted positively to my father's proposal after he described a future State Institute for Phonometry as a research institute where German—and, in particular, Germanic—culture and language were to be studied in a manner attuned to party politics. So my father was employed by the city and granted his own budget and access to the Villa Salve Hospes, a magnificent classicist building now home to the Kunstverein Braunschweig (opposite, bottom). However, he was soon called back to Warsaw, where he was commissioned to study the region's different forms of language at the Institute for German Research on the East in the Generalgouvernement, the occupied territory in Poland. Initially, a few staff members remained at the institute in Braunschweig, until they, too, were drafted, and work there came to a halt. In 1942, the institute closed permanently.

During the first years in Braunschweig, I saw my father only when he was home on leave. He remained in the war until 1945, ultimately ending up in American captivity. My mother ran the household by herself, now with all five children under one roof. As a practicing Protestant, she was committed to many social causes. In the afternoons, she taught English on a voluntary basis at the lyceum in Braunschweig and was always available to people in need. She kept in touch with supporters of the Social Democratic Party of Germany and other such circles. As a child, I sensed her ambivalent attitude toward the state, even though, to protect us, she never spoke openly about her feelings.

In the evenings, when he was home, my father often read to my mother from works by Hugo von Hofmannsthal, Rudolf Alexander Schröder, Rudolf Borchardt, and Gottfried Benn. He corresponded with these writers and owned first editions of their publications. On the walls of our house were reproductions of Flemish and German artworks, including *The Adoration of the Kings* (c. 1470) by Hugo van der Goes and *Bohemian Landscape* (1808) by Caspar David Friedrich, yet art did not play a major role in our lives. The name Vincent van Gogh was mentioned just once or twice, as my grandmother was friends with the van Gogh collector Helene Kröller-Müller. They had attended school together in Düsseldorf. Later, my parents also became close friends with the Kröller-Müllers, who sought medical advice from my father (their family doctor had been Oskar Vogt). In 1941, after Helene died, my mother and I visited Anton Kröller, who was by then seriously ill, at the family's summer residence, the Saint Hubertus hunting lodge, near Otterlo. Sam van Deventer, their art consultant and later the director of the Kröller-Müller Museum, was one of my godfathers.

My own interest in art, at first primarily architecture, was not awakened at home but rather in elementary school, through an instructor who used examples of historical buildings in Braunschweig to teach local history. I owe a great deal to this history teacher: he saved me from the National

Socialists and set me on my path in life. He encouraged me
to take part in the public guided tours of the city on Sun-
days, which started at the marketplace in the historic Old
Town. At that time, the old concert hall was still standing,
and the medieval half-timbered houses with wave-patterned
friezes were still intact. When they tried to recruit me for
the Napola, the elite National Socialist boarding school—I
was tall and athletic—my teacher, after consulting with my
mother, lowered my grades so that I could no longer be con-
sidered for enrollment.

It was during this time that I began to compile a collec-
tion of more than one thousand postcards featuring repro-
ductions of works from antiquity, the Renaissance, and the
Gothic and baroque periods. This was my introduction to art
history, alongside visits to the Herzog Anton Ulrich Museum
and, in particular, its collection of Dutch art. I learned to cat-
egorize my collection with the help of the art historian Eva
Stünke, the wife of Hein Stünke, who was an old friend of my
father's and who would later become important to me as well.
Eva and Hein helped me early on in my career in the arts, al-
lowing me to train under them at their gallery, Der Spiegel,
in Cologne. In these early years, the couple conformed to the
party line. As a municipal curator, Eva was responsible for
the Braunschweig Cathedral and its tomb of Henry the Lion,
which was symbolically and ideologically important to the
National Socialists. In 1942, Hein—who ultimately attained
the high rank of chief bannerman of the Reich Youth Lead-
ership of the Hitler Youth—was appointed a course leader at
the Academy for Youth Leadership in Braunschweig, where
he later became deputy director of the cultural office (p. 26).
The elite school for leadership training of the Hitler Youth
was one of the institutions that Minister-President Klagges
had brought to Braunschweig in 1937. With the beginning of
the war, however, school operations came to a standstill; both
teachers and students were drafted into service. The acad-
emy's rooms were given over to the League of German Girls
and eventually converted into a military hospital. They were

later used again by the Reich youth leader Baldur von Schirach as an educational center for former Hitler Youth leaders who were disabled during the war and were to be trained as bannermen. Stünke was entrusted with the task of training these young men. The enormous temple-like building in the typical Nazi architectural style was located very close to our house.

In the basement of the complex, there was a swimming pool with an eighty-two-foot lane, which Hein let me use. Soldiers who had returned home after having lost an arm or a leg would also swim here. One of them in particular impressed me very much. He showed me a small octavo with handwritten poems by Friedrich Hölderlin, Rainer Maria Rilke, Johann Wolfgang von Goethe, and Georg Trakl, which he had carried in the breast pocket of his uniform—a small private anthology of German poetry. The booklet had a hole in it: it had intercepted an enemy bullet in an exchange of fire on the front. The soldier's love of poetry had saved his life. At the time, I thought that anyone who loved poetry couldn't be a Nazi.

The Hall of Honor at the Academy for Youth Leadership, Braunschweig

Hein, who served under Baldur von Schirach, organized the Reich Youth Leadership's lecture program. Not all of the speakers Hein invited conformed to the system. Among the lecturers who maintained a critical distance from the ideology of the National Socialists were my godfather Harro Siegel, who was a puppeteer and taught art education at the Braunschweig School of Arts and Crafts, and the pedagogue Adolf Reichwein, who, as a member of the Kreisau Circle, was later executed in Plötzensee. Reichwein stayed overnight with my parents during his visit, and I attended his lecture.

After the war, Hein never spoke about his past in the Third Reich, not in public and not even to me, though I had experienced him as a Nazi functionary firsthand during my childhood. After his death in 1994, people were horrified when the role he had played in the Third Reich was made public—including the fact that he had assembled Hitler Youth combat groups for the Volkssturm, the national militia Hitler established in the final phase of the war. The artistic program of his gallery—including artists once persecuted and labeled "degenerate" by the National Socialists—testified to how far behind he wanted to leave his past and perhaps even how much he wanted to make amends.

At the end of 1943, I had to leave the city, like all children over six years old, as part of the Kinderlandverschickung, the relocation of children to the countryside as a protective measure against the imminent threat of aerial warfare. I was taken to Tanne, in the Harz, with my older brother Ruprecht, who went to the same school as me; Ruprecht and his class were accommodated in the inn Tanne, and I was in the guesthouse Zur Sonne. I was thus once again alone, this time as a ten-year-old, far from home and without my parents. Our English teacher and his wife served as surrogates of sorts: they were our youth hostel "parents." After breakfast, the service area of the hostel was converted into a classroom where we had our lessons.

Here I was sworn in as a *pimpf* (a German colloquial word meaning something like "squirt" or "little fart"), as the

new members of the Hitler Youth were called. In the morning, we woke up before sunrise and marched to a hill in front of a wide meadow, where we had to stand at attention and look to the east. When the sun rose above the horizon, we had to extend our right hand for the Hitler salute and shout, "We salute the Führer!" I have to admit that I enjoyed the pre-military exercises in the forest, the crawling and fake combat, but I was less fond of marching and singing. When my brother and I insisted on attending church services on Sundays, the rest of the class would march around the church and bawl out Nazi songs as a disturbance. But we remained steadfast, even when the platoon leader criticized us. Attending church services had been customary in our home, and our persistence strengthened our sense of independence.

Toward the end of the war, the indoctrination intensified and the fear of losing parents and siblings grew greater. Like my brothers and sister still in Braunschweig, I received a letter from my father, who was then in Russia, in which he bid farewell to us, as he expected to be taken prisoner in Kiev and deported to Siberia. However, like all fathers with more than four children, he was flown out of the combat zone: the logic behind this was that the Wehrmacht feared the high costs of orphan pensions. He was then transferred to the Army Group North. Meanwhile, telegrams from Braunschweig with death notices of our schoolmates' family members kept arriving in Tanne. The atmosphere was, of course, glum. One night, on October 15, 1944, the horizon in the north shone red. It was the worst attack on Braunschweig: two hundred thousand Allied bombs fell and the entire city erupted in flames.

The first retreating German troops were already marching through Tanne, and one day, in the spring of 1945, General Field Marshal Gerd von Rundstedt stopped off in the village. He had been commander in chief of the Army Group West in France and was reinstated by Hitler to fend off the anticipated advance on Berlin. His son, First Lieutenant Hans Gerd von Rundstedt, accompanied him as his adjutant. My

brother spoke to him, and it turned out that he knew our father from his studies—he offered to have us taken to Braunschweig in his father's car. This was our good fortune, as the front was drawing near. We had to stop numerous times and throw ourselves into a ditch because low-flying planes were above us. It took us several hours to cover nearly fifty miles. When, a few days after the surrender of Braunschweig, my brother and I returned to Tanne with our bicycles to pick up our things, we rode past destroyed tanks and corpses on the roadside. We had to make many detours on dirt roads to avoid control points, because, as children, we would have been sent home immediately. In Tanne, I asked the sculptor Kurt Edzard, who was my art teacher at the time, to return my book on Albrecht Dürer by Erwin Panofsky, which I had lent him.

I experienced the end of the war, the capitulation of Braunschweig, and the surrender to the Americans on April 12, 1945, in my parents' house. Before this, though, there had been additional heavy attacks, as Braunschweig—with its machine factories, steelworks, and photo industry—remained a target for the Allied bombers. Each time the alarm went off, we would descend into our own air-raid shelter, a concrete tunnel leading into the garden. If the house collapsed from an attack, we would have been able to escape through the tunnel. Every night, we had to go into our bunker: my mother would go first, together with my youngest brother and the bag with all our papers, which was always close at hand. Or we would go to the high-rise bunker on Salzdahlumer Strasse, the central bunker for the whole district, which was just fifteen minutes from our house and still stands today. Once, I came too late and knew that the door would already be closed. Pilots flying overhead had already marked the terrain for bombing with tracer ammunition—"Christmas trees," as they were called then. I ran into the neighboring Academy for Youth Leadership and waited out the attack in the air-raid shelter with the soldiers. Fortunately, nothing happened to me this time either.

My oldest brother, Kurt, saved himself in those last weeks before the end of the war by disappearing, deserting. Born in 1928, he was old enough to be drafted at the last moment. He said farewell to us all as he set off for his deployment, and we had to believe that we would probably never see him again. A few hours later, the military police showed up and searched the house for him, since my brother had never arrived at the train station. The whole episode was baffling to us, even frightening. It was later revealed that Kurt had gone to the Martin Luther House and asked the pastor who had confirmed him if he could go into hiding there. He stayed with the pastor in the cellar until the end of the war, and, to our great relief, returned home after the American invasion.

2

Youth during the Postwar Years

In the days between the negotiations around the city's surrender and the final capitulation of Braunschweig to US troops on April 12, 1945, a palpable power vacuum emerged in the city. The police had already withdrawn. The large forced labor camp with mainly Russian prisoners of war, which was close to our district, was no longer guarded. The prisoners quickly discovered the stranded trains loaded with food that were destined for Berlin. Looters were shot on the spot.

When I arrived, there were no longer any policemen in sight. One day, I took an empty sack with me from home, into which I put four packets of flour I found in a wagon. In one train car, I discovered a case of canned peaches, of which only five cans actually made it home with me because the load became too heavy along the way and I had to leave behind one can after the other. On the way home, I met two US soldiers in a jeep who stopped to ask me: "Where's the Rolleiflex factory?" Apparently, they, too, wanted to take the opportunity to help themselves to some "free merchandise" from the famous camera manufacturer based in Braunschweig.

Over the next few days, the plundering continued. Houses in our neighborhood were also looted—but by some

miracle, ours was spared. When my bicycle was stolen, the Russian priest from the forced labor camp returned it a short time later with an apology. This special treatment may have been because of my mother, who was particularly friendly toward the Russians in our neighborhood and, in particular, toward one Russian prisoner of war who helped out in our household. On Orthodox holidays, my mother cooked her traditional Russian dishes that she remembered from our time in Berlin-Buch, when we lived next door to the Russian scientists who worked with my father. Word of my mother's kindness seemed to have gotten around, and we remained unscathed during this critical time.

On the afternoon of April 10, 1945, before the capitulation negotiations began in the evening, I experienced what may still be the most dangerous situation of my life. When I stepped outside that day, an American plane flew over an open field directly toward our house. I immediately jumped back and threw the front door shut. At that same moment, several rounds from a machine gun hit the heavy oak door, which luckily withstood the attack. It was a very close call! The low-flying planes had clearly wanted to shoot any soldiers still in the town before the Allied troops marched in, and they had mistaken me for a fighter from the youth division of the Volkssturm.

There were other traces of war in our house. For example, a splinter of ammunition was stuck in the center of the portrait of Hitler hanging on the wall in the hallway. All households were required to have a portrait of the Führer in their homes; by not removing the shard of ammunition, my mother showed, at least indirectly, what she thought of Hitler. Only a few days after the last bombardment, when the armistice for Braunschweig had been signed, I was lying in our garden and saw a huge group of planes heading for Berlin, one squadron after the other. In that moment, they looked like beautiful silver birds to me—I knew that we would not be bombed anymore. For the people of Berlin, however, the war wasn't over yet.

There was no school in the months after the war; classes would start again in late November. My mother was still alone, since my father would not return from American captivity until the end of August. During this time, my brothers and sister and I went out to get food: we found what we could, picking ears of corn in the fields, collecting the small tubers left behind after the potato harvest, and shaking fruit from the trees lining the streets. In the sports closet at the Academy for Youth Leadership, I discovered ten footballs, which I exchanged for eggs at farms in the countryside. When it got cold, we began sawing trees in the nearby park, working bit by bit until they finally fell and we were able to cart them home in pieces as firewood.

More than anything else, however, we needed coal, or better still hard coal, which we took from moving freight trains as they passed through town. The first thing we did was manipulate the initial stop signal at the tracks with a stick, so that the train driver had to slow down. When the train was moving slowly enough, we jumped on and threw lumps onto the railroad embankment so that we could collect them afterward. As soon as the driver arrived at the second signal, which was open and gave him free passage, he picked up speed again. This was doubly dangerous because, in the beginning, American military police were still arresting looters. I am still surprised to this day that we were never caught. At that time, *fringsen*, the ecclesiastically approved theft of coal, did not yet exist—Cardinal Josef Frings would not deliver his sermon at the Cologne Cathedral, in which he condoned the theft of coal in the early postwar period, until New Year's Eve in 1946.

Our mother was, of course, very worried about us, but I was always able to put her at ease. After all, we were securing provisions, and not just for our own immediate family. Our household now also included the children of Adolf Reichwein, who had been hanged as a member of the Kreisau Circle in Berlin-Plötzensee on October 20, 1944. His widow, Rosemarie Reichwein, had asked my mother to take in the

children, since she had to find work elsewhere as a physical therapist. The children of Hans Gerd von Rundstedt, who had helped me and my brother to return to Braunschweig, also lived with us. He and his father were prisoners of war, and his wife, Editha von Oppen, similarly had to find a way to make do on her own. Their daughter Barbara von Rundstedt stayed with us the longest. It thus came to pass that the offspring of a resistance fighter and the grandchildren of one of the highest members of the Wehrmacht lived together under one roof without any issue. Everyone was just grateful to have a place to stay. My mother, warmhearted as she was, accommodated everyone—even a French couple who had been released from a detention camp in Berlin and appeared on our doorstep one evening with a handcart and nothing else: they were on their way to Paris. The house was completely overcrowded, but my mother cleared the garage for the very pregnant woman and made a bed for her out of bales of straw and blankets. My mother contacted a midwife, too, just in case the baby had to be delivered that night; the next morning, however, the couple moved on.

These months shortly after the war, without any form of authority—in contrast to the previous false stability, and the repression by the National Socialists—were a crucial experience for me. I developed a great deal of independence and, at the same time, felt a sense of responsibility for my family, which led to tension with my father once he returned from American captivity. It was late August and I was playing outside when I saw an older man, shabby and unshaven, in uniform coming down our street. I recognized him immediately but ran into the house first to tell my mother.

The war had changed my father: he became a devout believer. It was this intransigent attitude that saved his life during the Russian campaign. When, after the failed assassination attempt on Hitler of July 20, 1944, the order was issued that all officers must renew their oath to the Führer, my father refused on religious grounds, stating that he could not reconcile the oath with his conscience. At that time, he was a

consulting physician not far from Saint Petersburg with the Army Group North, which was almost surrounded and facing defeat. Because of his disobedience, my father was flown to Berlin by courier plane to answer to army command. He was, however, not executed, but merely demoted to corporal, since doctors were urgently needed in the Wehrmacht. He was then immediately reinstated on another front line, this time in Czechoslovakia. When I later discussed with him why he hadn't taken part in the resistance against Hitler—because he had indeed been asked to do so by friends in the Kreisau Circle—he always quoted Romans 13:1 from the Bible, the letter of Paul the Apostle to the Romans, in which he lays down that the emperor's power must be respected. My father thus accepted Hitler's authority as virtually God-given. I was never able to understand that.

When, as a young man, I discussed his position with Marie-Luise Borchardt, the widow of the writer Rudolf Borchardt, who had been my father's friend, she opened my eyes, arguing that there might perhaps be wisdom in not interfering with a power against which one could only lose. It would eventually expire on its own anyway. The conversation helped me to find my own standpoint: I developed my own system of values and never took sides. To this day, I am still suspicious of ideologies, and I am distrustful of any leadership. This has also had a decisive influence on my professional life. I never saw myself as a gallerist, someone who represents his artists unconditionally, through all the ups and downs, but rather as an art dealer who sells individual works worthy of being sold on the market. The paths of those involved could also part—I never wanted to put myself completely in the service of an artist. This could and did lead to the tarnishing of friendships, as it did with Gerhard Richter. Once, when he showed me new paintings in his studio, paintings that depicted his young wife breastfeeding their newborn child, I remained silent—because, for me, this motif was art-historically anachronistic, having long since been concluded with paintings of the Madonna. Richter must have resented my silence.

My father's stern disposition was often directed toward his own children. Unlike me, my brother Ruprecht did not steal coal from the freight trains in order to contribute to the household. Being older, he went even further, trading on the black market near the train station, where cigarettes were exchanged for bread, German cigarettes for American cigarettes. At some point, after school had started again, the military police caught him and put him in jail as a black market trader. My father found my brother's behavior morally unacceptable, though he never asked where the coal we used for heat came from. After my brother's arrest, my father went to the school principal, Lothar Dingerling, and demanded that he suspend my brother because, as a criminal, he was no longer worthy of receiving a high school education. Dingerling replied that this was not a matter for the parents to decide but rather for the school administration, and he politely ushered my father out of his office. When Ruprecht finally returned home, he was grounded for weeks. In his desperation, he even attempted to take his own life; Barbara von Rundstedt found him in the attic with his wrists slashed just in time, and he survived. Instead of showing leniency, my father's reaction was to pray with us at both lunch and dinner.

My brothers and sister were burdened by our father's behavior; I had already distanced myself inwardly and felt independent. The breaking point came when, on one occasion, my father raised his hand against my mother in anger. I intervened, and he let go of her, but for a long time we did not speak a word to each other; we lived together in mutual silence. Only much later did we find our way back to each other, after I had made a name for myself as a gallerist. I took both him and my mother on trips to North and South America. My father and I were able to develop a new relationship, as two autonomous individuals. He was now proud of me, because he could read about my achievements in the newspapers. From then on, we were able to connect through philosophical and theological discussions.

The only thing we didn't talk about was the past, specifically, our clashes in the period after the war, the Third Reich, and my father's involvement as a medical officer in the Wehrmacht. It was all off-limits between us. I knew that he had witnessed the Warsaw ghetto and was able to help a young man, the son of his cleaning lady, escape by speaking to his cousin Karl Eberhard Schöngarth, who was then the commander of the Security Police and the Security Service in the Generalgouvernement. It was not until much later that I again came across the name Schöngarth, in an exhibition at the memorial and educational site of the House of the Wannsee Conference. He had been one of the participants in the conference where the "Final Solution to the Jewish Question" had been decided. In 1946, a British military court sentenced him to death for war crimes and had him executed. During his time at the Institute for German Research on the East, my father went, in uniform, to see his cousin and asked to summon the son of his cleaning lady for the phonometry archive, so that he could better study Yiddish through his articulation. In doing so, he saved the boy's life. After the war, the two kept in contact, and he visited my father, who continued to support him, on numerous occasions throughout his life.

Still, I never spoke about the Holocaust with my father, nor with my parents' Jewish friends, some of whom I stayed with in New York when I was there on business for the gallery. In New York, I discussed Schiller, Goethe, Heinrich von Kleist, and humanism with Hertha Vogelstein, and we shared an admiration for the abstract painters Mark Rothko and Barnett Newman. As someone who was born in 1933, I still felt a part of the generation of perpetrators, and I shied away from conversations around Hitler and Auschwitz, despite the fact that I was only twelve years old when the war ended. Had I been born in 1945, I probably would have been at my father's throat during the student riots of 1968.

My father finally completed his postdoctoral studies in the 1950s, after which he was appointed professor of phonetics and phonology in Cologne and secured the long-term

future of the Institute for Phonometry under the umbrella of the Max Planck Society. However, he was interested more than anything else in philosophy. He wrote the philosophical treatise "The Medical Interview" on the relationship between physicians and patients and its consequences, which was initially published in the *Frankfurter Allgemeine Zeitung* and later as an offprint. For me, "interviewing" clients would become the basis of my profession. My father searched for a hierarchical, incontestable system of the sciences. After his death, I came across hundreds of notebooks written in Sütterlin—the historical form of German handwriting taught in all German schools from 1915 to 1941—in which he recorded his philosophical thoughts. Today, these notebooks are preserved in the Bavarian Academy of Sciences and Humanities in Munich.

Back when I was still in Braunschweig and the conflict with my father was at its peak, I promised myself, I'll go my own way, just finish school here and then goodbye! But I had to wait until graduation. The nine months without attending school was now showing its impact, though, as I could no longer follow the material. My parents decided to take me out of school temporarily and have me stay with friends in Stockholm for three months, partly because I was completely undernourished. Although I was taking nutritional supplements—thanks to the Schwedenspeisung, a mass food-aid program for children, financed by Sweden, the United States, Switzerland, Denmark, and Great Britain—my parents were still worried about my health. The months in Stockholm were a shock for me. Suddenly, I found myself in a city untouched by war. I had completely forgotten what that was like.

When I returned to Braunschweig, the reform of the school system had just taken hold: instead of eight years, secondary school now lasted nine. By repeating a class, I lost a total of two years, and, in the end, I was in an even greater hurry to get away. At first, the lessons took place irregularly, since there weren't enough classrooms for the number of students. The teachers had returned from captivity hungry,

and in front of them sat pupils who, in some cases, had also been at the front lines and now finally wanted to earn their high school diplomas. There were age differences among students in one class of up to three or four years. Some of them had returned from the war disabled, having lost a leg or an arm. The teachers first had to learn to communicate with them at eye level.

Some teachers continued seamlessly from where they had left off, as if they wanted to undo the past. Among them was my homeroom teacher, Senior Schoolmaster Gross, who had been our teacher during the Kinderlandverschickung, in Tanne, where he had lent me a pencil shortly before the end of the relocation period in the Harz and stressed that he wanted it back later. When I sat in his class again after 1945, he reminded me about his pencil. He reacted with complete consternation to my explanation that I had not had the pencil for long, since it had been lost in the war, and reproachfully said that he had only *temporarily* entrusted it to me at that time. Later, I observed that the people who had lost everything during the war or as refugees, who had had to leave behind their estates with forests and fish farms in the East, but who were able to inwardly free themselves from material things, were the most successful in making a new start after 1945. For them, their loss became a driving force; it was they who brought about the so-called economic miracle.

The postwar years in Braunschweig also had a strong cultural influence on me. As a student, I often went to the theater, attended concerts, visited exhibitions, and had conversations with artists and actors late into the night. Although I had class the next morning, I led a downright bohemian life, consciously distancing myself from the strict emphasis on religion in my parents' house. I could not share my father's enthusiasm for the conservative writers Rudolf Alexander Schröder and Rudolf Borchardt, who I found too academic and overly intellectual. Albert Bittner, Braunschweig's general music director, introduced me to the completely opposite cultural sphere of theater and concerts. In return for picking

up visiting soloists from the train station, I was allowed to sit in the director's box, directly in front of the stage. At that time, the state theater also served as a concert hall, so I attended concerts and operas conducted by Bittner as well as theater productions.

Following the performances, I would go with the actors and musicians to the nearby legendary artists' bar Der Strohhalm and discuss—perhaps a bit precociously—the productions with them until three or four o'clock in the morning. The bar was run by the Jewish couple Zenobjucz and Gertrud Messing, who had emigrated from Eastern Europe after the war and were known to everyone as Ziggy and Puppa. Here, I also met Charlotte Gmelin-Wilke—the daughter of the *Simplicissimus* illustrator Rudolf Wilke—who became a lifelong friend. In the late 1940s, she had been one of the founding members of the bar. Another regular guest was the renowned defense lawyer Oskar Kahn. Whenever he saw me walk in, he would shout from the bar, "The sandbox has arrived!" I was only sixteen years old at the time, seventeen at most. But the conversations with artists, the nightly debates, and the studio visits prepared me for my future work. From then on, I knew how to move about in artist circles. It was these human experiences that made me turn away from art history. I was more interested in the proximity to living artists, my contemporaries. During this time, too, I acquired my first painting, an abstract canvas, by the painter Heiner Kiesling. And I also made my first attempt to resell art. Unfortunately, it was in vain. The impetus for this came from the collector Otto Ralfs, who also lived in Braunschweig. In the 1920s, he had assembled a remarkable collection of works by the Bauhaus artists Paul Klee, Wassily Kandinsky, Oskar Schlemmer, and Lyonel Feininger, which he had acquired from them in exchange for household goods and services. (Ralfs was a deliveryman in Weimar and Dessau for his parents, who owned a shop for household goods and who knew the Bauhaus masters and their families from the Bauhaus festivals.) I never got to see his collection of paintings,

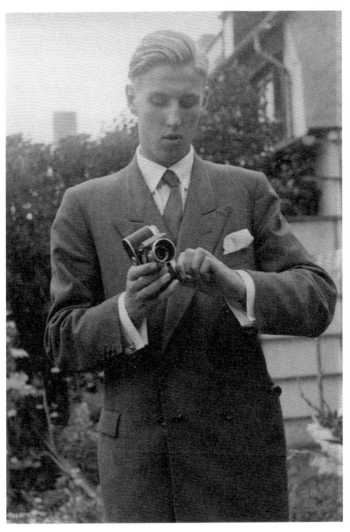

Rudolf Zwirner, 1951

since they were lost during the war—ironically, somewhere along the way to a Silesian mine for safekeeping. The works are now thought to be in Russia. On Sundays after the war, Ralfs invited people to his modest apartment in the Schuntersiedlung housing estate to show them the works on paper that were still in his possession. He would greet his guests wearing women's dresses, but no one seemed to mind. One day, he asked me to offer a work on paper by Klee for 200 marks to my father, because he thought my father had the money. My father turned down the offer, pointing out that he still had debts to the tune of 200 marks at the bookstore and wanted to settle these first. No one could foresee the enormous increase in value of pictures by Klee.

During these years, I learned a great deal that would be quite useful later in life. The only thing I regretted was my incomplete education, especially my inadequate English due to the canceled classes. Even more regretful was my lack of knowledge of the field of contemporary art. Because of the ban on modernism, the confiscation of "degenerate" art from museums, and the restrictive cultural policy of the National Socialists, I had a lot to catch up on. I was jealous of the knowledge of Werner Schmalenbach, who later directed the Kunstsammlung Nordrhein Westfalen, as well as that of the gallerist and collector Ernst Beyeler. Having lived in Switzerland during the war, they had learned everything as a matter of course as early as childhood. In contrast, I had seen mostly works by the old masters in museums as well as a great deal from the nineteenth century. It was not until 1955, at the first Documenta exhibition, that I came across a large number of modernist works.

3

Art Beckons

As soon as I finished high school in 1953—I didn't even wait for the graduation ceremony—I began hitchhiking: to Munich to the Pinakothek, to the museums in Hannover, Amsterdam, and Cologne, where, in 1955, the great Picasso exhibition took place in the Rheinisches Museum in Deutz— on the opposite side of the Rhine, directly across from the Cologne Cathedral—where *Guernica* (1937) was on display. But my visit to the first Documenta exhibition in Kassel in 1955 was a life-altering experience. Kassel was between Braunschweig and Freiburg, where I was studying law, so I took the opportunity to visit the exhibition. At the entrance to the Fridericianum, I noticed a group of people waiting for a tour to begin, including a lady who called out to me, "Rudolf, what are you doing here?" Surprised, I realized she was the princess of Waldeck, a neighbor from Braunschweig and a good friend of my mother's. She invited me to join the guided tour for the Rotary Club of Northern Hesse, conducted by the secretary general of Documenta, Baron Herbert von Buttlar. I immediately accepted.

This visit marked a turning point in my life. On the way back to Freiburg, I decided to abandon my law studies. I had only studied halfheartedly anyway, because I felt that I would never be more than a third-class lawyer. Attending a court hearing was especially illuminating. In my opinion,

it was not the defendant but rather the judge who had been sentenced to life. But I liked Freiburg and its beautiful location and proximity to Basel and Colmar, where I went several times by bicycle to see the famous Isenheim Altarpiece. Instead of spending my time in the law department, I started attending lectures in the department of art history, including those by Kurt Bauch on baroque painting and by Hans Jantzen on Gothic architecture, focusing on Chartres.

In the evenings, I often met with my brother Ruprecht, who was studying medicine in Freiburg, and with Günter Gaus. Like me, they had both graduated from the Gaussschule in Braunschweig. We would go to a tavern called Georgklause—named after the patron saint of Freiburg—two or three times a week, at around six o'clock, because drinks there were offered at half price until eight o'clock, and this was all we could afford. We felt sophisticated discussing world politics with a sundowner in our hands. Günter was working as a journalist and would later become editor in chief of the weekly news magazine *Der Spiegel*, then state secretary in the Federal Chancellery, and, until 1981, the first permanent representative of the Federal Republic of Germany in East Berlin. Through my conversations with him, I learned how to articulate myself politically.

The stopover in Kassel for Documenta marked the end of my time in Freiburg; I had suddenly found direction in life. I was especially taken by the art from the 1920s and 1930s on view—the Bauhaus, German expressionism, abstraction—which I hadn't seen much of before. Here, it was presented in a comprehensive manner. And contemporary art had an even stronger effect on me. The Documenta exhibition opened a door for many people who, like me, were seeing works by sculptors such as Alexander Calder, Hans Uhlmann, Naum Gabo, Antoine Pevsner, Bernhard Heiliger, and Henry Moore for the very first time. I was particularly impressed by one sculpture by Wilhelm Lehmbruck, his *Kneeling Woman* (1911), installed in the staircase. The experience of the work was heightened through its interaction with the space, the

ruins of the Fridericianum (below). Arnold Bode, the founder
of Documenta, had placed the artworks confrontationally
within the bare masonry of the Fridericianum, in front of
unplastered, whitewashed brickwork, or he hung works on
walls covered with sheets of black and white plastic. In this
environment, the art gained tremendous power: it was a de-
parture *ex ruinas*. Today, it is a common practice to present
art within dilapidated architecture—in abandoned churches
or rundown factories—in order to achieve a unique site-
specific effect. But at that time, this kind of staging was new
and particularly symbolic.

The first Documenta was intended only as an accompa-
nying exhibition to the Bundesgartenschau, the federal hor-
ticulture show, which took place a few hundred yards from

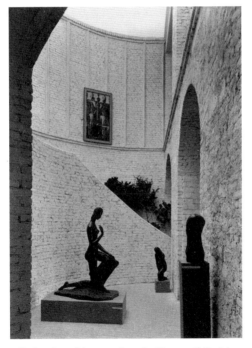

Installation view of the rotunda at the Museum Fridericianum,
with Wilhelm Lehmbruck's sculpture *Kneeling Woman* (1911) at far left, at the
first Documenta, Kassel, 1955

the Fridericianum. It was meant to signal a renewal for the war-torn city. The destruction was visible everywhere, because Kassel—with its armaments, automobile, and machine construction industries—had been particularly hard hit by the Allied raids. At the same time, located in the middle of Germany, it was the last large city before the Soviet zone and thus also a strategic location in terms of cultural policy. Documenta conveyed the message—both internally and externally—that something new would emerge from the ruins, that the wreckage left behind by Hitler would be overcome. The subtext was this: art had survived, and even the art that had been persecuted as "degenerate" was now back. For many, the exhibition was a revelation; it welcomed 130,000 visitors—an unexpected success that led to a second exhibition four years later and, ultimately, to Documenta's establishment as a permanent institution. It soon became the most important international exhibition of contemporary art.

Through Bode's intertwining of the space and the works of art on view, the exhibition became a total experience, and with this "staging" of Documenta, the painter and university lecturer created his masterpiece. Bode's model later inspired me in my work as a curator; through him, I understood space as a decisive factor in its combining with sculpture and painting. My encounter with contemporary art gripped my innermost being, unlike the old masters before, and I now knew what I wanted my life to be about, even if I didn't know what form it would take. But one thing I knew for certain: I wanted to be in the now.

It was only later that I became particularly interested in the art defamed by the Nazis as "degenerate," when I was running my own gallery and meeting collectors such as the textile manufacturer Klaus Gebhard from Wuppertal and the chocolate manufacturer Bernhard Sprengel from Hannover. They had started collecting expressionist works after seeing the *Degenerate Art* exhibition in Munich in 1937—the exact opposite of the effect intended by the Nazis. For Gebhard, Sprengel, and others, the defamatory presentation served

as an incentive to seek out such works. The press, which had been brought into line, was full of scathing reviews, but many visitors who first became acquainted with modernism through the exhibition in Munich's Hofgarten had a rather positive reaction. Through its shock value, the exhibition forced people to confront contemporary art.

Someone like Marcel Duchamp—who hung sacks of coal from the ceiling at the surrealist exhibition in Paris in 1938 and playfully obstructed the main space of the exhibition *First Papers of Surrealism* in New York in 1942 with a web of several hundred feet of twine—would have probably found the crowded hanging in Munich, with slogans intrusively positioned between the works, ingenious. Duchamp wanted to shock, too, albeit in order to forcibly overcome conventional viewing habits. With the end of the Third Reich, a new era in the reception of modernism began. The artist groups Die Brücke and Der Blaue Reiter returned in force to museums and other art institutions, in a gesture of reparations toward the persecuted artists and as an attempt to reconnect to an earlier, better time in the collective cultural memory. For my part, however, I was determined not to look back, even though I could have visited Emil Nolde in Seebüll or Otto Dix at Lake Constance at that time. I was not interested in the artists of yesterday.

I finished my semester in Freiburg and then traveled to Braunschweig to have a face-to-face conversation with my father before making my final decision. He was relieved when I announced that I had decided to give up law, even though his paying for two years of my studies on his modest income was no small matter. I found out later why he had been so relieved: when I asked to speak with him in private, he feared that I had gotten a girl pregnant and was going to ask for the name of a doctor who could perform an abortion. Of course, instead, I told him that I wanted to become a bookseller and do something with art. I was not yet familiar with the profession of an art dealer, and I did not want to switch to a proper study of art history, as I was not especially drawn to academia;

I was more a practitioner by nature. Whatever it was that I was going to do with my life, it had to have something to do with commercial trading. My father was more than happy about this decision and later admitted to me that he couldn't stand lawyers anyway.

Through my godfather Harro Siegel, who at the time was teaching puppetry at the School for Master Craftsmen in Braunschweig, I met Hanns Krenz. Between 1924 and 1930, he had headed the Kestnergesellschaft in Hannover, after having worked at Galerie von Garvens, also in Hannover. From 1933 to 1943, he ran a bookshop and art dealership in Berlin. I visited him in his small apartment, which was crammed with antiques, paintings by the German expressionists, and East Asian art. When I told him about my vague professional plans, he exclaimed, "Rudolf Zwirner, become an art dealer! It's the best profession you could ever imagine!" I knew then the direction I would take. When I left, he gave me a small sculpture, a flying dove made of bronze, which would accompany me for years as a talisman.

After it became clear to me that I wanted to become an art dealer, rather than a bookseller, I had to find a gallery where I could learn the trade, and set off to determine which city would be best. I quickly decided Cologne was a favorite, mostly because of its twelve Romanesque churches. At that time, in the mid-1950s, the Wallraf Richartz Museum, designed by Rudolf Schwarz and Josef Bernard, was being built to house the lawyer Josef Haubrich's collection of expressionist art, which he had saved from confiscation and destruction during the war and donated to the city in 1946. During construction, parts of the collection were on display at the Kunstverein, where Haubrich was the chairman. The Kunstverein was housed in the historical Hahnentorburg, the medieval west gate of the city, on Rudolfplatz. His Haubrich foundation was also important for the museum, as it provided a budget for contemporary art, supplementing the municipal acquisition budget. The museum was thus soon able to acquire its first works from the École de Paris.

Munich was also on the short list of possible cities where I could train, with the Galerie Stangl, which dealt in contemporary art. In Düsseldorf, Galerie Schmela had not yet been founded, and Alexander Vömel and Wilhelm Grosshennig followed a more classical program, like most of the others: Hanna Bekker vom Rath in Frankfurt am Main, Franke in Munich, the auction house Ketterer in Stuttgart, and Ferdinand Möller, whom Leopold Reidemeister, the director general of the Cologne museums, had lured from Berlin to the Rhine, thus establishing the city's first important gallery for art from the 1920s and 1930s since the war. If I were in today's world, I would probably have gone abroad to train; at that time, Sotheby's in London or the Kornfeld auction house in Bern would have been interesting. But such considerations were beyond my economic and intellectual reach.

I ultimately went to see Eva and Hein Stünke at their gallery, Der Spiegel, in Cologne, which had a reputation as one of the best avant-garde galleries in Germany. Founded in December 1945 in the Deutz district of Cologne, the gallery later moved to Richartzstrasse 10 in the center of the

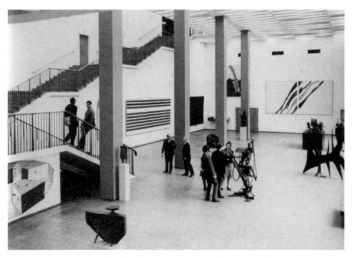

View of the former Wallraf Richartz Museum, with a sculpture by Jean Tinguely at center and works by Morris Louis and Kenneth Noland, Cologne, 1969

city—strategically located near the future Wallraf Richartz Museum and only five minutes' walk from the main train station. The gallery focused on contemporary artistic trends from Paris and Germany, and it was also known for its excellent catalogues, which were published in conjunction with its most important exhibitions under the series title *Geh durch den Spiegel* (Go Through the Mirror) and were themselves works of art. Hein developed a unique style for the catalogues and had them elaborately printed in gravure with hardback covers. They contained poems by the artists Wols, Hans Arp, and Max Ernst, and texts by the writers Henry Miller and Jean Genet, and were published in editions of one hundred to three hundred copies, each with one original print. The catalogue series not only elevated the gallery but its title also quoted the challenge made to a painter by a sculpture that had come to life in Jean Cocteau's first film, *Le sang d'un poète* (1930).

The fact that Hein and Eva did not operate their gallery under their own name had to do with their past during the Third Reich. Although, at first glance, the name of the gallery (which translates to "the mirror," in English) suggested that it would reflect the present, for the Stünkes, the name might also have been understood as a metaphor for the idea that there are many truths. Despite their history, I went to Eva and Hein, and not to Werner Rusche or Aenne Abels, who also dealt in contemporary art in Cologne, because I had known them since my childhood and felt close to them. Later, when I was a gallery owner myself and could talk to him as a peer, I often asked Hein why he didn't speak openly about his time at the Reich Academy for Youth Leadership. But he remained silent.

The greatest merit of Der Spiegel was that it became a meeting place for creatives and intellectuals—artists, art historians, and philosophers would gather regularly in the gallery for intensive conversations. I profited from this. Once a week, the gallery hosted a roundtable discussion in the afternoon that usually stretched into the evening hours. Among

the participants were the Cologne-based painters Ernst Wilhelm Nay, Hann Trier, Joseph Fassbender, and Georg Meistermann; from the board of the Association of German Artists, the philosopher Albrecht Fabri, as spokesman for abstract painting; and the critics Albert Schulze-Vellinghausen, John Anthony Thwaites, and Carl Linfert. Heinrich Böll, who was later awarded the Nobel Prize for Literature, also stopped by. The art historians Will Grohmann from Berlin and Werner Haftmann from Hamburg also joined when they were in town, as did the Cologne-based collectors Walter Neuerburg, Gustav Stein, Josef Haubrich, and Wolfgang Hahn. Even museum directors, such as Leopold Reidemeister, the director general of the Cologne museums; Ernst Holzinger, the director of the Städelsches Kunstinstitut in Frankfurt am Main; and Alfred Hentzen, the director of the Hamburger Kunsthalle, attended these roundtables, which was unusual at the time, because art historians and museum professionals generally maintained a certain distance from the trade.

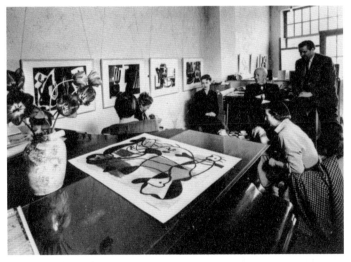

Roundtable held at the gallery Der Spiegel at Richartzstrasse 10 in Cologne, 1953. *From left to right:* Hubert Berke, Eva Stünke, Dorothee Schwarz, Josef Haubrich, Mrs. Hossdorf, and Hein Stünke. On the walls are works on paper by Gérard Schneider, and on the piano is a print by Joan Miró.

I sensed the arrogance behind this distance when I visited Reidemeister for the first time after opening my own gallery: "I cannot welcome your decision to become an art dealer," he told me. "In the future, you will always be on the wrong side of the desk." He, of course, thought he was on the right side, which the future would show was not always true. But he came to the Stünkes' talks anyway, because that's where the city's intellectual scene was.

In principle, Der Spiegel was more a place for discourse than it was a commercial gallery. Its financial success was limited. As an art historian, Eva determined the program, while Hein was responsible for the publications. Because she spoke perfect French, Eva traveled regularly to Paris to pick up the latest works by artists including Jean René Bazaine, Jean-Paul Riopelle, Victor Vasarely, and Wols from their studios on consignment for her exhibitions. Through her, I became familiar with the French avant-garde. Eva knew Max Ernst from the period before the war: she came from Cologne, and he was born and raised in Brühl, only a few miles away; the two of them enjoyed speaking with each other in the Rhenish dialect. Ernst was the only truly major artist of the gallery who was already part of art history; otherwise, the Stünkes were primarily interested in new contemporary art and that was hardly salable at the time. The big German collectors still preferred to acquire expressionist works and also some Bauhaus pieces as well as paintings by the realists George Grosz and Otto Dix—anything that had previously been labeled "degenerate." There was urgency in catching up on lost time, in purchasing works of art that had been banned by the Nazi regime; and the international trade had not yet been able to reestablish itself in Germany.

The fact that Der Spiegel showed primarily abstract art also had something to do with the Stünkes' history. Everything that had happened before 1945 was largely eclipsed, and nonobjective art was liberated from a content-related debate. Abstraction was also the credo of the gallery's in-house philosopher, Albrecht Fabri. For him, as well as for the art

historian Werner Haftmann—the *spiritus rector* of Documenta, alongside Bode—figuration had been compromised by the doctrine of the Third Reich. In the roundtable discussions at the gallery, I experienced the aftershock of the fierce disputes between the figurative painter Karl Hofer and the theorist Will Grohmann, for whom the new "universal language" of abstraction, as Haftmann later put it, was the perfect culmination of art. Despite this, it was still extremely difficult to sell.

To make matters worse, the Stünkes did not have a sense for business, and I learned very little about buying and selling there. Their bookkeeping was a disaster: all invoices and overdue notices were thrown into one cavernous cardboard box. When things became precarious because a creditor threatened to sue, Eva would send me to the garret to bring down the box. Then she'd say something along the lines of, "Why don't you look for all the invoices from Michael Hertz from Bremen? He'll come by later and wants to be paid." Through Hertz, who represented Daniel-Henry Kahnweiler in Germany, you could purchase Picasso prints. Naturally, the Stünkes did not want to get on his bad side. In the end, Hertz usually received only 5,000 to 7,000 marks in partial payment of a total outstanding sum of 20,000. Instead of collecting the debts in full, he issued the next invoice for another order of Picasso prints. It was a never-ending story—complete chaos. The Stünkes earned their money more through their publishing work as well as their in-house framing workshop.

Der Spiegel was also important as an exhibition space, where many artists presented their works for the first time (again) in Germany: Hans Hartung in 1951; Henri Matisse and Alexander Calder, whose representation the Stünkes had taken over from Galerie Parnass in Wuppertal, in 1952; Henri Laurens, Max Ernst, Joan Miró, and Rupprecht Geiger in 1953; and Serge Poliakoff, Julio González, Marino Marini, and Ernst Wilhelm Nay in 1954. And before I joined them: Fernand Léger and Wols. During my training, Victor Vasarely

and HAP Grieshaber exhibited there. The gallery primarily sold prints, which for many buyers were their first acquisitions. In time, the print buyers evolved into picture buyers and, finally, into serious collectors. My job was, more than anything else, to watch and listen. I didn't have a desk of my own, and I was paid fifty marks a month. With an additional 150 marks from my parents, I could afford a room with access to a communal bathroom in the district of Bickendorf, in the northwest of Cologne. At the gallery, I would run errands and pick up paintings from artists and then bring them to the framing workshop. I witnessed the selection of artists for exhibitions and was allowed to help with the hanging, but I wasn't able to organize my own exhibition. When I later opened my own gallery, the first thing I did was show works on paper, because that was really all I had learned from the Stünkes.

The discussions at the gallery were just as important as learning the daily business activities of operating a commercial space. The Stünkes always involved me in their internal discussions. Since they had no children, they treated me like a son. Later, after I had become their competitor, Eva spoke of me as the "viper that she had nurtured in her bosom." We were nevertheless able to maintain our friendship.

I often sat together with the Stünkes after the gallery closed at six o'clock and had dinner with them. So it was only natural that Hein took me to the Weinhaus Denant for the *jour fixe* hosted by the sculptor Ewald Mataré on the fourth of every month. At the time, Mataré was teaching at the academy in Düsseldorf. He designed the south portal of the Cologne Cathedral, and he was also represented by Der Spiegel. The winehouse was located in a vaulted cellar that dated back to the Gothic period, directly behind the Romanesque church of Saint Maria im Kapitol. Those who dined in the winehouse were first invited to see the offerings of meat, fish, and vegetables arranged on tables in the anteroom of the kitchen and then place their order with the head waiter. The atmosphere was very personal: even the four or five women

who prepared the meals in the kitchen were greeted with a handshake. The restaurant was especially popular with artists, similar to the Paris Bar in Berlin today. Guests would come in from other cities, because one could be sure to meet artists here. For me, these were important evenings, because, though I was still a very young man, I could sit with artists such as Meistermann, Mataré, Fassbender, and Trier as well as with collectors like Haubrich, and I was taken seriously.

When my year of training at Der Spiegel came to an end, I knew I still had much more to learn. The knowledge I acquired from discussions of contemporary art and the German and French art scenes was not enough: I still lacked training as a dealer. And so I applied for a position at Galerie Rosen in Berlin—not so much because Berlin was my birthplace, but because I wanted to become acquainted with the auction business. Berlin became my next stop.

4

Berlin and Paris

I wanted to work at an auction house that dealt in old prints because I was already acquainted with modern and contemporary prints—Pablo Picasso, École de Paris—through my training with Eva and Hein Stünke. And I wanted to work at an auction house affiliated with a gallery. Galerie Rosen in Berlin was the perfect fit. The three founders—the bookseller Gerd Rosen, the collector Max Leon Flemming, and the painter Heinz Trökes—opened the gallery in a storefront on Kurfürstendamm in the district of Charlottenburg in August 1945, just three months after the end of the war. During Galerie Rosen's first exhibition of art that had previously been labeled "degenerate," with works by Wilhelm Lehmbruck, Alexander Archipenko, Ernst Barlach, Käthe Kollwitz, and Franz Marc, passersby would stop in amazement in front of the large window. In 1949, the gallery moved to Hardenbergstrasse, where it was able to hold out even during the Berlin Blockade. What truly saved the business were the book and art auctions, for which the gallery became well known even outside the city. Rosen, for whom the gallery was named, was an important book collector who, during the Third Reich, had worked as an antiquarian bookseller in the service of high-ranking party members in Vienna and was thus able to survive, despite being Jewish. People said he still owned a library comprising more than fifteen

thousand volumes, and that he rented an entire apartment for it.

The early postwar years must have been pretty wild. No one asked where the work that was brought in actually came from. Trökes recalled how a truck driver, who had purportedly hoarded works from the artist group Die Brücke in his attic, once came to the gallery. He offered seventeen paintings by Max Pechstein, Ernst Ludwig Kirchner, Karl Schmidt-Rottluff, and Otto Mueller in exchange for two tires. The deal was struck. Provenance research was not a regular practice at the time, and, truthfully, no one was interested in the obscure sources or whether the works had originally belonged to Jewish collectors. The modernist market flourished, with dealers, collectors, and museum professionals once again buying art—and at very low prices. This was the opportunity to fill the gaps left by the National Socialists.

This atmosphere enticed me to put Rosen to the test toward the end of my time at the gallery, and so I offered him a watercolor by Emil Nolde. In reality, however, it had been painted by my girlfriend, and later wife, Ursula Reppin, who had been studying at the art academy since 1955. She used a reproduction from a booklet published by Piper as a model. I then forged Nolde's signature. I told Rosen that my landlady had entrusted me with the painting to sell for 1,000 marks. He was delighted ("Wonderful, wonderful!") and offered 300 marks, although he knew full well that he could easily resell a Nolde watercolor for 2,000 marks. His colleague Gerda Bassenge, who was responsible for the department of contemporary art and twentieth-century auctions, was also enthusiastic about the work. Only the auction house's autograph expert, Mrs. Preuss, was surprised that the typical dot after the artist's signature was missing, but she didn't seem to suspect anything. At that time, there were practically no Nolde forgeries in circulation; his works weren't that valuable yet. When the work was handed back to me, I tore it up right in front of Rosen's eyes. Being convicted for forgery would have been the premature end of my career as an art dealer.

When, the following day, I was asked to report to Rosen, I expected to be fired over my provocation. Instead, he offered me the position of manager at a new branch in Düsseldorf, which he wanted to open in the near future. I graciously declined and soon left the gallery. I had other plans.

During my time with Rosen in Berlin, I became widely acquainted with the local art scene. Besides Rosen, there was Galerie Schüler in Charlottenburg, which dealt in gestural painting, and Galerie Bremer on Fasanenstrasse, with a bar in the back room, designed by Hans Scharoun, the architect of the Berlin Philharmonic. This is where one met after the openings. Anja Bremer's bar, which was run by her Surinamese partner Rudolf van der Lak, was also frequented by Scharoun's colleague Werner Düttmann, who began building the Academy of Arts in 1958.

Another early Berlin gallerist I got to know was Rudolf Springer, who had also initially worked for Rosen. We soon became friends and would remain close until his death in 2009. After the war, he did not want to join his family's large scientific publishing house; he was devoted to other muses. Through his contacts in Paris, where he had secretly served as a soldier for the Resistance during the occupation, he had French avant-garde works transferred to him by a French military train. Among the artists I met during my time in Berlin were Alexander Camaro, Hans Uhlmann, and Mac Zimmermann. Essentially, the scene was quite small, even provincial.

The photographer Herbert Tobias, whom I had met as a high school student on the North Sea island of Sylt, brought a bit of extravagance to the scene. My artist friend Heiner Kiesling from Braunschweig had taken me to the island, where he had rented a small vacation apartment in a house with a thatched roof. He let me sleep on the sofa, and so I spent my vacation on the North Sea coast. One evening, we were sitting outside by the campfire in front of a meadow with a view of the tideland. We were singing along to the guitar when an old VW Beetle came toward us. Tobias was at the wheel, honking loudly. He was a well-known photographer by that time:

Vogue had been publishing his pictures since 1953, and in 1954, he had his first, highly acclaimed exhibition in Berlin.

Tobias was on his way to Valeska Gert's legendary bar, the Ziegenstall, which was close by. The two knew each other from Berlin, where Gert had performed as a dancer and actress during the Weimar Republic and later founded her own cabaret. Tobias stayed with us for a while, hoping to hook up with Kiesling or me, because he thought we were gay. Nothing came of it, but we still went out with him at midnight to the Ziegenstall to see Gert, who at some point urged him, "Tobias, do Marlene Dietrich for us!" He fixed himself up accordingly and, to the enthusiastic applause of the audience, sang several songs by Dietrich. On the island of Sylt,

A portrait by Herbert Tobias of Rudolf Zwirner in Kampen, on the North Frisian island of Sylt, mid-1950s

he shot photographs of me with a dramatic gaze and trench coat (opposite). Later in Berlin, he positioned me under a sink and slapped me in the face a few times before he pressed the shutter release button so that I looked as though I were suffering. Another time he sprinkled some water on my face to make it look as if I were crying. It was then that I realized how subjective photography actually is.

Back in Berlin, I often visited Tobias in his basement apartment on Königsallee on Sunday afternoons. He would open the door just a crack and exclaim, aghast, "For God's sake, don't let the bourgeois sunshine in!" And he was just as quickly surrounded by darkness again—a young man often in his bed. He would play music by Marlene Dietrich or Juliette Gréco on his portable record player, transporting us into another world. Or he got dressed to get fresh rolls, instructing me on his way out that I should make coffee in the meantime. Many times, he wouldn't come back for hours; I kept myself busy by reading a book. When he finally returned, he would apologize, saying that he had met this or that acquaintance in the public bathroom opposite the bakery on Hagenplatz and had gone with him to the Grunewald forest. It was always the same, always a bit of drama. I was fascinated by Tobias's extreme personality. Decades later, I invited him to our house on Cape Cod. But he got stuck with the boys at the piers in New York, where he might have been infected with HIV. He himself believed until the very end that he had syphilis. When he died, in 1982, AIDS was hardly known in Germany.

Through Tobias I got to know the Berlin nightlife; it was still much like it had been described in literature in the 1920s. I went out with him in the evenings and went to work at the gallery during the day. I was assigned to work with Wilhelm Soldan, the head of the auction department, a connoisseur of drawings and prints. Soldan taught me the connoisseurship of old master prints and how to distinguish between the different printing states, using Rembrandt, Dürer, and Adriaen van Ostade as examples. We would sit at a large

table, where he showed me how to differentiate the states by the scratches and minimal traces. I wrote articles on Emil Nolde, Lovis Corinth, the German expressionists, and others for the auction catalogues for the twentieth-century art sales. In those days, there was nothing genuinely contemporary at auctions.

Among the dealers who regularly came to the gallery to either purchase works of art for resale or to offer their own prints was Heinz Berggruen, who was born in Berlin, immigrated to the United States at the end of 1936, and opened a gallery in Paris in 1947. His private collection of works by Picasso, Matisse, and Klee was first loaned to Berlin in the mid-1990s and was acquired by the Prussian Cultural Heritage Foundation for a symbolic sum in 2000. From the 1950s through the 1970s, Berggruen was the largest print dealer in Europe. He stopped by Galerie Rosen once a month, always with his case of works on paper and the editions he had published himself. He also carried with him his American military uniform, from his time as a sergeant in the US Army. He wore it in the evenings when he went out, because that was what the girls in Berlin liked. I acquired my first print from Berggruen, a small black-and-white etching by Pierre Soulages, for fifty marks.

During these years, Berlin was a hub for the art trade. Much of what came pouring in from Eastern Europe also went through the doors of Galerie Rosen. I even saw a Raphael and a Tintoretto. Particularly in the early postwar years, when people desperately needed money and Die Brücke artists were once again gaining recognition, many works by Kirchner, Schmidt-Rottluff, and Mueller were consigned for auction or immediately resold in the gallery.

Berggruen also profited from this. One day, he said to me, "What are you doing here? You have to come to Paris and then start your own business." When I explained that I didn't have money and first needed to learn more, he brushed my arguments aside and offered me an internship in his gallery. Berggruen thus gave me the incentive to leave Berlin.

Paris was a good decision that would later also benefit him, because when I opened my own gallery, I financed it almost exclusively through prints I obtained through him. Berggruen called me one of the fastest and most knowledgeable print buyers; only Eberhard Kornfeld from Bern was faster. He continued to support me as a young colleague. When I wanted to have an exhibition with Antoni Tàpies, he sent the Spanish artist a letter, noting that he would be in good hands with me.

Paris was a center for international contemporary art, and I knew I would need to be fluent in English and French to become an art dealer. Only later did I realize that I should have learned Italian as well, since after the war, the market was strongest in Italy; Paris was primarily a place for exhibitions. The Italian art trade was particularly strong because of the numerous collectors in Turin, Milan, and Bologna who were open to new trends—not only to Italian art, with Lucio Fontana, Piero Manzoni, and Alberto Burri, but also to German painters such as Gerhard Hoehme and Karl Otto Götz. Unlike Germany, Italy had kept its currency, and the country had suffered far less destruction during the war. In northern Italy, industry quickly began to flourish again, so that numerous galleries soon settled in Milan, which became a prominent center for the art trade. The first major survey exhibitions of contemporary art were held at the Venice Biennale from 1948 onward. In 1949, Peggy Guggenheim acquired the Palazzo Venier dei Leoni, which she moved into with her collection. It was there that many Europeans first encountered contemporary American art, for instance, works by Jackson Pollock and Franz Kline, artists who were completely unknown in Germany at the time.

In Paris, I found a place to sleep for free, in a dusty room without any windows behind the office of a friend's father. My own father continued to send me 150 marks a month, to which my grandmother added another thirty marks. Since I did not earn a salary as an intern at Berggruen's gallery, and the money from my family was not enough to

cover my expenses, I donated blood every three months to supplement my income. During my year in Paris, I lived very modestly—but it felt okay, because I had a vision for my own gallery, even if it seemed a bit illusory without any seed capital. In the mornings, I went to French classes at the Institut français, in the afternoons to galleries, and at least once a week I went to Berggruen's gallery in the rue de l'Université, where his loyal assistant, monsieur André, showed me various print portfolios. In the gallery, where hundreds of prints were stored, works by Picasso, Miró, Léger, and Marc Chagall hung on the walls.

Another important German gallerist in Paris whom I visited that year was Daniel-Henry Kahnweiler. I knew him from my time as a trainee with Eva and Hein Stünke, as they had business connections. Apart from him, though, I hardly made any other contacts in the city; because of my poor language skills, I lacked the courage to converse in French. I was intimidated by the intellectual conversations at gallery openings and felt provincial without international connections. I didn't even go to cafés, but mostly because I could hardly afford them. My main activity then was wandering through galleries and exhibitions. While 1956 marked my transition from a law student to a prospective art dealer, and in 1957 my knowledge of the trade was crystallized, in 1958 I became a connoisseur of contemporary art.

I got to know Paris at a decisive, even historic moment, when French abstraction, mainly art informel, was in decline and a new form of realism was emerging: the nouveau réalisme movement, around the theorist Pierre Restany. In 1960, Arman, Yves Klein, Daniel Spoerri, Jacques Villeglé, Raymond Hains, François Dufrêne, Martial Raysse, and Jean Tinguely officially founded the artist group Nouveaux Réalistes. I was lucky enough to experience the beginning of this shift. Abstraction still dominated. There was a lot of action in the galleries, an incredible atmosphere. One opening followed the next, and they were always well attended. There was a gallery on every second or third street. Paris was a big

city with an electrifying contemporary art scene, which I would experience only two other times: in New York and later in Cologne.

Initially, there were at least thirty so-called vanity galleries, where artists from outside Europe paid good money to show their art in the sterile spaces. Whoever wanted to make a career in the United States had to have had an exhibition in Paris first. It wasn't until much later that I realized these galleries didn't have an actual program and that you could, in fact, rent them on a monthly basis. Most of the other galleries represented art informel and tachism. But I began to recognize how vacuous, how impersonal, the École de Paris had become. You would go from one exhibition to the next, and one hour later you no longer remembered what you'd seen besides a lot of dabs, splotches, and strokes.

One exception was Iris Clert's tiny gallery in the Saint-Germain-des-Prés, which became the epicenter of the Nouveaux Réalistes. I went to every one of her openings. The year I was there, in 1958, Yves Klein presented the exhibition *Le Vide* (The Void), for which he completely cleared out the gallery and painted the walls white. It was a sensation. In 1960, in response to Klein's exhibition, Arman presented *Le Plein* (Full), for which he completely filled Clert's gallery with rubbish, which caused a scandal. For his *Poubelle* sculptures, which preceded the exhibition, Arman emptied the contents of garbage cans and wastebaskets into transparent Plexiglas containers. Now he used an entire gallery for this. At that time, César created his first compressions using scrap metal. Jasper Johns exhibited his bronze beer cans and light bulbs at Galerie Rive Droite. Daniel Spoerri moved to Paris and developed his *Snare Pictures*, with which he captured reality in a frozen moment. The object suddenly played a role in art again—even when it was destroyed, as with Arman, who smashed violins. I was not shocked or dismayed by this injection of reality into art; on the contrary, I was attracted by the nouveau réalisme. Through my love of art, I had never lost sight of the object. Now it had finally returned.

I was immediately drawn to the Nouveaux Réalistes likely because the protagonists were from my own generation. I became friends with Spoerri, who was only three years older than me. I visited him in his studio on rue Mouffetard. Hans Bellmer lived on the same street, not far away—a shabby area at the time. Bellmer's address had been given to me by Berggruen, and I tried my luck by simply ringing his doorbell. A grim-looking older man opened the door for me, but only a crack. Somehow, I was able to convince him to invite me in—perhaps because of my youth and my interest in his work. His partner, the artist Unica Zürn, was in Berlin, so he was alone at home, which made it easier for me to gain access. I entered his combined living room, bedroom, and studio, where one of his dolls was leaning on the sofa—it was certainly an eerie impression. I was surprised to see how cramped the space was in which he lived and worked.

As with Bellmer, I was able to speak with Spoerri in German, because he had grown up in Switzerland. Later, I exhibited his works in my gallery in Cologne. The Düsseldorf-based gallerist Alfred Schmela always said, "Zwirner has no taste—he exhibits Spoerri. What nonsense. I much prefer to show Arman." But I was utterly convinced by Spoerri, and especially by his tabletop works. Unlike Arman, who after the *Poubelles* continued to accumulate objects in Plexiglas containers, including enamel pots, shoes, dolls, and cutlery, Spoerri brought objects from the horizontal to the vertical. By fixing the detritus of a shared meal—plates, glasses, cutlery, leftovers, and overflowing ashtrays—to a tabletop and hanging it on the wall, he created a completely new geometric figuration.

This transformation of matter into something spiritual has fascinated me throughout my life. It is what I was always looking for. It was evident in Spoerri's early works from the 1960s, but as soon as his gluing objects onto a table became a kind of routine, a gimmick, it was no longer interesting to me. The spiritual moment is that in which the artist searches for a personal form but is not yet completely sure of it. Only

a few artists remain seekers through their old age, skeptics such as the Italian painter Giorgio Morandi and the American sculptor Joseph Cornell, with his boxes. This was another reason why I was resolute in not representing the complete works of a particular artist. Sooner or later, most artists enter into a phase of mass production with their work. Then it's no longer special, no longer unique.

At the end of my time in Paris, I received a telegram from Hein Stünke asking me to come to Cologne. Arnold Bode wanted to meet me in Stünke's gallery for an interview as soon as the next day or the day after next. Bode and Stünke had been friends since the first Documenta exhibition. For the second Documenta, Stünke had been appointed to the advisory board and had recommended me as secretary general.

5

Secretary General of the Second Documenta

Before I met Arnold Bode for the job interview, I consulted with Hein Stünke about my salary, because I had no idea what I could or should ask for. Stünke proposed 1,000 marks per month. That was quite a lot, especially in comparison to the small amount of money I had at my disposal. When I conveyed my salary expectations to Bode, he immediately agreed, so I knew that I had been too low in my proposal. From that moment on, however, I was taken seriously, even though I had no experience in organizing a major exhibition and the only knowledge I had of such an endeavor was of the first Documenta.

Before I was officially hired, Bode requested that I introduce myself to my predecessor, Baron Herbert von Buttlar, in order to get his approval. Buttlar was now the secretary general of the Academy of Arts, so I hitchhiked to Berlin to

meet up with him. We had a lively exchange about, among other things, kinetic art, which was very popular at the time, although I didn't like it at all. I explained that I didn't see any progress in simply introducing movement into art. Buttlar liked that. While I was there, he called Bode and said, "We just had an interesting conversation here. I can only recommend Zwirner to you. He's the right man for the job." My mother was so overjoyed that she bought me a suit to make sure I'd be dressed appropriately.

Although I wouldn't officially start until January 1, 1959, I decided to take a look around my new workplace in December, because the timing until the opening on July 11 was tight. When I arrived in Kassel, I found that all the files had been packed up when the exhibition closed in 1955 and that the office as such no longer existed. Bode, who worked as a professor at the art academy in Kassel, told me to find an office for myself. After all, I had been hired for the organizational side of things, so I should set up my own workplace. I was sent to the town hall in Palais Bellevue, where a free room was available for me. There was, in fact, a room for me, but there was no table, no chair, and no telephone. In an attempt to acquire such necessary items, I knocked on another office door in the same corridor, where the Brothers Grimm Society maintained its archives and office. An elderly gentleman was somewhat taken aback when I introduced myself. He asked if I was related to Eberhard Zwirner, and it turned out that Karl Kaltwasser, the managing director of the society and my future office neighbor, had been my father's former commander in the First World War. He was pleased to meet the son of his lance corporal. Kaltwasser called the town hall for me. When I introduced myself there as the new secretary general of Documenta, I was immediately cut down and classified as the "office manager," in keeping with the hierarchy of the city's administration. I raised no objections, because Documenta was largely financed by the municipality, from which I got everything I would need, right down to my typewriter.

The only thing missing was a secretary, who I would meet by chance at an evening dance. While dancing with a woman named Gisela Zimmerle, I learned that she was from Kassel, had worked for the past two years as an executive secretary for a German chemical company in Argentina, spoke English, French, and Spanish, and was now looking for a new job. She was immediately enthusiastic about my offer to work on Documenta. The salary she asked for, however, was the same as mine. Bode agreed with her on 800 marks. She was phenomenal: she could speak on the phone in one language, write on a typewriter in another, and talk to someone standing in front of her desk in a third. The one drawback was that she seemed to expect that we would continue to go out together; in the evenings, she would swish her petticoat invitingly. I asked Bode to hire a young man who would not only run errands and lend a hand here and there, but who would also be available as an escort, especially after hours. Bode understood me immediately and hired one of his students, the painter Peter Mook, who drove an Opel Kapitän.

What would require a huge staff today we accomplished back then with a small, manageable team. As secretary general, I was responsible for collecting the loans from museums, galleries, and collectors, organizing the opening reception at city hall, sending invitations, hiring and supervising guards for the exhibitions, and the accounting. The daily telephone calls with the forwarding agency in Munich took up to an hour. Procuring the illustrations for the catalogue also proved to be a laborious task. Bernhard Heiliger, for example, submitted a portrait photograph of himself with Henry Moore in an attempt to enhance his reputation by being close to the most important sculptor of the time, who was also represented at Documenta. Heiliger allegedly had only this one photograph of himself, but when I warned him over several phone calls that he would be the only artist without a portrait in the catalogue, he found another photograph of himself, alone.

I was also responsible for public relations. I found this out only when, after a meeting at the town hall in early

January 1959, I was sent to quickly draw up a press release. I sat at my desk, bewildered, with absolutely no understanding of what this really meant. My cluelessness was clearly written all over my face, as Lauritz Lauritzen, the mayor of Kassel, followed me back to the office and helped me write the press release. He basically dictated it to me. It announced the opening date and that, this time, Documenta would take place in the Fridericianum as before, but also in the Orangerie, where sculptures would be on display, and in Palais Bellevue, where prints would be exhibited. It also introduced the members of the selection committee: Arnold Bode, as chairman; Werner Haftmann, for painting; Eduard Trier, for sculpture; and Hein Stünke, for prints. The committee also included Herbert von Buttlar, Ernest Goldschmidt, Will Grohmann,

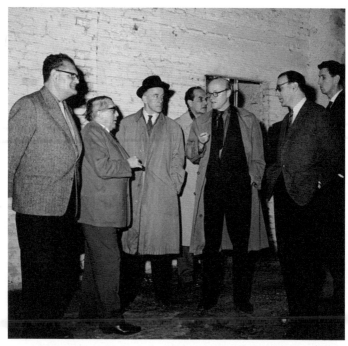

Members of the painting and sculpture committee of the second Documenta, 1959. *From left to right:* Kurt Martin, Arnold Bode, Ernst Holzinger, Eduard Trier, Werner Schmalenbach, Ernest Goldschmidt, and Rudolf Zwirner

Ernst Holzinger, Kurt Martin, and Werner Schmalenbach. In addition, Porter McCray from The Museum of Modern Art in New York was responsible for the American artists.

The advisory board meetings were always a struggle. Everyone tried to push their own candidates through for selection, and Haftmann, in particular, threw himself vehemently into the discussion. He argued until the very end, for example, that it was imperative to show twelve instead of six works by Alberto Magnelli, even though all the other members of the board found Magnelli boring. When he didn't get his vote through, he began the session the next morning by saying that he had slept badly all night because of the previous day's decision, which he insisted on discussing again. After all, he argued, Magnelli is of eminent importance for abstraction in Italy. When he failed a second time, he dramatically declared that he could no longer be a member of the jury if he stood in such isolation, ultimately persuading the others to agree to his nomination.

Haftmann, unsurprisingly, was the driving force behind the second iteration of Documenta. With this exhibition, he aimed to assert his vision of abstraction as a universal language. For him, figuration had been discredited through its use in propaganda during the National Socialist regime. As a result, figurative art was completely underrepresented in the exhibition; hardly any surrealist works were shown, either— just a few from Max Ernst, René Magritte, and Paul Delvaux. Bode was officially the head of the board, and he was primarily interested in his artist friends Fritz Winter, Ernst Wilhelm Nay, and Hans Mettel, as well as in a few artists from Paris, such as Wols, Pierre Soulages, and Hans Hartung. Yet he was far from being able to assert himself as strongly as Haftmann. I grew tired of these discussions about the candidates and the number of works they would be able to show. Bode would calm me down, whispering, "In the end, we'll hang the paintings, that's where the final decision will be made." And that's exactly how it was. The other committee members did not live in Kassel and were presented with a fait accompli.

Gallerists also interfered in the decision-making process. They pursued their own interests: in return for securing loans from our preferred candidates, they pushed us to include artists from their respective galleries. Daniel-Henry Kahnweiler, for example, made sure that we got Picasso from him, but that we also had to take works by André Masson and Eugène-Nestor de Kermadec. Of the 338 artists participating in the second Documenta, at least twenty are likely to have made it onto the list of participants in this way. Another issue was, while the committee named the participants, the gallery owners determined which works they sent. One loan could result in our accepting two or three unwanted works. Art informel, gestural painting from Europe, thus dominated this edition of Documenta, which corresponded perfectly to Haftmann's conception of the exhibition.

It did not, however, come across as powerfully as he had expected. It was clear from the outset that, unlike the first edition, this Documenta also had to take into account artistic creation in the United States. Four years earlier, the exhibition celebrated the return of the avant-garde, which had previously been shunned; now the Documenta organizers were seeking to catch up with the present. Through the inclusion of American art at the Expo in Brussels in 1958 and the exhibition *The New American Painting*, which was touring Europe at the time, and which, at its Berlin venue, had a major influence on painters such as Georg Baselitz, one was well aware of the growing importance of painting from America. Haftmann and the other members of the advisory board were, however, not sufficiently familiar with this field. As a result, the board sought help from Porter McCray, the director of the international program at The Museum of Modern Art, who was responsible for the museum's traveling exhibitions and who worked closely with its International Council. Financed by the Rockefeller Brothers Fund, which in turn supported the US government, the museum's International Council served as a cultural re-education program in Europe.

During the Cold War, art was an important arena for ideologists in both the East and the West in the struggle for intellectual supremacy. Abstraction and socialist realism were diametrically opposed. The small but effective performance put on by the Russian ambassador Andrey Andreyevich Smirnov during his visit to Documenta had to be understood in this context: when he passed by Picasso's sculpture group *The Bathers* (1956) during an official tour of the exhibition, he took a small child, who was visiting the exhibition with his mother, in his arms and explained to the accompanying journalists that, in contrast to the Picasso, this child was a "beautiful" person, a "beautiful" sculpture. With this simple gesture, he promptly made it into the international press. I was amused by the simple comparison.

The Museum of Modern Art's support of Documenta was contingent on one condition: the advisory board could not object to the selection made in New York and was obliged to exhibit each work sent. Documenta covered most of the transport costs and insurance, and Porter McCray, Frank O'Hara, and William S. Lieberman from the museum took care of everything else. I received the registration forms for the paintings from New York and passed them directly to the DuMont publishing house in Cologne, without taking a close look at the size specifications of, for example, works by Jackson Pollock, Mark Rothko, Barnett Newman, and Franz Kline. Normally, a painting measured roughly thirty-one by forty-seven inches—almost every work by Picasso or Wols was this size. So I assumed that this was also the case with American art, but I should have noticed the deviation and sounded the alarm. This mistake had art-historical consequences, as the Americans received a truly spectacular presence at the Fridericianum. With the second Documenta, the supremacy of the École de Paris, the European abstract artists, began to crumble, and American painting came into favor. When the shipping crates from the United States arrived in Kassel shortly before the opening, we were shocked by the enormous formats. Jackson Pollock's *Number 32* (1950), which

Werner Schmalenbach later acquired for the Kunstsammlung Nordrhein-Westfalen in Düsseldorf, measured 106 by 180 inches and took up an entire wall of the Fridericianum. We had not expected this—even the works on view at the Expo in Brussels were much smaller. But with these works, the size was suddenly part of the content: it became part of the work's statement. In order to show these works, we had to throw the concept we established for hanging the show out the window.

Originally, we planned to present the European avant-garde on the first floor of the Fridericianum, integrating the American contributions into the layout. Now the first floor had to be cleared for American painting. Pollock was given a separate room for his twelve paintings, with *Number 32* on the main wall—almost a solo exhibition, a tremendous demonstration of power (below). Theodor Adorno, whom I took on a walkthrough of Documenta, was so impressed by the staging that he spontaneously decided to move his lecture, which had been scheduled to take place that evening at the Kunstverein, to the "Pollock Hall." The expansive formats of the works by Franz Kline, Mark Rothko, Philip Guston,

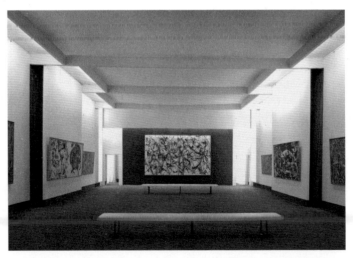

Installation view of works by Jackson Pollock, featuring *Number 32* (1950) at center, in the Museum Fridericianum at the second Documenta, Kassel, 1959

Barnett Newman, and Robert Motherwell took up so much space that the smaller paintings of the École de Paris could no longer be accommodated, with the exception of pieces by two Europeans artists, Hans Hartung and Pierre Soulages. Works by the "second-tier" artists were moved to the attic, which was not actually intended as an exhibition space, and at the last minute, partition walls were installed to hang the paintings for viewing.

With the canvases crowded together in the attic, I felt the impression I had had in Paris was confirmed: the art informel works seemed interchangeable—a unique artistic concern was no longer recognizable in each piece. But what was worse: the attic had no insulation, and it was a hot summer. Anyone who entered the attic left just as quickly—that's how stuffy the air was. While the accommodation upstairs was devastating for the École de Paris, the rooms on the first floor were really no better for Hartung and Soulages. Due to their immediate proximity to the Americans, they did not fare well in direct comparison. These paintings suddenly seemed traditional, even academic, while the works from America radiated an enormous liveliness, an alloverness that was not only seen on the canvas but felt in the room. It was overwhelming.

Harry Fischer and Frank Lloyd, from the London gallery Marlborough Fine Art, came to visit following the first month of the exhibition. They represented Rothko and looked after the estate of Pollock, whose work they had contributed to the exhibition. After they had a look around, they wanted to know, briefly and concisely: "What remains stable? What is on the decline?" I replied, "The École de Paris is on the decline, and the Americans remain stable." I then added, "With one exception: Giorgio Morandi also remains stable." Later, as an art dealer, I often wondered why I didn't act based on my own judgments. I could have visited Morandi in his studio in Bologna and proposed a solo exhibition to him. In the end, though, his art seemed too traditional to me. I was fascinated by the way Fischer and Lloyd viewed the exhibition in a completely sober, purely commercial way, and I began

to see the show from this perspective myself. While a large painting by Soulages could cost up to 100,000 marks, a work by Kline, who would prove much more vital, cost just 40,000 marks. The other dealers and collectors also noticed that something wasn't right.

The assessment I shared with Fischer and Lloyd was further confirmed a few years later. Siegfried Adler, the managing director of Galerie Aenne Abels in Cologne, which had previously specialized in German expressionism, announced that Pollock and Kline would also be added to its program. The consequences of this paradigm shift were enormous. Up to now, museum directors had traditionally shopped in Paris, but now they were orienting themselves farther west. Collectors then began to part with their French art and wanted to acquire American art instead. This trend became fatal for the art trade in Paris, because the most important customers for European art came from America. Berggruen, who dealt in classical art, continued to do well, but business collapsed for Galerie de France. This reappraisal all began with the second edition of Documenta.

Commercial considerations did play a role at Documenta, but not blatantly. Those who were interested in prices were directed to me, as the secretary general. The collector Bernhard Sprengel, for example, inquired about the prices of sculptures by Henri Laurens. To even my surprise, Laurens's sculptures were listed for only 20,000 or 30,000 marks. I thought this could only be the insurance value, since the cost of the casting itself was similar. To be safe, I called Kahnweiler in Paris, who confirmed that these were indeed the prices. The collector was so pleased with this information that he purchased three works from the exhibition, of which *La femme à la grappe* (1952) and *Le matin* (1944) are still in the Sprengel Museum in Hannover. Kahnweiler was equally pleased that Laurens's work had finally been sold.

Hein and Eva Stünke, however, made perhaps the best deal at Documenta. In return for Hein's consulting on the exhibition, their gallery was given a sales stand for prints

adjacent to the exhibition rooms in Palais Bellevue. This later sparked criticism. Hein was highly successful in offering his duplicates of the exhibited prints in large editions. The influx of customers was unlike anything he had experienced at his gallery back in Cologne. Bode suggested that the gallery offer editions at the next Documenta in dedicated rooms with additional galleries. But Hein refused the proposal, as he did not want to have to stay in Kassel for three months; in fact, he was already in the process of developing the initial concept for the Cologne fair, which later led to the founding of the Kunstmarkt Köln, now known as Art Cologne. I learned about the popularity of his prints from my partner, Ursula Reppin, who was continuing her art studies in Kassel and worked for Hein and Eva as a saleswoman during Documenta. Hein sold twenty to thirty prints every day, so that Eva had to travel to Paris time and again to get more. Ursula wrote the invoices and noted the addresses of the various customers. When we opened my gallery in Essen the following year, we certainly utilized this considerable database of addresses.

In addition to the Fridericianum, the Orangerie, and Palais Bellevue, there was another, albeit unofficial, exhibition location: my office. There, Robert Rauschenberg's *Bed* from 1955 hung on the wall behind my desk. On loan from the New York–based gallerist Leo Castelli, the work was one of the artist's first "Combines," in which everyday objects were integrated. Of course, the work should have been exhibited together with the other American paintings, but to Bode, the quilt mounted on canvas with a pillow and paint squeezed straight out of the tube was simply unacceptable. He refused to present a painting with the exact dimensions of a bed in the main exhibition. But since it had to be shown, following the conditions laid out by The Museum of Modern Art, he hung it in my office. When they visited Kassel, Porter McCray and William S. Lieberman, of The Museum of Modern Art, were furious about this banishment from the public spaces. I was able to reassure them that this measure was actually

intended to protect the work. Rauschenberg's other contribution to the Fridericianum, a picture with jeans nailed onto it, repeatedly provoked visitors to put objects such as money or handkerchiefs into its pockets, which I regularly fished out during my morning rounds. His *Bed* would certainly trigger more extreme reactions, so that a guard would have had to be placed in front of it. McCray and Lieberman didn't want that either, and I promised to let interested visitors view the picture behind my desk at any time and give them an introduction. Incidentally, Castelli later donated Rauschenberg's *Bed* to The Museum of Modern Art, where it is still held in high esteem as an icon of contemporary art.

One day, a visitor who could not find certain pictures in the exhibition came by my office: it was the painter Konrad Klapheck. He was holding the catalogue in his hand and wanted to know why not all the illustrated surrealist works were on display. He also complained about the miserable placement of Magritte, whose works were hung close to the toilets. I shared his opinion, and so began our acquaintance. He later visited my gallery in Essen and gave me the decisive hint to take a closer look at pop art, which he had discovered at the gallery of Ileana Sonnabend, the ex-wife of Leo Castelli, in Paris. During this time, I met another artist who, like Klapheck, would later be represented at Documenta: Hans Haacke. The conceptual artist was studying at the academy in Kassel and worked as a guard at Documenta. He spoke fluent English and French, so we had him lead guided tours for groups of foreign visitors—he was absolutely reliable. This made him an exception among the student guards, who usually didn't take their job very seriously. But Bode insisted on hiring these young people as a sign of a new beginning. I remained skeptical and would have preferred professional guards.

A proper security company might have prevented the assassination attempt on a work by Picasso, which I discovered the day after the attack. On my morning round through the exhibition spaces, I saw a knife stuck in a cubist painting.

I carefully pulled it out, took the painting down, affixed a note to the wall that read "Temporarily Removed"—including an official Documenta stamp—and took the Picasso to the restoration workshop of the Old Masters Picture Gallery. In response to my request to take care of the damage as quickly as possible, the restorer immediately began to pull the canvas together, thread by thread, from the reverse side. The front side was then retouched, and two or three days later the painting was hanging in its place again without anyone—neither the owners nor Bode—having learned of the incident through me. I was able to prevent a scandal by ensuring the damage was repaired.

Another incident, however, did not go unnoticed: during the installation of Barnett Newman's large-scale painting *Cathedra* (1951), which measured roughly eight by seventeen feet, it slipped out of the art handlers' hands and suffered a tear. Months of arguments ensued with the artist, who estimated the value of the work as much higher than we thought appropriate. History would, however, prove him right. At that time, I called the painting, a bit disparagingly, "the Ping-Pong table" because of the white line in the middle of the large blue field. Today, it is in the Stedelijk Museum in Amsterdam, where it is one of the most important pieces of the collection. Continuing the picture's dramatic history, in November 1997, while hanging at the Stedelijk Museum, it was once again damaged, this time more severely, by five long incisions—incidentally cut through with a knife by the same assassin who had attacked Newman's work *Who's Afraid of Red, Yellow and Blue III* (1967–1968) in the Stedelijk eleven years earlier. Luckily, it was restored and returned to view.

While the second Documenta was more controversial than the first, due to the dominance of abstract painting and the "invasion" of the Americans, it was again considered a success, welcoming 134,000 visitors. My contract expired in November, and the supervision of the dismantling also fell within my remit. Bode would have liked to extend my contract for the next Documenta, but I knew that, given our

different temperaments, we would not have been able to get along with each other through another exhibition. He was the emotional artist, I the controlled organizer. Every day, Bode came up with a new idea. He regularly deposited slips of paper with instructions noted underneath a big Z on my desk but was otherwise not available. I kept one of these slips of paper, which reads, "Please report where we stand." And below: "Carry on!" That made me laugh. The Z was to become the signet of my gallery catalogues.

I was also not inclined to work on the next edition of Documenta as I received an enticing offer from the Hannover-based collector and industrialist Bernhard Sprengel. He was chairman of the Kestnergesellschaft and knew that it needed a new head to replace Werner Schmalenbach, who intended to move on to the future Kunstsammlung Nordrhein-Westfalen as founding director. Sprengel indicated only one condition to my appointment: they were looking for an art historian with a PhD, so I would have to complete my studies. After briefly thinking it over, however, I knew that, as someone from Braunschweig, Hannover was not suitable for me. My hometown was smaller but was more important historically, with its famous cathedral, the grave of Henry the Lion, and the half-timbered houses. I declined the offer, but with the somewhat unconventional explanation that I would rather work in a city beyond the Limes, on Roman soil. At that time, I was thinking of Cologne, but I opened my first gallery in Essen.

6

A Rookie Gallerist in Essen

While the exhibition in Kassel was being dismantled, I began looking for a space in Essen to open Galerie Rudolf Zwirner. I found one on Kahrstrasse, not far from the Museum Folkwang, but the building was in Holsterhausen, a working-class district. The rooms were, in reality, unsuitable—the space was an ordinary storefront—but as a complete rookie, I didn't have an eye for such things yet. I knew the small but beautifully designed gallery Der Spiegel very well, but it hadn't prompted me to think about the nature of an exhibition space and the mediation of contemporary art.

First off, I had to clean the windows, which were filthy from the busy thoroughfare outside. The workers I had hired suddenly began to disappear, one after the other, and their bosses came instead to submit their invoices in advance. They were afraid that someone who cleaned the windows himself wouldn't have money. I was at least able to make down payments, but it was all I could afford with what I had saved from my Documenta salary. My brother Ruprecht advanced me the remainder of the funds I would need—he had just started a position as a scientific assistant at the Institute of Anatomy of the University of Freiburg after completing his doctorate

in medicine. Since the paint on the walls had still not dried by the opening date of my first exhibition, on December 9, 1959, I showed prints, which were less sensitive than paintings. Documenta artists who I had worked with trusted me and gave me prints on commission.

I set up shop in the Ruhr region because I believed there must be a need for contemporary art in its network of urban communities with twenty million people and numerous large and small museums, but no galleries. I knew Essen a little better than the other cities in the area because an uncle of mine lived there. Düsseldorf would also have been a good choice, because of its famous academy, but Alfred Schmela had already claimed his territory there. And in Cologne there was Aenne Abels and Werner Rusche—as well as, of course, the Stünkes, with whom I did not want to compete directly. Instead, I hoped to be able to work with their framing workshop and receive works on commission from them. Moreover, I was determined to make my gallery a cultural outpost, bringing contemporary art to the people of the Ruhr region. That's why I opened on Sundays, too, in the hope that someone would stop by the gallery instead of going to the local tavern. This quickly proved to be naive: with the exception of one railroad engineer, no one showed up. After that, I kept the gallery closed on Sundays like everyone else.

Even well-to-do visitors didn't really show up. Those in the Ruhr region who did buy art were not interested in contemporary art, but rather in German expressionism, which was on display in the Museum Folkwang. I had also underestimated and misjudged the social hierarchies of the Ruhr: people followed the artistic preferences of the directors of the Krupp company, and even more so those of the directors' wives. The von Bohlen und Halbach family, especially, determined the accepted tastes.

Essen lacked a bourgeois middle class with an affinity for culture, such as I had gotten to know in Cologne, but I nevertheless started out full of optimism. I organized exhibitions mainly of Hann Trier and Victor Vasarely, whose

works I obtained through Galerie Denise René, as well as Jesús Rafael Soto and Takis. My first major exhibition that was met with a true response took place in December 1960, with works by Karel Appel, including about ten large-format paintings. When I received the transport invoice of 8,000 marks, I was shocked—the sum covered only the shipping to Essen, and the works had to be returned afterward at the same cost as well. I knew that I had no chance whatsoever of selling a painting by Appel for 12,000 marks. When I spoke to Hein Stünke about my concerns, he said, "Young man, you can't expect to earn enough money with contemporary art. You also have to be active on the secondary market. Buy paintings that customers are looking for and then resell them at a profit." This was indeed good advice, but it worried me even more, because instead of acquiring capital for an initial purchase, I only accumulated more outstanding invoices, particularly from Michael Hertz, Daniel-Henry Kahnweiler's representative in Germany, from whom I had purchased Picasso prints at Documenta.

A fortunate coincidence helped me resolve my predicament. At a dance party in Düsseldorf during the carnival season, I met Edith Sommer, a daughter of the watch manufacturer Junghans, who was married to the Wuppertal-based entrepreneur and collector Dieter Rosenkranz. I asked her if she could look after my gallery on the weekend, because I wanted to visit my girlfriend and later wife, Ursula, in Kassel. Edith agreed, in the hope of being able to exhibit with me later. She used the time at the gallery to have a look at my print holdings, which she valued at 20,000 marks. When I returned, she proposed that she become a partner in the gallery by investing exactly this amount. As this was not a good deal for me, since it didn't properly value my expertise, I suggested that she instead purchase one or two paintings, which we would resell according to Hein's advice. We would then share the profit. Edith accepted the deal.

So, I traveled to Paris to acquire a painting by Max Ernst, whose work I had learned to appreciate during my time as

a trainee with the Stünkes. Compared to the other surrealists, his prices were lower, because, as a German, he was still not well liked in France and the United States at that time. I purchased one of his Colorado landscapes for 18,000 marks and immediately learned my next lesson as an art dealer. One year earlier, the painting had cost only 8,000 marks, and I suddenly understood that there are no fixed prices in the art trade—everything is in a state of flux. With the painting in hand, I quickly visited the collector Bernhard Sprengel, who purchased it for 24,000 marks. Edith then had not only half of the profit paid out but also her deposit. From what was left, I was barely able to pay the outstanding costs of the Appel exhibition, which had just come to a close.

My entry into the art trade as a dealer in the secondary market secured my survival as a gallerist. With the money Edith repeatedly advanced, I was able to purchase individual works by Picasso, Miró, and Léger and resell them to collectors. This went well until, one day, an overjoyed Edith came to the gallery to present her own first investment in art. For 20,000 marks, she had acquired the recently reissued Picasso book *A Los Toros* (1961) with aquatints depicting bullfights, which was in reality worth twice as much. I congratulated her, but then discovered that the signatures had been crossed out. Edith now possessed a worthless edition of "forbidden" prints; someone had used the invalidated printing plates without authorization. Angry about her blunder, and indirectly also angry with me, she left the gallery and never returned. That was the end of our business relationship.

But I got lucky a second time: at one point soon after Edith left, Caroline Reinhold-Merck, whose family owned a large pharmaceutical company in Darmstadt, called me because she wanted to sell a Tiepolo painting owned by the family. Her sister was a godmother of mine and had given her the idea to contact me. After examining the Venetian carnival scene at her home, I advised her to put the exceptional painting up for auction at Sotheby's, where it would fetch much more than on the open market. When I learned

of the provenance of the work, I knew that this painting would cause a sensation. The pharmacist, scientist, and author Johann Heinrich Merck, an ancestor of the company's founder, had acquired it on a joint trip with the poet Goethe, a close friend, in Venice. It had been hanging in the Merck mansion ever since.

Sotheby's in London responded enthusiastically to the consignment. I warned Caroline not to let anyone change her mind. And in fact, the first dealers soon contacted her in Darmstadt to purchase the painting before the auction for twice the alleged reserve. The atmosphere was so heated that Sotheby's, at its own risk, placed bidders in the salesroom to prevent a cap on bids by cartel agreement among dealers. The auction took place on July 3, 1963, with the Tiepolo fetching 72,000 pounds, or about 880,000 marks. The New York–based gallery Rosenberg & Stiebel acquired the work for the American collectors Jayne and Charles Wrightsman, who donated it to The Metropolitan Museum of Art in New York in 1980. Caroline was so pleased with the success that she gave me a generous fee. With the commission from Sotheby's, I had enough capital of my own to finally be able to operate independently as an art dealer.

Still, my gallery in Essen was not flourishing. I held some interesting exhibitions, including one with kinetic sculptures by Takis and Soto, which Iris Clert had given to me on commission. The Venezuelan Soto played guitar at the opening. It became suddenly clear to all those present that plucking the strings of his instrument had inspired him to create the vibrating lines of his wire sculptures and paintings.

My exhibition with Cy Twombly, his first solo show in Germany, in 1961, was particularly important to me. The art critic Albert Schulze-Vellinghausen, the *éminence grise* of the German newspaper *Frankfurter Allgemeine Zeitung*, had drawn my attention to Twombly. Schulze-Vellinghausen lived in the Ruhr region and often stopped by the gallery. During one visit, he showed me a drawing by the American painter, who was living in Italy at the time. The art critic had acquired

Rudolf Zwirner with Jesús Rafael Soto (left) and Takis (right) at the opening
of their exhibition at Galerie Rudolf Zwirner, Essen, on January 13, 1961

Invitation card to the opening of Cy Twombly's first solo exhibition in Germany,
at Galerie Rudolf Zwirner, Essen, on October 3, 1961

the drawing through the gallerist Jean-Pierre Wilhelm, who ran Galerie 22 in Düsseldorf together with Manfred de la Motte in the late 1950s. I was fascinated by the drawing: a large sheet of white paper with only dots on it, light tiny strokes, as if a fly had walked over it—a visual poem. I wrote to Plinio De Martiis in Rome, who represented Twombly at his gallery La Tartaruga. De Martiis agreed to collaborate on the show and sent me a package of roughly twenty-five drawings in various formats. The small works would cost 450 marks each, while the medium-size pieces would be priced at 600 marks, and the large works at 800 marks.

My first exhibition with Konrad Klapheck, whom I had met at the second Documenta, was similarly uncomplicated. He visited me in Essen and showed me black-and-white reproductions of his paintings, which immediately appealed to me because of their proximity to surrealism. I visited him in his studio in Düsseldorf, and we decided to do a show together in 1962. This was the only time I discovered an artist at the gallery, so to speak, where an artist came to me and presented his work. When Klapheck arrived to hang the exhibition, he had a small box with homemade sandwiches, each wrapped individually in paper labeled with "meat" or "cheese." At noon, he unwrapped his sandwiches, poured himself a cup of coffee from a thermos, and enjoyed his "petit bourgeois" lunch. Klapheck, who was meticulous in every respect, had previously exhibited with Schmela in Düsseldorf, but this did not prevent him from showing with me. In those years, the connections between gallerists and artists were not yet as binding as they are today; and Schmela had little use for Klapheck's paintings anyway. In any event, a friendly relationship continued to develop between Klapheck and me. We even gave our children, who were born in the mid-1960s, the same names: Esther and David.

Nevertheless, Klapheck's obsessiveness eventually led to a break in our relationship. I could only laugh when he sent me overdue notices because I didn't calculate and pay out his share from a sale down to the last penny. After the second

and third overdue notices, which I also didn't respond to, I finally explained to Klapheck that his absurd letters would have a much higher value if he published them. After that, he stopped sending overdue notices. In the end, Klapheck was more concerned about being right than about the money. For him, it was a matter of principle. And when he confided in me about how difficult it was to accurately paint the spokes of a wheel, I suggested he use a photograph as an aid, and he felt totally misunderstood. While I eventually grew tired of his nitpicking, I remained grateful to him—his suggestion that I look at the program of Ileana Sonnabend's gallery helped me make the connection between the surrealists and pop art.

There was one other gallery specializing in contemporary art in Essen, which opened the same year as mine: a branch of the Munich-based Galerie van de Loo, which showed Hans Platschek and Fred Thieler in its first year. I quickly became friends with its director, Carlheinz Caspari, who was an important conversation partner for me. He, too, did not stay in Essen for long: Caspari moved on to Cologne

Konrad Klapheck, *Die Ahnen*, 1960. Oil on canvas, 45¼ × 49¼ inches | 115 × 125 cm. Museum Ludwig, Cologne

in 1961, one year before I did, where he served as the direc-
tor at the Theater am Dom. There was no successor to his
post in Essen, so van de Loo's branch soon closed. As I, too,
had to admit, business there was actually not worthwhile.
During my four years in Essen, I sold works to only one col-
lector, the psychiatrist Dr. Steffen, who came to me regularly
to talk about art. When he would leave the gallery, he would
say that he had to go back to his rabbits. When I asked him
one day if he bred rabbits, he answered, laconically: "Oh, Mr.
Zwirner, they're my patients." I sold him my first Tàpies paint-
ings and Twombly drawings. Steffen remained loyal to me as
a customer even after I moved on to Cologne.

My encounters with other collectors in the Ruhr region
were less encouraging. Although Berthold von Bohlen und
Halbach did indeed invite me to his legendary teas, where he
served an excellent Darjeeling, nothing much developed from
it. And when the Wuppertal-based collector Fänn Schniewind,
one of Alfred Schmela's most important customers, came in
during my exhibition with works by Soto and Takis, my de-
light in seeing her was premature. To my euphoric greeting
of, "How nice of you to drop by, despite the fact that I'm a bit
off the beaten track," she replied that her dog's vet was just
around the corner. I got the point. She still purchased a sculp-
ture by Takis and wanted to take it with her. When I told her
that the exhibition had just opened and that the work would
be missed, she complained bitterly, "What a pity. I wanted to
have something amusing for my guests this afternoon." I was
so perplexed by this that I let her take it with her.

When I was showing watercolors by Wols, another vis-
itor made it even clearer to me how unfavorably situated my
gallery was. He held an important position at Krupp but was
only a minor collector. At the beginning of our conversation,
he told me in a snobbish tone that he would have come ear-
lier, but parking in the area with his chauffeur was impossible.
When the "gentleman" then complained about the condition
of the works on paper, some of which had creases in them, I
explained that the painter, who like many other exiled artists

classified as enemies during the war, had been imprisoned in the internment camp Les Milles in Aix-en-Provence. It was there, under the most difficult conditions, that he created his surrealist drawings. "Then I'm not interested," the collector responded harshly, and then walked out. I later learned that he held a high-ranking position during the Third Reich.

I became increasingly frustrated with Essen. When I took the night train home from Paris, I was always the only one left in my compartment after the stop in Cologne. This got me thinking, and I started to spend my evenings in Cologne. Artists met there; it was an inspiring city. I had to go to the city regularly anyway, to deliver prints to Hein Stünke for framing or to pick up framed pictures. Stünke used a very special method for framing—the works were laid out on a matte without an actual frame, covered only by a pane of glass, which was fastened on the sides with four to eight clamps. Nobody does this anymore, but at that time, Stünke's "Spiegel frame" was considered ultramodern. I convinced my customers that, should yellowing occur, the sheet would remain one uniform color. "We don't want a frame, we only want to see the art" was my sales pitch. In fact, in the end, the framing and prints business was the only thing that worked. Framing five or six works a month for clients paid for the rent, because Stünke gave me a thirty percent "dealer discount."

My biggest buyers of works on paper, however, weren't private customers but museums. On set days, with a portfolio of prints under my arm, I knocked on doors at various museums throughout the region, traveling, for example, to Hagen and Gelsenkirchen and paying my respects to the directors. This is exactly how I had imagined it would be, maneuvering like a spider in the web of the Ruhr region, scrabbling at times to Recklinghausen and other times to Duisburg, where I'd check in on my customers there. But I was only really effective when it came to the prints by the international artists such as Braque, Picasso, or Léger, which I was able to sell to museums toward the end of the year, when—luckily for me—the little bit that was left in their budgets had to be spent or forfeited.

The museum contacts and the Tàpies collector would turn out to be the only people from my time in Essen who would remain important to me in the future. Compared to Alfred Schmela, who was able to establish himself as an avant-garde gallerist two years earlier in Düsseldorf through his contacts in the academy and his connection to Yves Klein and the Zero group, these first years in the Ruhr region were artistic stagnation for me—with the exception of the exhibitions with Klapheck and Twombly. That it was time for me to leave became clear through an encounter with the head of the art department of a large bookstore in Essen that also sold prints. He proudly told me that he had succeeded in selling the 1961 edition of *Daphnis and Chloe* by Longus, with more than forty color lithographs by Chagall, five times for 20,000 marks each: He had sold the work to the wife of a Krupp director, who ranked just below the company's top management, knowing full well that this would trigger a chain reaction among the various collector wives among the local high society. And in fact, after one of the teas at the home of von Bohlen und Halbach, the wife of the general director called and demanded to know why she had not been offered the splendid work first. Satisfied with the information that a reserved copy had long been waiting for the madam in the bookshop, but he had not been able to reach her, the lady purchased the second book from the edition. The remaining three orders for *Daphnis and Chloe* soon followed.

I knew then that I simply could not win against the likes of Chagall—and I actually didn't want to. I would never include him in my program. I accepted the situation for what it was and offered the surprised department head of the bookstore my complete stock of prints for a flat rate. As a farewell gift to the Ruhr region, I later donated a roughly seventy-nine-by-seventy-nine-inch black cloth painting by Blinky Palermo to the Museum Folkwang. Not too long ago, I came across it by chance during a tour of the museum's new building and was amazed by this gift: today, it would be completely unaffordable for the museum.

7

Fresh Start
as an Art Dealer
in Cologne

While I tried in vain to gain a foothold as a gallerist in Essen, a new scene was establishing itself in Cologne. Düsseldorf had the State Academy of Art, but Cologne had the Studio for Electronic Music at WDR, the West German Broadcasting Corporation, which attracted an increasing number of the protagonists of New Music: Karlheinz Stockhausen, his student Nam June Paik, and John Cage, to name a few. They often met in the studio of Mary Bauermeister, Stockhausen's lover and later wife, who had rented a top-floor room at Lintgasse 28. Poets, artists, and composers would gather there. George Maciunas, Joseph Beuys, Wolf Vostell, Christo, and George Brecht, along with Paik and Cage and many others, stopped by her studio. It was here that the Fluxus movement in Germany took off, with exhibitions, readings, and concerts. In 1961, Christo wrapped huge rolls of industrial paper with tarpaulin and rope and stacked a large number of oil barrels in the Cologne harbor—his first project in a public space, before he blocked the narrow rue Visconti in

Paris in 1962 with stacked oil barrels, which had a far greater public appeal.

Interesting things were also happening within Cologne's lively theater scene. The epicenter was the Theater am Dom, where Carlheinz Caspari was the director. He staged a key work of the Fluxus and Happening movement, Stockhausen's *Originale* (1961), consisting of eighteen scenes with seven independent structures, some of which were performed in parallel. Bauermeister created the stage set, in which an aquarium with goldfish and bird cages with lovebirds and white doves hung from the ceiling. During the performance, Bauermeister sprayed fluorescent paint onto an enormous canvas. Stockhausen's strict score—electronic sounds, piano, and drums—actually contradicted Caspari's associative concept. Without any preparation, the director had the actors read obituaries from the daily newspaper and react spontaneously to comments from the audience. While Stockhausen worked with meticulous timing, Caspari had his protagonists improvise—order and structure on one hand and chaos on the other. One of the performers on stage was Paik, who emptied a bag of flour over himself, climbed into a bathtub filled with water while shouting, and finally threw flour, sugar, and rice at the audience. Consequently, the Cologne Cultural Office canceled the theater's subsidies.

This and similar productions were a revival of Dada, in a belated reflection on the Second World War. Much like the Dadaists, who, a generation earlier, had responded to the First World War with a fractured sense of reality in their pictures and absurd stage plays, the Fluxus artists now used Happenings to process their experiences on the front. During his time in Essen, Caspari had told me a great deal about his traumas from the war; here he acted them out. Later, he became a successful television director and, as a counterpart to Western films, invented the genre of the Eastern, with which he strove to process his war experiences on the Eastern Front.

There was a remarkable culture around discourse in Cologne. During my training at the gallery Der Spiegel, I had

experienced the Wednesday discussions hosted by the book-seller Gerhard Ludwig in his shop in the main train station, the Third Waiting Hall. These discussions were often polit-ically highly controversial. Among the guests were Heinrich Böll, Ludwig Erhard, Gottfried Benn, Gustaf Gründgens, and Peter Lorre.

Although Bonn had become the seat of the new post-war government, the neighboring, lively city of Cologne de-veloped into a cultural capital. Düsseldorf, as a prosperous fi-nancial city with its academy and artists, could have also been a good option for my next gallery. The surrounding region, with its large base of collectors, was also attractive. Krefeld, with its centuries-old textile industry, was in the immediate vicinity, as were Wuppertal and Mönchengladbach, where many collectors who were open to anything new lived. But I was drawn to Cologne's Romanesque churches, which gave the city a completely different essence. Here, with the new Wallraf Richartz Museum and the foundation set up by Josef Haubrich, which provided the museum with its own acqui-sitions budget for contemporary art, there was a distinct at-mosphere of possibility and change. More than anyone else, Kurt Hackenberg, the city's head of cultural affairs, was a man who wanted to make a difference and encouraged me from the very beginning. During my first visit to his office to introduce myself, he promised to make an acquisition for the city from my gallery, and he kept his word. Before he re-tired in 1979, he purchased from my gallery the sculpture *L'ascension* (1929) by Otto Freundlich for the Wallraf Rich-artz Museum—to do this he went over the head of the direc-tor, who never did hold it against him. Today, the sculpture is in the collection of the Museum Ludwig, which began as the department for modern and contemporary art of the Wall-raf Richartz Museum.

Another aspect in Cologne's favor was its geographical location. Cologne had excellent transport in all directions. From here, it was not far to Eindhoven and Amsterdam, where Edy de Wilde and Willem Sandberg were important museum

directors, or to Brussels, with its lively collector scene. Paris, which was considered the secret cultural capital of West Germany, was easily reached by train, so that one could arrive there in time for exhibition openings or have dinner at La Coupole in Montparnasse. Long-distance travel was also easy from Cologne. The airport—at that time still a simple barrack—was in the process of being expanded. In Cologne, I wanted to make a fresh start as a gallerist and an art dealer.

I deliberately looked for spaces in the vicinity of the Wallraf Richartz Museum and discovered a small storefront on Kolumbakirchhof, where there had once been a cemetery and where Kolumba, the art museum of the Archdiocese of Cologne, is now located. Right next to the space was a large parking lot, which proved to be extremely convenient for the delivery of artworks but also as a place where guests could stand outside during openings. Very close by was the gallery Der Spiegel, so visitors could reach their next exhibition destination within a few minutes' walk. It was also only a stone's throw away from WDR on Wallrafplatz. A completely different point of reference for me was the neighboring Minoritenkirche, the Church of the Immaculate Conception, with the grave of the medieval theologian and philosopher Duns Scotus. The workshop of Wolfgang Hahn, who was a conservator at the Wallraf Richartz Museum, shared a border with the church and the grave. With Hahn, who quickly became my most important collector, I talked a lot about Duns Scotus, the monk who emigrated from Scotland; we were both interested in his epistemology.

I had become acquainted with Hahn earlier, during my time with Eva and Hein Stünke. Before openings at Der Spiegel, he would come by during his lunch break to take a look at the exhibitions in advance. Well dressed in a dark blue suit with a vest and tie, his graying hair neatly combed, he looked at the art on view with a rare intensity. Due to his profession as a conservator, he had a special eye for details. After a while, Eva would join him and begin conversing with him. She was the communicator in the gallery and,

Rudolf Zwirner with his daughter, Esther, and wife, Ursula, and his employee Albert Moehn (back), in front of Galerie Zwirner at Kolumbakirchhof 2, Cologne, c. 1962–1963

Wolfgang Hahn and Rudolf Zwirner at the Kunstmarkt Köln, 1968

at times, was overly direct. When a collector once remarked to her about an abstract work, "The picture doesn't say anything to me," Eva simply replied, "It *can't* say anything to you; after all, there's no loudspeaker behind it." But she got on very well with Hahn. After each discussion, he would reserve one or two works, mostly rather small format, because his price limit was 10,000 marks. That was all he could afford on his museum employee's salary, which was, however, entirely at his disposal, as his wife, Gisela, financed the household in the affluent Lindenthal district through her income as manager of a fashion store. By the time I returned to Cologne from Essen, Hahn had assembled a comprehensive collection of works by the so-called Cologne Progressives, including Franz Wilhelm Seiwert, Heinrich Hoerle, Otto Freundlich, and August Sander, and works by the École de Paris as well as younger Cologne-based artists such as Ernst Wilhelm Nay and Joseph Fassbender. In order to achieve a more complete representation of a particular period, he also included second-rate artists in his collection.

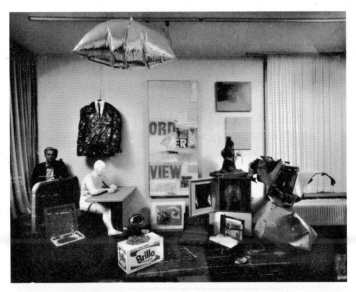

Wolfgang Hahn with works from his collection, c. 1970

Just at the time when I opened my gallery in Cologne, Hahn began to turn his attention to the Nouveaux Réalistes. He stopped buying at Der Spiegel and became my client instead. To enable him to restructure his collection, he gave me works on an exchange basis—not for speculative reasons, but simply because his interests had shifted. Various paintings he had previously acquired from the Stünkes—by Wols, Hans Hartung, or Jean René Bazaine, for example—thus came into my hands. In 1964, Hahn paid for his first Robert Rauschenberg work, the "Combine" painting *Hazard* from 1957, with a painting by Freundlich, which I then resold to a collector in Vienna. It was the first time that a Rauschenberg painting was acquired by a private German collection.

Hahn was an exceptional, passionate collector—eager for knowledge and always interested in the present. He had a keen sense for new developments and, since he was only nine years my senior, was much closer to me than the Neuerburgs, Stein, or other collectors in Cologne. The war had left its mark on him: he had experienced the vulnerability of humans and now looked at the world with skepticism. Hahn distrusted pristine paintings on canvas and instead became enthusiastic about Fluxus and the centrifugal forces of the movement. He was one of the first people to recognize the connection between the Nouveaux Réalistes and pop art, the reciprocal influences between Europe and America. The first public presentation of his collection at the Wallraf Richartz Museum in 1968 was a decisive caesura for Cologne, its museums, and its collectors.

I learned a great deal from Hahn. He often came to my gallery at lunchtime with a plastic bag in his hand containing three or four catalogues he planned to study later that evening when he got home. Much later, Hahn would get these catalogues at Walther König's now famous bookshop, which opened up across the street from my next location in Cologne. He was certainly one of König's best customers. Hahn wanted to know as much as possible about the work and environment of the artists he was interested in. Only then did

he talk to the gallerists about possible acquisitions. He corresponded with numerous artists and held on to everything related to them. Many also went directly to him. Whenever Nam June Paik needed money, he brought Hahn a work, which he always purchased. Over time, his house in Lindenthal became filled with Fluxus works. When he visited me, we would talk about artists, their work, and their significance. Hahn was the intellectual among my collectors. Because of my work in the gallery and my family life, I didn't have the time to deepen my interests as he did. Later, I regretted that I never developed a clear, guiding concept for my gallery. Instead, I focused on the daily business and often let myself be guided by coincidences. Hahn was not only an important source of information for me but also often acted as an agent for other collectors, for which he never expected a commission.

The first artist I showed at my gallery on Kolumbakirchhof, in 1962, was the French sculptor Eugène Dodeigne, whose work I had seen in Rudolf Springer's Berlin gallery. He was an expressive sculptor with an impressive personality who typically worked in granite and who has, today, undeservedly all but fallen into oblivion. My debut with him in Cologne had very practical reasons: I was able to take over the exhibition from Springer. I hadn't thought about a cohesive program until then; program galleries, such as Alfred Schmela's gallery in Düsseldorf, which represented the Zero group, or Otto van de Loo in Munich, whose gallery was committed to the CoBrA group, were still an exception in West Germany. At that time, I felt as if I were still just starting out, because, in Essen, there were no opportunities to make contact with artists. My previous visits to Mary Bauermeister's studio had been rather observational. I was fascinated by Paik, Maciunas, and Christo, but I would never have thought of exhibiting them. Unlike Schmela, who was an artist himself, I came from an academic, bourgeois household, received a strict education, and was full of reservations about anything revolutionary. That all was about to change.

The next artist I exhibited was Inoue Yūichi, a Japanese calligrapher whose work I had encountered for the first time at the second Documenta. Through his work, I better understood what Werner Haftmann meant by his idea of abstraction as a global movement, since the artist's work was based on a millennia-old Eastern tradition, which had echoes in contemporary European tachism. Yūichi's works were both unconventional and spiritually charged. His one-character calligraphy didn't fit into any existing category. I wrote to him, and he sent me a roll of his prints by airmail. When I asked him to come to the opening of his exhibition, he replied that he couldn't come to the opening because he couldn't afford the trip to Germany. I was happy to invite him, but I didn't have the money for his flight. For the opening, the Japanese composer and Cage student Toshi Ichiyanagi gave a concert. (Cage, in 1962, dedicated the piece *0'00"* to Ichiyanagi and his wife, Yoko Ono.) Ichiyanagi's composition *Sapporo* (1962) involves as many as sixteen participants, who each receive a different page of the score, which they can also exchange among themselves. For this performance, the participants included the Beuys student Michael von Biel, whose landscape drawings and collages I exhibited in 1974, and the nineteen-year-old Kasper König, my trainee at the time. Hahn was the only one who purchased a work by Yūichi, even though his art didn't fit at all into his collection. But the spirituality of the work appealed to him as much as it did to me. After the exhibition closed, I purchased the rest of the calligraphies myself, because I just didn't have the heart to send the roll back to him. I kept them with me for decades and later sold them to the Museum of East Asian Art in Cologne for an insignificant sum. Today, however, the museum would not be able to afford them at market rate. At that time, they cost between 3,000 and 4,000 marks; today, they sell for up to 200,000 euros.

The following year, in 1963, I gained a proper foothold in Cologne. I once again exhibited works by Cy Twombly and Konrad Klapheck, and introduced Klapheck's teacher Bruno

Goller, as well as Rupprecht Geiger, which led to a retrospective in the Von der Heydt Museum in Wuppertal. In Cologne, I finally received the publicity I had wished for in Essen—not least of all through a small scandal, which I deliberately provoked in the spring of 1963 with the exhibition *Zeichnungen von Schimpansen und Gorillas* (Drawings by Chimpanzees and Gorillas). The press made a big fuss, and in terms of media presence, this exhibition was very successful. At that time, the newspapers were full of reports about monkeys that could paint and the British behavioral scientist Desmond Morris, who conducted extensive studies with a chimpanzee named Congo. For Morris, these pictures were proof that apes possess artistic skills; for the general public, however, they proved only that the gestural painting of artists such as K.R.H. Sonderborg and Hans Hartung resembles the scribbling of a chimpanzee. I wanted to disprove both theories, so I went to a zoological institute that also experimented with having monkeys paint pictures and obtained loans for an exhibition. I no longer had any patience for statements such as "My child can do that too," and wanted to demonstrate that gestural painting has a completely different spirituality, that it cannot be compared to the learned daubing of a monkey. There was a tremendous amount of hype, which led to a steady stream of visitors, many of whom I was able to engage. Nevertheless, no one really understood what I wanted to achieve with the exhibition. But the media attention and the large number of visitors were a welcome side effect.

The exhibition with Daniel Spoerri was also spectacular—and the shortest of my career. It lasted exactly as long as it takes to hard-boil an egg: seven minutes. And that's exactly what it said on the invitation. The day of the exhibition— September 12, 1963—the audience waited eagerly in the gallery, staring at the empty walls. Then the door opened and the pictures were brought in, and the guys from the shipping company hung them on the walls. I then put an egg into a small cooker on the windowsill and set a timer. After seven minutes, I shouted, "The egg is hard!" The guys then took the

pictures down and put them back in the truck. In those seven minutes, I sold four paintings. One collector, who couldn't see everything so quickly, ran outside and had one painting taken back inside. To make sure the guests didn't leave after the seven minutes were up, we held a dinner, for which Spoerri obtained various delicacies not normally available in Germany: flies, worms, snakes, and other vermin from China, pickled in oil. With these, he prepared special omelets. Afterward, we all drank an Underberg.

Another fascinating experience was collecting Spoerri's *Table de Robert* from his studio on rue Mouffetard in Paris. The work measures roughly seventy-nine by twenty inches, replicating the size of the table on which Spoerri and the Fluxus

Rudolf Zwirner boiling an egg at the opening of Daniel Spoerri's exhibition at
Galerie Rudolf Zwirner, Cologne, on September 12, 1963

Hahn's Supper, May 23, 1964, with Daniel Spoerri, Wolfgang and Gisela Hahn, Konrad and Lilo Klapheck, Ursula and Rudolf Zwirner (center), and guests

Daniel Spoerri, *Hahn's Supper*, 1964. Various objects mounted on wood, 78¾ × 78¾ × 15 inches | 200 × 200 × 38 cm. mumok – Museum moderner Kunst Stiftung Ludwig Wien, Vienna

artist Robert Filliou dined while preparing an exhibition in 1961. Spoerri drove me to the Gare du Nord in his small Peugeot, with the artwork tied to the roof of the car. I then carried it like a pair of skis through the station and had to leave it in the train's service compartment since it wouldn't fit anywhere else. The conductors didn't know what to do with the work, but I was allowed to stow it in their luggage net, and, back in Cologne, I carried it unpacked through the city to the gallery—similar to the way the Parisian art dealer Ambroise Vollard transported his Cezanne paintings home in a handcart. Later, Wolfgang Hahn acquired Spoerri's *Table de Robert* from me. In 1969, he sold it to Peter Ludwig, who donated it seven years later to the Museum Ludwig, where it remains today.

Hahn was so enthusiastic about Spoerri that his wife, Gisela, together with the artist, initiated a work as a gift to celebrate the collector's fortieth birthday: *Hahn's Supper*. In May 1964, fourteen friends were invited to the Hahns' home in Lindenthal for a feast, including the Klaphecks, the photographer Manfred Tischer and his wife, the art dealer Alfred Otto Müller, also with his wife, and the architect Heinz Hossdorf. The artist provided the roughly eighty-by-eighty-inch tabletop, and the guests had been asked to bring their own tableware. The different plates were like each participant's business card in the work of art; the blue-and-white crockery came from Ursula and me. As master of ceremonies, Spoerri cooked again, this time a kind of goulash, accompanied by red wine. As guests, we were all involved in a process, comparable to the Last Supper of Christ, in which a transformation takes place. We talked about this during the meal. After Spoerri declared the meal finished, everything had to stay in place, unchanged, right down to the cigarette butts in the ashtray. While the artist fixed the leftovers with resin, we spent the rest of the evening standing. The ordinary remnants of the meal revealed their effect the moment the enormous tabletop was titled vertically, thus transforming the objects on it into elements of a picture.

The captured moment of reality was suddenly an abstract and yet highly representational composition. *Hahn's Supper* (p. 112, bottom) is now in Vienna, where it is one of the most popular works in the mumok – Museum moderner Kunst Stiftung Ludwig Wien. That autumn, I returned to Hahn's home with another artist to discuss the exhibition of the Swiss artist Jean Tinguely, whom I had met during one of my visits to Spoerri's studio. I was permitted to exhibit five or six water sculptures by Tinguely in Hahn's garden, as an outpost of the gallery, so to speak. Rauschenberg, Cage, the choreographer Merce Cunningham, and Bazon Brock, among others, attended the opening.

The new artistic practice of the early to mid-1960s often injected exhibitions with the character of Happenings; environments emerged. The Japanese artist Ay-O, for example, filled the space at my gallery in 1966 to the brim with crumpled newspapers and included a tunnel, through which we all had to crawl. I was scared to death that someone might light a cigarette. There were also readings, concerts, and discussions, similar to those I experienced during my time with Eva and Hein Stünke (who had taken Alfred Flechtheim and his accompanying exhibition activities as their model). On July 18, 1963, the American action artist Allan Kaprow gave a lecture on Happenings and Fluxus, which Joseph Beuys also attended.

The involvement of the viewer and the end of the static image had been gaining momentum for some time. Jasper Johns had attempted to actively engage the viewer in 1955 with his painting *Tango*, which Peter Ludwig later purchased through me. The viewer was supposed to press a button in the center of the blue encaustic surface. Johns's painting was an invitation to touch, actually even damage. After all, the Latin term *tango* translates to "I touch." Pressing the button caused dance music to emanate from the music box positioned behind the canvas, and the viewer was supposed to start dancing. Later, Rauschenberg created his "Soundings," which reacted to noises such as the clapping of hands or the

stomping of feet. Andy Warhol's monumental painting *Close Cover before Striking (Pepsi-Cola)* from 1962, which is now also in the Museum Ludwig, has a strip of sandpaper along the lower edge, just above a line of text that reads, "American Match Co., Zansville, Ohio" (below). The picture shows traces of human activity—more precisely, scratches on the sandpaper that suggest the striking of matches.

Participation was also a keyword for the Fluxus artists. On the evening of Kaprow's lecture, Beuys adapted the term

Andy Warhol, *Close Cover before Striking (Pepsi-Cola)*, 1962.
Polymer paint and sandpaper on canvas, 72 × 54 inches | 183 × 137 cm.
Museum Ludwig, Cologne

for himself in a different way: while the American artist was giving his lecture, Beuys "spontaneously" placed a cardboard box with animal fat in one corner of the gallery window. Normally, there wouldn't have been anything wrong with that, but I was annoyed by the whole process, because as soon as Kaprow finished his lecture, Beuys began his own lecture on fat as a material and symbol. Everyone listened to him politely, so that, in a certain sense, Beuys had an exhibition without my having initiated it. This appropriation, the transformation of someone else's evening into a Beuysian action, was typical for him. Beuys was always looking for situations in which he could draw attention to himself.

In the end, this sideshow at the Kaprow lecture would be recorded into art history. It was the first time that Beuys presented a "fat corner" in public. And with my gallery as an exhibition venue, institution, and stage for events, I, too, had firmly established myself in Cologne within just two years.

8

Stations of
a Gallery

I exhibited primarily European artists in my gallery—with the exception of Inoue Yūichi and Cy Twombly—and showed some of the first representatives of folk art, or art brut, by painters including Matija Skurjeni from Croatia, Nikifor from Poland, and Henry Darger from the United States. But behind the scenes, I became increasingly interested in pop art. Konrad Klapheck's advice to look into Ileana Sonnabend and her gallery, which opened in Paris in 1962, steered me in a very new direction. Klapheck frequently visited Cologne, spoke very good French, and was in touch with the surrealists, with whom he felt a close affinity, especially with the theorist André Breton. During my time in Essen, I had traveled to Paris time and again to purchase prints from Heinz Berggruen, but I had also visited the galleries Louise Leiris, Stadler, Rive Droite, Iris Clert, and the Galerie de France to see contemporary art.

It was around this time that my wife Ursula visited New York, where an artist friend took her to various studios. This painter was a friend of Jim Dine's and knew almost every young pop artist, including George Segal, James Rosenquist, and Andy Warhol. Ursula regularly sent me letters with

reports from the studios, describing the works she had seen: Segal's life-size plaster figures, Rauschenberg's paintings integrating waste, and Dine's watering cans dangling in front of canvases. Although I knew of Rauschenberg's "Combine" paintings through Documenta, it was Ursula's letters that made me curious to learn more about these artists. At Sonnabend's gallery on Quai des Grands-Augustins, I was able to view their works myself. Her inaugural exhibition was dedicated to Jasper Johns, whose painted everyday objects had both confused and fascinated me at Galerie Rive Droite as early as 1958. And with his pair of painted bronze beer cans, I could no longer tell the difference between readymade and sculpture. How were these different from Duchamp's *Fountain* (1917)? Was it still art? I suddenly had an entirely new awareness of these objects, and from then on, I wanted to deal with things like this. Much later, I acquired Johns's now iconic beer cans, *Painted Bronze/Ale Cans* (1960), for Peter Ludwig (below).

Jasper Johns, *Painted Bronze/Ale Cans*, 1960. Oil on bronze, 5½ × 8 × 4¾ inches | 14 × 20.3 × 12 cm. Museum Ludwig, Cologne

Sonnabend's gallery was extremely influential. It was the pioneer for pop art in Europe. Even after her divorce from Leo Castelli, who operated a gallery in New York, and her subsequent marriage to the Dante expert Michael Sonnabend, she continued to work with her ex-husband: Castelli represented pop art in the United States, she in Europe. Later, whenever the two came to Cologne, Ileana called me the Saturday before to request that I attend to her accommodations: "Rudolf, reserve me a room in the Excelsior, but make sure that Leo's room is connected to mine." There would always be a connecting door between them, and their collegial friendship persisted to the very end.

I acquired my first pop art pieces through Sonnabend. It was impossible to establish a direct relationship with many of the artists, since they were already under contract with Sonnabend and Castelli. Like other European gallerists, I was dependent on my collaboration with her and Castelli. Or I would have to switch to the secondary market and acquire works that collectors wanted to sell. The more I became interested in their artists, the less Sonnabend and Castelli wanted to sell works to me and instead preferred to contact my collectors on their own. But I was still a welcome guest with both of them, especially as a customer for works that they found difficult to sell in Europe. That's why the American market itself became more important for me—so that I could acquire pop art, works of classical modernism, and, to a certain extent, works from the École de Paris. In the 1940s and 1950s, American dealers had facilitated sales of works by the tachists to American collections directly from Paris, and these were now available again as American collectors increasingly turned to contemporary art from their own country. But when the market for works from the École de Paris collapsed—precipitated by Galerie de France's filing for bankruptcy—my French colleagues were no longer able to buy them back. At that time, the auction houses didn't accept consignments of contemporary art, even though now contemporary consignments make up the bulk of their business. Because of my New York

purchases, primarily of classical modernism, I brought many museum-quality pieces by Picasso, the surrealists, and other contemporary European artists back to Europe.

In 1963, I made my first business trip to the United States, where I went straight to the pop artists' studios. And yet, this was the first time I didn't dare to buy anything contemporary. Karl-Heinz Hering, the director of the Kunstverein in Düsseldorf, had organized the trip, a three-week tour for gallerists, museum professionals, heads of cultural departments, and collectors, first along the East Coast, then to Detroit and Chicago—the origins of abstract expressionism. Just before our departure from Düsseldorf, the art critic Albert Schulze-Vellinghausen took me aside, patted me on the shoulder, and said, "When you're in New York, don't forget to mention Hans Werdehausen, an important painter." The suggestion was grotesque; after all, we were just about to depart to discover new things and artists in the United States. But Schulze-Vellinghausen, who otherwise had an excellent eye for art, left no stone unturned to promote his friend Hans Werdehausen, whose work is all but forgotten today.

Shortly after the charter flight took off, Arnold Rüdlinger, the director of the Kunsthalle Basel, stood at the on-board bar and enjoyed a drink. He was a pioneer of American art in the old world; as early as 1958, he had brought the show *New American Painting*, organized by The Museum of Modern Art, to Basel and was one of the first to acquire paintings by Franz Kline, Barnett Newman, Mark Rothko, and Clyfford Still for a museum in Europe. This spectacular purchase was made possible by the insurance company Nationale Suisse, which made 100,000 francs available to him for this purpose to celebrate its centennial anniversary. Even then, the budget was not sufficient enough for a work by Jackson Pollock, who was much more expensive than the others. Not long after takeoff, Rüdlinger, who had remained attentive despite considerable alcohol consumption, noticed a defect in the aircraft—something hardly conceivable in today's world. We had to stop over in Amsterdam. After the damage was

repaired, we were able to continue our journey without further incident.

When we arrived in New York, my colleague from Düsseldorf, Alfred Schmela, and I broke away from the travel group, because we were less interested in the abstract expressionists than in the younger generation of American painters. Separately, we looked around and visited Leo Castelli, Sidney Janis, Paul Bianchini, and Richard Bellamy from the Green Gallery. They gave me recommendations as to which artists I should visit in their studios. I thus was introduced to Warhol, Segal, and Dine as well as Roy Lichtenstein and Claes Oldenburg. On this first trip, it was important to get to know not only the artists personally, but also their art dealers—it was through the dealers that I would be able to invite artists from New York to exhibit with me in Cologne. But instead of investing my money in this younger generation, I ended

Max Ernst, *Two Anthropomorphic Figures*, 1930. Oil on canvas, 26 × 21¼ inches | 66 × 54 cm. Von der Heydt Museum, Wuppertal

up bringing home a modern classic: *Two Anthropomorphic Figures* by Max Ernst from 1930 (p. 123). I purchased it from Pierre Matisse, the son of Henri Matisse and a friend of Ernst's, and sold it to the Von der Heydt Museum. I was sure that I could sell Ernst's work in Germany; with pop art, I would not have even known whom to contact for a sale. In the early 1960s, people in Germany were still skeptical of pop art. Abstraction continued to be regarded as the highest developmental stage of art, and pop art's harsh representationalism was perceived as vulgar—especially so in Cologne, where the word *poppen* (colloquial for "intercourse") was associated first and foremost with sex.

In contrast to my conservatism, Schmela did not shy away from risk. He had been in the business two years longer than me, was knowledgeable, and had already built a client base for contemporary art. And he was confident that he could count on his collector Fänn Schniewind, who indeed acquired the painting by Lichtenstein that he purchased from Castelli in New York. Schmela paid cash and took the canvas rolled up directly with him on the plane. Shortly thereafter, Schniewind experienced firsthand how little the experts appreciated her decision, which was courageous for the time. To present her latest acquisition, she proudly hosted a festive luncheon. Among the guests was Werner Schmalenbach, the founding director of the Kunstsammlung Nordrhein-Westfalen. During dessert, he began to make disparaging remarks about the painting. But his comments made no impression on the confident collector, who remained steadfast.

Although I didn't bring any works of pop art back to Cologne from New York, I did have a plan in my back pocket. When I visited Jim Dine's studio, I arranged an exhibition with him for February 1964. I was able to work directly with Dine—who integrated everyday objects, especially tools, into his paintings—because he was not under contract with Sonnabend. Nevertheless, his paintings were delivered via her Paris gallery, where I could pick them up. While Sonnabend may have been generous about Dine, I was not permitted to

work directly with Jasper Johns. Only much later did I understand why. Johns had a more intellectual acuity—he was more radical—while Dine soon weakened somewhat and tended toward sweetness with his heart motifs. But, as always, I learned something through this experience—through working with Dine, a second-tier artist, I worked my way up to the first tier, and then really learned to appreciate the great artists of that generation. Nevertheless, the Dine show was important, and it was his first exhibition in Europe. I was able to sell only one painting: *Yellow Oil Can* from 1962, an oil can mounted with a hook and line in front of a monochrome yellow surface (below). *Yellow Oil Can* was purchased by Wolfgang Hahn and marked the start of his collecting American pop art. Today, it is in Vienna, in the collection

Jim Dine, *Yellow Oil Can*, 1962. Oil on canvas, oil can, hook, and cord, 35½ × 20 × 6¾ inches | 90 × 51 × 17 cm. mumok – Museum moderner Kunst Stiftung Ludwig Wien, Vienna

of the mumok – Museum moderner Kunst Stiftung Ludwig Wien. In late 1964, I showed Dine again, this time in a group exhibition together with Beuys, Dubuffet, Geiger, Goller, Klapheck, Spoerri, Tàpies, Tinguely, and five other Americans: Allan D'Arcangelo, Twombly, Lichtenstein, Oldenburg, and Rauschenberg. It marked the culmination of my work at Kolumbakirchhof, since, after the subsequent solo show with Tinguely, I said goodbye to the space that served as my first gallery in Cologne, which had become too small for me after just two and a half years.

The next station would be Albertusstrasse 16, a storefront with more than seventeen hundred square feet. The long, deep space would allow me to display large-format works. I could show many more pictures at once and welcome up to one hundred guests at evening events. Yet I was not really satisfied, because the new building radiated with the stuffy atmosphere of the 1950s petite bourgeoisie. In the end, however, I stayed there for eight years. When I moved the next time, it was only next door—where I was able to build my own space. I took over this third property with the help of Kurt Hackenberg, the city's head of cultural affairs, to whom I had turned for advice and assistance. When I approached him, he immediately called the city's head of construction to find an appropriate space. After I received various unsuitable suggestions, I approached Hackenberg once again, this time about the vacant property immediately adjacent to Albertusstrasse 16. It belonged to a bank, which did not want to sell—at best, they wanted to exchange it for another plot of land. The head of the building department initiated the negotiations and paved the way. The bank received a plot of land from the city, and I was able to build.

While it was still quite common in the 1960s to convert storefronts into galleries—as I had done—in the 1970s, the specific gallery space became a prerequisite for serious gallery work. The new picture formats, as well as large three-dimensional objects and expansive installations, demanded a new type of space. The models for this were once again found

in New York, where entire offices or factory floors were converted into huge exhibition venues. The proliferation of these spaces, which were built out or extended especially for the purpose of a gallery, with corresponding museum-quality facilities for presentation, storage, and lighting, indicated the expansion of the contemporary art market. The professionalization of gallerists themselves soon followed.

Whereas in the 1950s completed works of art were selected in the artist's studio and presented in the gallery, in the 1960s artists came into the gallery to incorporate its spatial specifications into their work. The gallery thus became an integral part of the art, developing from a pure exhibition space into an artistic event space, which in the ensuing years considerably increased galleries' social prestige but did not yet guarantee economic success. Paradoxically, the professional gallery space initially served as a place for artistic realization beyond economic and social constraints. The "white cube," as the Irish conceptual artist Brian O'Doherty aptly characterized the gallery space in 1976, was the ideologically neutral framework of a supposedly autonomous art free of any constraints. A typical example of this historical development is the Leo Castelli Gallery, which opened in Castelli's own apartment building on Seventy-Seventh Street in 1957, then moved downtown to a converted loft space on West Broadway in 1971, and expanded in the early 1980s to a huge "white cube" on Greene Street.

In 1972, I also had a loft-like gallery built in order to provide an appropriate framework for the changes taking place in contemporary art. The building at Albertusstrasse 18 was designed by the architect Erich Schneider-Wessling, a friend of mine, who had created residential buildings for the composer Karlheinz Stockhausen, the publisher Reinhold Neven DuMont, and the von Dohnanyi family. I gave him precise specifications for the ceiling height, storage space, and the family apartment, which was to be located directly above the gallery. I wanted a loft similar to those I had experienced in the United States—no wood, no tiles, no carpet, just plain

The building at Albertusstrasse 18, designed by Erich Schneider-Wessling, in Cologne, 1972

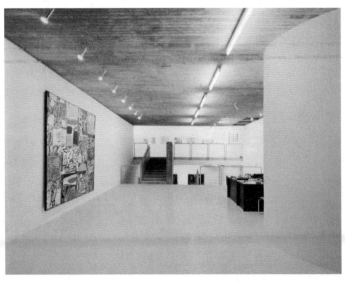

Installation view, *Jean Dubuffet: Théâtres de mémoire, Assemblagen 1976–1977*, Galerie Rudolf Zwirner, Cologne, 1977

concrctc. It was the era of minimalist art, with Donald Judd and Dan Flavin, and the architecture was accordingly cool and clear. The most important thing for me was that the exhibition space should remain free of columns and that there should be no partitions. The brutalist architectural language, the exposed concrete of both the interior and exterior walls, was an aesthetic statement. At the same time, the architecture of the building was to compete with Alfred Schmela's new gallery by Aldo van Eyck on Mutter-Ey-Strasse, just behind the Kunsthalle Düsseldorf, which was clearly influenced by De Stijl structures. Because of its smaller size, however, his gallery, which opened a year before mine, never really functioned well as an exhibition space.

The opening of the new gallery building, in June 1972, was, of course, appropriately celebrated; in particular, the artists I worked with came to see the space, which offered completely different possibilities. My gallery finally became a center of cultural life in Cologne. When I celebrated the gallery's twentieth anniversary seven years later, the legendary actor Bernhard Minetti performed *Krapp's Last Tape* (1958) by Samuel Beckett in the large hall of a restaurant across the street. There was a stage in the ballroom, and the Schauspielhaus, Cologne's municipal theater, helped out with lighting and technical equipment. Minetti brilliantly played Krapp, a codger who reminisces about his life, dressed only in soiled underwear and sucking on a banana. Minetti was an old friend of mine; we had met while I was working at Galerie Rosen in Berlin, when I saw him on stage playing the role of an old man. His acting impressed me so much that I gave him a print by Lovis Corinth as a gift: it was a self-portrait from 1912, shortly after his stroke, on which the artist had scratched the words "when I was ill." After his next performance, I waited for Minetti at the theater exit to give him the print as a token of my appreciation.

Whenever Minetti had a premiere in the Rhineland, I had to go. I was in the audience the day of the Kennedy assassination, on November 22, 1963, when he was performing

as King Lear at the municipal theater in Düsseldorf. In the middle of Minetti's monologue, the manager of the theater, Karl-Heinz Stroux, stepped up to the ramp and interrupted him: "Ladies and gentlemen, I have just received the news that the president of the United States has been shot and killed. At this moment I am thinking of Sarajevo. I ask you to leave the theater; the performance is over." A painful silence fell over the auditorium, and one by one the audience members got up and left the theater. Minetti was furious when I picked him up at the stage door: Stroux had spoiled his performance. I tried to calm him down, but I had to agree with him: Stroux could have waited half an hour before making the announcement, and the outbreak of a world war, which he alluded to in his reference to Sarajevo, was not to be feared. The etching by Corinth is now again in my possession. A few years after Minetti's death, his daughter Jennifer asked me to meet her in the Red Salon of the Volksbühne in Berlin, where she returned Corinth's self-portrait. Minetti's performance on the occasion of the gallery's anniversary was a testament to our friendship.

For me, the exhibitions and events of all kinds went hand in hand with the discovery of young artists as well as with the rediscovery of works by famous painters such as René Magritte. The rediscovery of paintings by Max Ernst was particularly successful: after decades of remaining unseen, his wall paintings from the 1920s, in the house of his friend Paul Éluard in Eaubonne, near Paris, appeared on the market. The Parisian gallerist André-François Petit had had them removed from the wall through an elaborate process and transferred to canvas (opposite, top). I presented them in my gallery, where Werner Schmalenbach was especially drawn to them. Yet he waited until they were on display at Ernst Beyeler in Basel before purchasing them. He thought that he could see defects in the restoration while they were hanging in my gallery, but it was obvious to me that he received special accommodations from Beyeler and preferred to do business with him. Today, they are among the most important

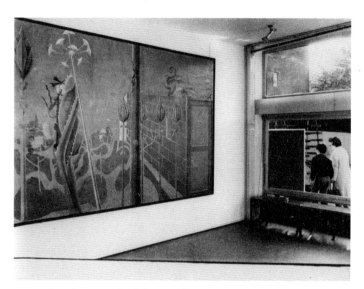

View of Max Ernst's exhibition with *Au premier mot limpide* (1923),
Galerie Rudolf Zwirner, Cologne, 1970

Invitation card to the opening of René Magritte's first solo exhibition in Germany,
at Galerie Rudolf Zwirner, Cologne, on January 30, 1965

works by Ernst in the holdings of the Kunstsammlung Nordrhein-Westfalen.

Another coup was my second exhibition at Albertus-strasse 16, a solo show with Magritte. Konrad Klapheck once again steered me in the right direction by suggesting I look into Magritte: he knew the artist personally from Brussels, where he worked at home on rue Esseghem, far from the public eye. Although Magritte had shown at the second Documenta, he had not yet had a solo exhibition in Germany. I contacted his gallerist, Alexander Iolas, in Paris, who gave me carte blanche.

To be honest, this exhibition in 1965 was nothing to be especially proud of in the sense that, for such an important artist as Magritte, it came much too late. Yet there was still a lot of convincing to be done around his work in Germany. Professor Wolfgang Krönig, for example, who taught art history at the University of Cologne, tried to explain to me in front of the pictures on view why Magritte was not an artist. I listened to his lecture for fifteen minutes and then threw him out. A young man had been listening to all this in the background. He came up to me and said that he was a student of Professor Krönig and that he had been surprised by my vehement reaction. He agreed with me and liked the exhibition very much. A few weeks later, he returned and declared that he wanted to stop his studies at the university and train under me instead. This young man was Thomas Borgmann, who later founded his own gallery in Cologne.

Two other young men also joined me, more or less by chance, as interns, who, like Borgmann, would later make names for themselves in the international art world. Kasper König became aware of my gallery in Essen while he was still a high school student. He was visiting the Museum Folkwang with his class from Münster, and he saw a poster advertising my Cy Twombly exhibition in the entrance hall. König was much more interested in Twombly than in the impressionists and expressionists on view at the museum, so he snuck out and walked over to see the show. At the time, he

couldn't believe that such "scribbles" were considered art and that there was money to be made with it. Shortly after my move to Cologne, he got in touch again. After he was expelled from school, he wanted to train with me. His father also called me and asked me to take on his son in the gallery. He said he wanted to give me paternal authority, including the right to corporal punishment, so I told him, "What you haven't accomplished, I'm certainly not going to try." And so it came to pass that König the troublemaker began working for me. I later recommended him to Annely Juda in London to continue his training there. And six months later, he moved from London to New York, where he knew all the artists after only a few months and began to stir up the art trade. But he returned to the Rhineland several times over the course of his career, as curator of the legendary exhibitions *Westkunst* (West Art) in Cologne (1981) and *Von hier aus* (From Here) in Düsseldorf (1984) and, most recently, as the director of the Museum Ludwig from 2000 to 2012.

Another intern at the gallery was Benjamin Buchloh, who is now an art historian and a professor at Harvard University. The first time he came to the gallery he was a high school student in Cologne and was particularly drawn to Twombly—he wanted to purchase a drawing from me for 800 marks. We agreed that he would pay in installments. But the deal was ultimately thwarted by his mother once she saw the drawing. After he completed his studies in Berlin, Buchloh returned to Cologne and began training under me. I took him with me to Richard Hamilton's studio in London and sent him on his first trip to the United States, to prepare exhibitions with Jack Smith, Neil Jenney, and Richard Tuttle. What neither of us suspected at the time was that America would later become his home. Today, he is one of the most important theorists to have studied the interaction of transatlantic artistic practices since the 1960s. Even in the 1960s, Buchloh was less an art dealer than a critical mind. It was he who suggested that I take a look at Marcel Broodthaers, whom I didn't know yet and later included in my program.

In addition to the exhibitions, the evening events attracted a large audience and contributed to the popularity of my gallery. Word of these activities also got around in literary circles. The author Helmut Heissenbüttel gave a reading at my gallery, and members of Wiener Gruppe, the Viennese poetry group, including Gerhard Rühm, H. C. Artmann, and Friedrich Achleitner, as well as Gunter Falk from Graz, made guest appearances with their experimental work. The literary critic of the newspaper *Die Welt*, Heinrich Vormweg, reacted enthusiastically in his review on August 24, 1965: "Zwirner is once again on the trail of something new. You could call it anti-sociability—a sociability without rules, without conversation, without evening attire, without obligations. There is not even the obligation to listen to the program. Everyone can come and go as they please, unnoticed through a side door. Admission and beer are free. Surprises are guaranteed."

One special performance featured the American baritone William Pearson, who was living in Cologne at the time. Hans Werner Henze often composed pieces with Pearson in mind, including *El Cimarrón* (1969/1970), which is based on the biography of the Cuban slave Esteban Montejo, with a libretto written by Hans Magnus Enzensberger. Henze described the piece as a "recital for four musicians," including a guitarist, a flutist, and a drummer. On other occasions, the American choreographer and dancer Twyla Tharp performed at the gallery, and the conceptual artist Bill Beckley invited the audience to participate in his installation *Silent Ping-Pong* (1971), for which both the paddles and the table were covered with foam in order to silence the sounds of the ball. The Kipper Kids, a British artist duo that toured Europe with their spectacular performances, also made an appearance. They performed a brutal duel, as if it were truly a matter of life or death. The visitors were more shocked than amused by the blows that Martin von Haselberg and Brian Routh dealt each other. The concert by Nam June Paik and Charlotte Moorman caused an even greater sensation: Paik began by playing Beethoven's "Moonlight Sonata" conventionally

on a grand piano. But after the first movement, he dropped his trousers, showed the audience his naked backside, and climbed into the piano, where he plucked the strings. After Paik climbed out again, he lay down flat on the floor. Moorman then appeared with her cello, placed the tip of her instrument in Paik's open mouth, and played Bach. Of course the audience immediately understood the obscene gesture. After a few bars, the first visitors left the gallery shouting, "Scandal! Pornography!" What remained was a very small circle of guests who appreciated the Happening.

Although the duo made a second guest appearance at the gallery, and I sold quite a few of Paik's pieces, I never put together an actual exhibition with them. I was interested in Fluxus, but the products of this movement were practically unsalable. My only customer would have been Wolfgang Hahn, but the artists turned to him directly as their close friend and patron—which was the right thing to do. I admired Hahn for his courage in collecting Fluxus. It wasn't until the presentation of his collection at the Wallraf Richartz Museum in 1968 that people finally saw that this art was indeed worthy of exhibition. With minimalist art, I showed more courage but also realized that it, too, was not yet understood by a wider audience; the breakthrough for this came later. In 1966, my gallery was the first in Europe to present an exhibition by Dan Flavin.

Flavin was affordable for me back then. He was at the beginning of his career and had to earn his money as a guard at The Museum of Modern Art, like many other artists in New York at the time. Moreover, transporting his work wasn't an issue, because he could purchase the fluorescent tubes for his installations at a store near the gallery. During his show, visitors came in to ask when I was mounting my next exhibition, and I responded that they were standing in the middle of it. They were entirely perplexed: light as sculpture was not something they had encountered yet. Even Gisela Fitting, a Cologne-based collector of surrealist art, didn't want to believe it and, in the course of our conversation, took a

step back and accidentally stepped on one of the fluorescent tubes, making it burst. When I said to her, "Mrs. Fitting, you just destroyed a work of art for 2,000 marks," she simply replied, "You are and always will be a rogue." At the time, the damage wasn't tragic, since the tube could be easily replaced. A few years later, however, the incident would have caused a scandal. But Flavin also had a few admirers: the important collector Count Giuseppe Panza di Biumo was immediately enthusiastic about his work and traveled to Cologne specially to see the exhibition, as did the Munich gallerist Heiner Friedrich, who later exhibited him.

As if that wasn't enough, the Warhol exhibition held shortly after Flavin's at the start of 1967 was also unsuccessful in terms of sales—but it was designed to be unsuccessful, since the artist showed nothing but silver helium-filled

View of Andy Warhol's exhibition with *Silver Clouds* (1966) and *Cow Wallpaper* (1966), Galerie Rudolf Zwirner, Cologne, 1967

balloons that floated to the ceiling and his wallpaper printed with cows. With his installation *Silver Clouds* and the silk-screen series *Cow Wallpaper* (both 1966), he declared his withdrawal from painting (opposite). The inspiration for the helium balloons came from Duchamp's *Exposition inter-nationale du surréalisme* at Galerie Beaux-Arts in Paris in 1938, where twelve hundred old sacks of coal hung from the ceiling of the darkened exhibition space. Warhol developed something light and airy out of it. Such adaptations were typical of his work. He liked to appropriate ideas without being accused of plagiarism. It was precisely this knowledge of art history and its incorporation into his work that distinguished him. For me, the balloons also alluded to sex, as they kept colliding and rubbing against one another under the ceiling. In contrast, the cows, staring out at the viewer, were the epitome of stupidity.

Only Hahn recognized the value in *Cow Wallpaper* and asked me to give him a section of it as a gift after the exhibition closed. He had it framed; today it is the only piece of the exhibition that still exists. Actually, only the *Silver Clouds* were for sale—at 200 marks per balloon. I had to be careful not to lose them, because as soon as someone opened the door to the gallery, the balloons were set in motion by the draft and there was the risk they would float away. Once, just in time, I caught a balloon that had made it outside: it was floating in the air directly above a parked car, and I quickly pulled it back in and thought to myself, 200 marks saved!

Although I owned what was now one of the most respected galleries in the city, business was bad. So bad, in fact, that I seriously considered moving to London. At that time, conservative forces were gaining ground in Germany, which also influenced my desire to leave. In Lower Saxony, the far-right National Democratic Party of Germany won ten seats in the state parliament in 1967, the same number as the liberal Free Democratic Party. In London, I was already working quite a bit with the art dealers John Kasmin and Robert Fraser, and interesting artists such as David Hockney, Richard

Hamilton, and Peter Phillips were based there. London was "swinging." I even found a space for the gallery on Cork Street as well as an apartment for the family.

To make sure that I was doing the right thing, I visited the gallerist Erica Brausen the evening before the contract for the new space was to be signed. Born in Düsseldorf, she had gone to Paris in the early 1930s and met many artists there. During the German occupation, she moved to Mallorca, where she ran a bar popular among artists and sailors and helped many Jews to escape. In 1947, she opened Hanover Gallery in London, where she and her companion Catharina "Toto" Koopman showed Francis Bacon, Alberto Giacometti, Lucian Freud, and Henry Moore as well as Ernst and Duchamp with great success. She advised to have a look around the London galleries before making my decision; it was the end of the year and thus time for the Christmas exhibitions. Appalled by the miserable quality, the kitsch, I returned to her on Saint George Street, where she told me, "That's exactly what I wanted to hear." She then told me about the sobering situation in London: "I have three or four collectors in New York that you don't have. They come to me once a year, partly because there's no duty on art here. But heaven help me if the political situation changes, then I'd lose these customers. Besides that, I have a banker who finances me, and that's something you don't have. You need an English patron of the arts behind you, a lord or a duke like at the Marlborough Gallery. Otherwise, you'll never make it here as a German." I canceled the move to London and returned to Cologne. Once I got home, I visited Hein Stünke, who wanted to know how my trip had gone. I told him, "I won't go. But something has to change here. It can't go on like this."

9

The Birth of the First Contemporary Art Fair

The situation at home was desolate, and not just for me. The few collectors in Germany who were interested primarily in classical modernism or the École de Paris tended to travel to Paris, Milan, or Basel. Foreign collectors came only once a year to visit the Ketterer auctions in Stuttgart. Apart from Wolfgang Hahn, I had hardly any collectors—Peter Ludwig was not yet in sight. At the time, Ludwig's focus was on medieval art and antique sculpture. In total, there were roughly ten collectors in Germany who were decidedly committed to contemporary art in the early 1960s, among them Hahn, Fänn Schniewind, Gustav Stein, and Gustav Baum. At the same time, gallerists in Munich, Hamburg, Berlin, and Cologne were not yet suppliers of German art for the international market. The relationships we had hesitantly developed with collectors in the United States shifted in 1961 with the

Eichmann trial in Jerusalem and the Auschwitz trial that began two years later in Frankfurt am Main. Ernst Wilhelm Nay, Norbert Kricke, and Emil Schumacher, who had begun to establish themselves in the United States, could no longer find buyers. Their contracts with American art dealers were terminated because the primarily Jewish collectors feared that the artists might have been involved in the Holocaust. This shadow also fell on the next generation. Nay's market was once again restricted to Germany. Conversely, the pictures German gallerists purchased in France or the United States were difficult to sell back in Germany, as we had to raise prices to recoup the costs of transport and customs. So it was more expensive to buy through us than through our colleagues in Paris or New York, and, consequently, we were less in demand. Something had to happen to breathe new life into the stagnant art trade in Germany. We were not satisfied with merely importing works by foreign artists to Germany— we also strove to export German art abroad.

Hein Stünke and I thus sat down together: he as a generator of ideas and a well-known figure in Cologne with many connections in politics and society, and I as the man of action and promoter of the business venture we intended to set in motion. We thought back on the great sales success of his gallery at the second Documenta in 1959, where after viewing the exhibition of prints at Palais Bellevue, visitors automatically passed by his sales stand and could purchase editions of the prints on display. These were often editions of Documenta works, which increased the demand. The 1960s saw a veritable boom in prints and editions. In the same way that catalogues are purchased today as souvenirs of sorts, people then purchased prints to take home with them. The second Documenta marked a commercial breakthrough for Eva and Hein Stünke; visitors from all over Germany suddenly began shopping at Der Spiegel. We wanted to transfer this model to Cologne, especially since the German Arts and Antiquities Fair had existed in Munich since 1956, the fair for antiquarian books and prints in Stuttgart since 1962,

and the Salon International de Galeries Pilotes for contemporary art, in which the Stünkes participated, at the Musée cantonal des Beaux-Arts in Lausanne since 1963.

The idea of developing an open marketplace for contemporary art was inspired not least of all by Warhol's production methods and marketing strategies. With the presentation of his *Brillo Boxes* (1964) at the Stable Gallery in New York in 1964, he had bluntly declared art a commodity. For him, artistic success and commercial success were one in the same: artistic value equals monetary value; or as Beuys put it, "Kunst = Kapital." Warhol would have preferred to exhibit at Tiffany & Co. In his Factory, art was no longer *created* but rather *manufactured* for the people. Just as he had converted his studio into a production facility, we wanted to abandon the sententious aura of the gallery and present art like a product at a trade fair.

The purpose of galleries had long since changed anyway, shifting from exhibition spaces and sales rooms to spaces for artistic events. At the same time, the media was becoming interested in contemporary art. Although the reports were still rather negative, Beuys soon became a major topic for the weekly news magazine *Der Spiegel*. In 1965, the Cologne-based art historian and journalist Wibke von Bonin set up an independent editorial department for visual art at the West German Broadcasting Corporation that provided radio and television coverage. Public attention for contemporary art and commercial success was clearly disproportionate. It was high time to experiment with new forms of mediation and sales strategies, and it was clear from the very beginning that Cologne would be the location for this experiment. It could not have been Kassel, despite the fact that Arnold Bode did his best to lure us there as a parallel event during Documenta. And Berlin was also out of the question because of its remoteness and delicate political situation. Cologne was predestined to be the cultural capital of Germany, and we wanted to finally do something to counter Paris.

Before we approached Kurt Hackenberg, the city's head of cultural affairs, to discuss our plan, Hein and I founded the Verein progressiver deutscher Kunsthändler (Association of Progressive German Art Dealers) along with sixteen other gallerists—whom, incidentally, we had difficulty getting together—in order to have an organizational group vis-à-vis the city as a negotiating partner. In terms of a specific location in Cologne, we did not yet think of the trade fair grounds on the other side of the Rhine as a location. The museum or the Kunstverein also seemed out of reach to us, because public art institutions continued to keep their distance from the trade. Instead, the Gürzenich, the city's medieval festival hall, proved to be a suitable choice. Contrary to our expectations, Hackenberg responded positively to our proposal. As a Social Democrat with deep humanist principles, he was immediately persuaded by the idea of a trade-fair-like event that would make art accessible to a wider audience. He disliked the elitist nature of museums, whose primary intended audience was the educated middle class. And as a politician, he saw our concept of a trade fair for art as a contemporary instrument for making a low-lift offer to various levels of society.

Hackenberg promised us the Gürzenich as an event location right from the start, without actually having the authority to do so. The only condition he put forth was that the entrance fees be transferred to the city treasury. We agreed, especially as we could not have demanded additional rent from the gallerists, who were already contributing 1,800 marks each in order to participate. Hackenberg, in turn, promised to take care of lighting, exhibition architecture, and fire protection arrangements. He also made sure that we were given the Kunstverein free of charge for an exhibition, in which each participating gallery could show works by one or two artists for an extended period. Since I was responsible for project management—and Stünke was the chairman of the association—I made notes during our conversation, which I then summarized point by point in an official letter

to Hackenberg. This letter was quickly returned, crossed out in red, and included a handwritten note from Hackenberg that read, "Nothing has been agreed upon. Everything will happen." A short time later, he called me and said, in no uncertain terms, "Mr. Zwirner, if you want to cooperate with me, then stop writing such asinine letters. My word is my word— you can count on it." I apologized and slowly began to realize that he could not accept my letter, because in his position he should not have made such decisions on his own.

This episode was typical of Hackenberg's style of working. He often informed the other aldermen or the chief municipal director only after the fact. His authority was so great that he was able—despite all opposition—to make the ballroom of the Gürzenich available to a commercially oriented association such as the Progressive German Art Dealers. I again experienced his ability to maneuver and keep the Cologne coterie of businessmen and other influencers in check at a public ceremony for Andreas Becker. Becker, who had taken over the management of the Cologne branch of the Flechtheim gallery in the 1920s and served on the city's cultural committee in the 1960s, was being honored for his ten years as chairman of the Kunstverein. In his speech, Hackenberg ostensibly paid tribute to Becker for always ensuring that the city's art scene remained "clean," referencing the saying "One hand washes the other." For this false praise, his allusion to Cologne's cronyism, indeed its corruption, Hackenberg received an approving applause from the audience. But I went to him afterward and said, half seriously, half jokingly, that I would sue him for slander if he ever said anything like that about me. But Hackenberg simply shrugged and explained the purpose of the remark: he had publicly let Becker know that he had precise knowledge of his business dealings—"Now you know that I know."

Hackenberg was a phenomenal strategist. He foresaw many more opportunities than we did when we founded Kunstmarkt Köln. From the very beginning, he had speculated on the entrance fees, while we had estimated expecting

a maximum of two thousand visitors. To everyone's surprise, when the art fair opened the week of September 13, 1967, fifteen thousand visitors came—without much advertising—from Cologne and the Rhineland as well as from Hamburg, Copenhagen, Amsterdam, and Brussels. People who would never enter a gallery strolled through the booths in the Gürzenich without any inhibitions. The fair was a complete success. All major newspapers reported on the event. *Der Spiegel* wrote on September 25, 1967, "The troubled economic sector saw the light of a brief economic boom—along with hope for better days. Germany's contemporary art trade, otherwise dispersed and thus insignificant by international standards, had a metropolitan center for five days."

The eighteen avant-garde galleries were set up in the ballroom of the Gürzenich in three rows of simple timber-framed booths, which had been awarded by lot. Prints were available in the foyer. The various offerings were mainly of the most recent production, with prices ranging from twenty marks for a print to 60,000 marks for top works—a breathtaking sum considering that a brand-new VW Beetle cost just over 5,000 marks at the time. For old-school dealers such as Daniel-Henry Kahnweiler, however, this aggressive marketing and public pricing was a sacrilege. For them, business should be conducted discreetly in a cultivated atmosphere. It was precisely this principle that we intended to breach.

In my booth, I showed works by Klapheck, Warhol, and Lichtenstein, among a few others. The biggest attraction at my stand was Tinguely's *Balouba No. 3* from 1961, named after a Bantu tribe in central Africa (p. 148). The sculpture's "machinery" consisted of scrap metal parts and found objects that rattle, jerk, and jiggle at the push of a button. Whenever it became too quiet in my booth, I pushed the button. This led Dieter Brusberg to come over from his stand to complain, "It's unfair that you always make such a hell of a noise. People run out of my booth—to where the noise is. To you." And I said to him, "I can't help that. That's part of the machine." Today, *Balouba No. 3* is in the collection of the Museum Ludwig.

The commercial success of the first contemporary art fair was also enormous. A total of 1 million marks in sales was recorded between September 13 and 16, 1967. We all sold magnificently. The record was set by Hein with Ernst's painting *Der blaue Mond* (1956), which he sold to a private collector for 65,000 marks. Klapheck proved to be a big hit at the fair, and on the very last day, the Berlin-based gallerist Rudolf Springer bought his painting *Das Gesetz des Alltags* (1960) from Brusberg for 3,500 marks and immediately re-offered it for 5,500 marks. This was a vivid demonstration of the laws of the market! On the closing evening, the participants met for a last glass of beer in the cellar of the Gürzenich. I was the last to arrive, as I was finishing some work upstairs in the main hall. When I entered, all the gallerists stood up and applauded. It was an unforgettable moment for me, that my colleagues, who were, after all, also my competitors, were applauding me. We had given birth to the first contemporary art fair—Kunstmarkt Köln, known today as Art Cologne—not knowing that this would revolutionize the gallery business and the art trade in general.

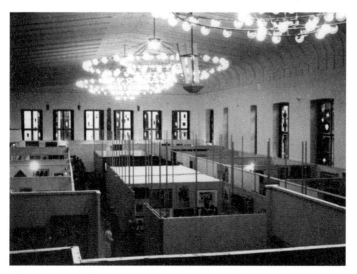

The Kunstmarkt Köln in the ballroom of the Gürzenich, 1967

As we all had hoped, we were able to acquire new customers and were no longer dependent on the four or five collectors we already knew. As late as the 1960s, a gallerist was only on the safe side if he or she had more than six collectors who could each spend roughly 20,000 marks a year. If three or four of those collectors went on a shopping spree abroad, things would get tight. The first Kunstmarkt Köln opened the door to meeting new types of collectors, similar to what we experience today with the globalized art market. In my time, Japanese collectors were just beginning to enter the market, and those from the United States were becoming more and more numerous. Today, the whole world collects on a grand scale in London, New York, Hong Kong—wherever the international fairs are.

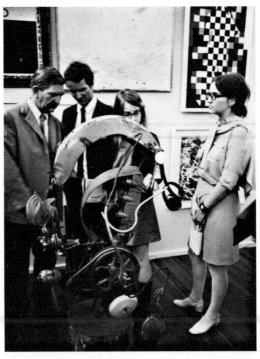

View of Jean Tinguely's *Balouba No. 3* (1961) in the Galerie Rudolf Zwirner booth at the Kunstmarkt Köln, 1967

The concept of the Kunstmarkt Köln was immediately copied elsewhere, and competition quickly arose in the neighboring city of Düsseldorf—competition, however, that soon led to an amicable agreement. It was more difficult to compete with the Art Basel fair, which was launched three years after our premiere in Cologne and corrected many of our initial mistakes. When we kicked off in 1967, we were nationally focused and had not yet fully recognized the enormous potential of a trade fair for contemporary art and had as a result wrongly excluded foreign gallerists, from whom we often obtained our works of art. At the time, we still believed we could do the business all on our own. But our vision did not extend farther than Munich. Another fundamental error was limiting the number of participants to eighteen galleries. The idea was that visitors should be able to see everything comfortably on one day and be able to remember individual works in order to make decisions. Following the success of the first event, we should have immediately enlisted the help of the city's head of cultural affairs to draw up a cooperation agreement with the Koelnmesse, Cologne's trade fair company. Art Basel recognized these shortcomings, worked directly with the Messe Schweiz, the Swiss trade fair company with its headquarters in Basel, and, at its premiere, admitted 113 galleries and publishers from ten countries—although the number of visitors, at 16,300, did not greatly exceed that of Cologne. The Swiss also got it right with their choice of date in June, just before the summer break, instead of in autumn, cleverly positioning the fair after the important international modern and contemporary art auctions and making it a fixed point on the itinerary of American collectors who came to Europe for the openings of the Venice Biennale and Documenta in Kassel. For the inaugural fair in Cologne, we did not even have the American collectors in mind, because as late as the second half of the 1960s, they were still avoiding traveling to Germany and were hardly interested in German artists.

Art Basel was a resounding success from the very beginning, with sales at the first edition amounting to 5.8 million

Swiss francs. It was hard to beat as a competitor—not only because Basel was already a well-established center for the art trade, but also because many companies' finances were managed through Swiss accounts. In order to put Art Basel in its place, we forced the foreign gallerists to make a decision with regard to future participation—either Cologne or Basel, but not both. Although Castelli and Sonnabend decided in favor of Cologne, this did not put a damper on the growing success of Art Basel, just as it did not stop other fairs from popping up in cities across Europe. FIAC in Paris was launched as early as 1974.

In 1974, the European Art Dealers' Association, founded in the wake of the fairs, also called for an abolition of art fairs in the long term, since business was gradually shifting from the galleries to the fairs. Collectors preferred visiting the fairs and abandoned their ties to a single dealer. The works increasingly became a commodity for them as well, which they bought wherever it was offered at the lowest price, without considering that this meant galleries' physical locations began to lose importance. The transparency of the prices also increasingly led collectors to auction houses, which until the 1970s were visited primarily by dealers. And with the commercial success of the fairs, auction houses redirected their holdings toward contemporary art and its collectors.

Prices gradually became the dominant topic of discussion, and the press began to report primarily on this development. In 1970, Willi Bongard, once a stock market editor at the *Frankfurter Allgemeine Zeitung*, published his Kunstkompass (Art Compass) for the first time in the business magazine *Capital*, featuring a list of the one hundred most successful artists, a list that is maintained to this day—with Gerhard Richter at the top of the list for more than fifteen years, as of 2020. Until 2005, this barometer of fame, which is calculated based on a system of points for exhibitions, sales, and publications, appeared regularly in the autumn, just in time for the Cologne art fair, thus influencing the buying behavior of collectors there. When, in 2006, Gérard Goodrow,

the director of Art Cologne, announced that the fair's date would shift to the spring, Kunstkompass followed suit, at least for a couple of years. Art took on the status of stocks and was evaluated as such by Bongard and others. As a result, people who were not interested in art began to view contemporary art as an investment; since the 1980s, corporations such as Deutsche Bank have been buying art and building their own collections—either to promote their image or as an investment, or perhaps both.

When we founded the Kunstmarkt Köln in 1967, we could not have foreseen the development of a truly international market. But we did feel pressure from the very beginning. There was immediate competition in our own sphere and criticism that the Cologne art fair was not progressive enough and that it was too exclusive. The Munich-based gallerist Heiner Friedrich (later a cofounder of the Dia Art Foundation), whom we did not allow to participate because of his aggressive business tactics, presented a group exhibition titled *Demonstrative* in parallel to the fair, down the street from the Gürzenich, at the DuMont publishing house. The following year, *Prospect 68*—an international survey exhibition from avant-garde galleries—was held at the Kunsthalle Düsseldorf in the run-up to the fair, after the neighboring city had tried in vain to convince us to shift the event to Düsseldorf. For the second edition of the Kölner Kunstmarkt, as it was next called, which had twenty-eight participants, including galleries invited from New York, London, Paris, and Milan, Cologne's head of cultural affairs made the newly built Kunsthalle available. Once again, a parallel exhibition took place in the Kunstverein. The events were overshadowed, however, by a police operation on the third night of the art fair, during a screening of underground films by the group XSCREEN, including the director Birgit Hein, at the construction site of the new Neumarkt subway station. The police demanded to see the IDs of each of the approximately seven hundred attendees and confiscated the films, including those of the Viennese actionist Otto Muehl. The subsequent demonstrations

in front of the police headquarters at Waidmarkt and the temporary occupation of the opera house almost led to the closure of the art fair. In the course of all this turmoil, it was demanded that I face an "interrogation" by the demonstrators, but I didn't go. The atmosphere became increasingly heated, perhaps further spurred on by the spirit of the Ausser-Parlamentarische Opposition, a political protest movement affiliated with the German student protest movement of the late 1960s. In the art scene, radicalization was in full swing. There were heated debates taking place everywhere. "Art as a capital investment for the rich" was a catchphrase that aroused the emotions of the public, as did the question of whether it was ethically acceptable to make money from art.

Beuys rode this wave in 1970 with his protest action *Wir betreten den Kunstmarkt* (We Enter the Art Market). Additional protagonists of Beuys's art-political action included the artists Klaus Staeck, Wolf Vostell, and Hans Peter Alvermann, as well as the gallerists Helmut Rywelski and Ingo Kümmel. To keep them from disturbing the press conference held the day before the fair's opening, I simply locked the Kunsthalle's glass door right in front of them, whereupon the group knocked against it loudly with their keys. After half an hour of vociferous objections made through the closed door, Kurt Hackenberg, as head of cultural affairs, intervened, unlocking the door and allowing the demonstrators to set up an information stand in the foyer with a condolence book for the sudden demise of the Cologne art market.

That was typical of Beuys, who once again staged himself quite cleverly. The slogan "Wir betreten den Kunstmarkt" suggested separate spheres, although Beuys, who often parked his Bentley farther away and came on foot, profited from commercialization. I myself had purchased a grand piano encased in felt by Beuys from Anny De Decker at the Antwerp gallery Wide White Space's booth shortly before the opening (opposite). It stood in our basement for years like a trapped elephant before I was finally able to sell it to the

From left to right: Wolf Vostell, Helmut Rywelski, Joseph Beuys (wearing a hat), and Klaus Staeck tap their keys on the glass doors of the Cologne Kunsthalle in protest against Kunstmarkt Köln, on October 12, 1970

Joseph Beuys, *Infiltration homogen für Konzertflügel*, 1966. Grand piano, gray felt, and red fabric, dimensions variable with installation. Centre Georges Pompidou, Musée national d'art moderne, Paris

Centre Georges Pompidou in Paris. When we held exhibitions upstairs, we all sensed its presence; it simply could not be ignored. Beuys was thus a beneficiary of the fair, which he simultaneously criticized to great public appeal.

The year before, in 1969, he had already caused a stir at the art fair—this time with a sales success. On the last day of the fair, the Berlin-based gallerist René Block sold Beuys's work *Das Rudel* (1969) for 110,000 marks—deliberately matching the price paid for a Rauschenberg offered at the fair by another gallery—to Jost Herbig, the heir of the Cologne paint factory Herbol-Werke. This environmental piece, consisting of a VW bus and twenty-four sledges with felt blankets, was the first work by a contemporary German artist to break through the 100,000-mark threshold and made a significant contribution to the fair's record turnover of approximately 3.5 million marks.

The art fair finally established Cologne as a key trading center for contemporary art. Galleries were drawn to the city from all over Germany: Rolf Ricke from Kassel, Dieter Wilbrand from Münster, Hans Neuendorf from Hamburg (who later became CEO of artnet), Heiner Friedrich from Munich (who opened a second gallery in Cologne), and later Paul Maenz from Frankfurt am Main. In the year after the first fair, the brothers Christoph and Andreas Vowinckel founded the Galeriehaus Köln at Lindenstrasse 18-22, which followed the New York model where, for example, several galleries shared an address on Fifty-Seventh Street in Manhattan. Since the art fair's success led to a strong demand for gallery spaces in the city, there was immediate interest in a building that was specially tailored to exhibitions. Among the building's first tenants were Ricke, Wilbrand, Neuendorf, and Friedrich as well as Hans-Jürgen Müller, Reinhard Onnasch, and M. E. Thelen, who together published their own magazine and coordinated their openings to attract a larger audience. Willi Bongard praised the initiative as the "center of activity" within Cologne's art scene. But as early as 1972, the first tenants moved on after finding the proximity

of their competitors too jarring. In the end, the concept of the "shopping mall" gallery building did not work out. The anonymity of the visitors was no longer guaranteed, and collectors felt too closely observed on their tours through the various galleries.

Another meeting place for the art scene, and still important today, was Walther König's bookshop, which he founded in 1969. I was one of the people who inspired it. I was well acquainted with the art bookshop Wittenborn & Schultz on the Upper East Side from my trips to New York. It was located smack in the middle of various important galleries. It was an intellectual center, a magnet for the European and American art scenes, because the latest catalogues and antiquarian books were always on display there. George Wittenborn, the descendant of a dynasty of booksellers in Hamburg, had immigrated to the United States in the 1930s and, with his bookshop, created a platform for transatlantic encounters in art. I encouraged Walther König—Walther was the older brother of Kasper König and trained at the

Rudolf Zwirner and guests at dinner within Andy Warhol's exhibition
Thirteen Most Wanted Men, Galerie Rudolf Zwirner, Cologne, 1967

Bücherstube am Dom, a bookstore directly across from the Cologne Cathedral, where he later took charge of the art book department—to copy this model in Cologne. During my first years in Cologne, he often sat at our dinner table at home, when Bruno Goller and Konrad Klapheck were also guests. He bought his first Dubuffet book from me, which he paid for in monthly installments. After the opportunity to work directly for Wittenborn & Schultz in New York fell through, he opened his own business in Cologne. Strategically clever, like Wittenborn, he later moved to a location at a crossroads for gallery-goers, at the corner of Ehrenstrasse and Albertusstrasse, just up the street from my own gallery, so that people regularly stopped by his store on their way to one or another exhibition.

The art fair made Cologne the most important art metropolis in Germany, a gateway for international exhibitions, especially of pop art. In order to demonstrate my position as one of its main representatives, on the evening of the opening of the first fair, I invited key players to my gallery for Warhol's exhibition *Thirteen Most Wanted Men*. The opening became a social event, and the show itself is now considered one of the most important pop art exhibitions of 1967 in Germany.

10

The Kahnweiler of Pop Art

I had dedicated a solo exhibition to Warhol at the beginning of 1967, in which there was nothing more on view than his *Cow Wallpaper* and silver helium balloons floating up to the ceiling. Although it was not a commercial success, it had significance as an event. Warhol's refusal to serve the market triggered a debate about the position of art and the art trade. It prompted countless discussions with and among gallery visitors. The artist intentionally overstepped the boundaries that the art trade had set until then, questioning the previous forms of presentation and marketing.

To show him at my gallery again nine months later, during the same time as the Kunstmarkt Köln, the first contemporary art fair, with *Thirteen Most Wanted Men* (1967) was a clear signal. I wanted my gallery to be understood as the herald of a new era, with Warhol as its figurehead. I demonstrated this to the outside world through the avant-garde architecture of my gallery, built five years later, and my fashionable outfits. I had my suits tailored in London, including one made of green velvet, and wore my hair long. (An article titled "The Art of Making Money with Art" in the April 1970 issue of *Twen*, a popular lifestyle magazine for

the younger generation, began with a multipage interview with me and photos of a visit of mine to New York, where I am wearing a leather jacket and a hat made of genuine python leather.) Three years earlier, in 1964, Warhol had declared art a commodity with his *Brillo Box* exhibition, thus directing attention to art as an investment object. Presenting him in parallel with the first contemporary art fair, held in the Gürzenich, was also intended as an homage to the artist, who had paved the way for new forms of distribution. In my second Warhol exhibition, marketable works could now be seen. The silkscreens featuring mug shots of thirteen criminals from the United States were highly attractive. Soon, museums began to take an interest, and sales were ultimately made to public collections in Mönchengladbach and Krefeld, among others.

Warhol's images were taken from a booklet issued by the New York City Police Department titled *Thirteen Most Wanted*. He first used it as a source for a monumental project for the 1964 World's Fair, in Flushing Meadows Park, in Queens, where he placed the portraits in five rows on the facade of the New York State Pavilion building, designed by Philip Johnson. As with the floating helium balloons, this work was inspired by Duchamp, who had created *Wanted: $2,000 Reward* in 1923 before his return to Paris from New York, and which was later made as a replica in 1963. Duchamp modeled his work after a wanted poster, on which tourists could have their own portrait copied as a souvenir. In addition to his own portrait, Duchamp added his alter ego, Rrose Sélavy, as the purportedly "wanted" gangster. Warhol's *Most Wanted Men* was installed on the New York State Pavilion for one day. New York Governor Nelson Rockefeller intervened, demanding the piece be removed just as quickly as it was installed, as he feared the work would irritate his Italian electorate, given that the majority of those depicted were of Italian descent. Yet again, Warhol drew attention to himself and became the talk of the town. After consumer goods had become socially acceptable as art motifs thanks to pop, these images of wanted

men pushed one of the supreme disciplines of painting from its throne: the portrait itself.

In Germany, such alliances of art with the banalities of everyday life were well received by a new class of collectors. While Ileana Sonnabend, from whom I was able to take over this second Warhol exhibition after it went to Hans Neuendorf, was based in Paris, French collectors reacted rather cautiously to her offers, since they preferred to continue their own traditions rather than venture into new territory. In contrast, after the end of fascism in Germany and Italy, there was a great need for international connections, especially to American culture. In 1967 alone, fourteen solo exhibitions with pop art artists were held in galleries in West Germany.

At the peak of this hype, between 1967 and 1971, I held a dozen or so exhibitions with pop artists, including John Chamberlain, whose assemblages comprising crushed and manipulated car parts led to protests among the public, since he presented the Germans' most prized possession—the car—as wreckage. Passersby came into the gallery demanding, "Why are you displaying this piece of junk here?" I replied, "My dear ladies and gentlemen, who's paying for this exhibition—you or me?" And the discussions continued, "It's not art, it's junk!" The reactions were so strong that people spat at my front window. Later, Peter Ludwig purchased Chamberlain's *White Shadow* (1964)—as a vanitas symbol of a society obsessed with automobiles—which is now in the collection of the Museum Ludwig (p. 162, top).

In those boom years, I was known as "the Kahnweiler of pop art" in reference to the German-born French art dealer Daniel-Henry Kahnweiler, who had paved the way for cubism, especially Picasso. Many other gallerists in Germany were, however, also committed to pop art, especially Rolf Ricke, Alfred Schmela, and Heiner Friedrich. In 1970, eighteen solo exhibitions with pop artists were held in galleries, which then dropped to fifteen in 1971 and to four in 1972. The hype was over—not because the gallerists had lost interest in the movement, but because the works had become unaffordable.

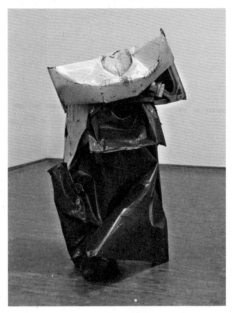

John Chamberlain, *White Shadow*, 1964. Painted and chromium-plated steel, height: 67¾ inches | 172 cm. Museum Ludwig, Cologne

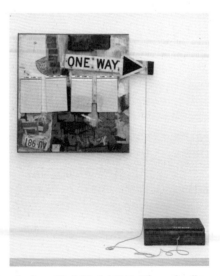

Robert Rauschenberg, *Black Market*, 1961. Oil, wood, collage, and metal on canvas, suitcase, 59⅞ × 50 inches | 152 cm × 127 cm. Museum Ludwig, Cologne

In the wake of the growing enthusiasm among German collectors, American museums began changing their attitude. Artists, too, were now demanding that their works remain in the country and that in Europe they be sold only to public collections. This naturally caused prices to rise. Sonnabend was more or less forbidden to sell pop art to German dealers. As a result, I was forced to turn more to British pop art and the next generation of American painters. In public collections, there was a similar trajectory to that of the galleries but with a slight delay. While in 1968 there were only three pop artists honored with museum solo shows, the number rose to ten the following year, and sixteen in 1971. In 1972, the boom slowed down again across museums, with only six solo exhibitions.

Sonnabend, with whom I worked closely because she had the exclusive right of representation for many artists in Europe, later honored my part in supporting pop art: "Zwirner had arranged that art fair in Cologne where pop art was quite well represented. From there on, the artists were quite well known. Zwirner did a lot for the pop artists, showing them and talking about them. And other galleries started asking for exhibitions," she told Jochen Link in the context of his research for the dissertation *Pop Art in Germany: The Reception of American and English Pop Art by German Museums, Galleries, Collectors, and Selected Newspapers between 1959 and 1972*, published in 2000. The Cologne art fair, where the large format and striking motifs of pop art were genuine eye-catchers, acted as a catalyst. The poster for the first fair was, fittingly, designed by Robert Indiana, in 1967. At the third Documenta exhibition, in 1964, Arnold Bode categorically refused to show pop art. With the fourth Documenta, which took place in 1968, one year after the fair, he finally gave in.

The year of 1968, a year of great political and cultural upheaval, saw Warhol's first European museum exhibition at the Moderna Museet in Stockholm. It then traveled to the Stedelijk Museum in Amsterdam, Kunsthalle Bern, and the Kunstnernes Hus in Oslo. The show was engineered by Kasper König, who had met the Swedish museum director

Pontus Hultén during his training with me before he moved to London and then to New York. Since the exhibition had a tight budget, König came up with the idea of having the works reprinted by the Factory on site in Sweden, in order to reduce shipping costs. He thus applied Warhol's theory of reproduction to the artist's own works and reprinted all his well-known motifs. Instead of sending the original Warhol *Brillo Boxes* to Europe, König contacted the Brillo factory in Brooklyn to order a small shipment of boxes that were then assembled on site at the museum. König printed the catalogue, with 636 full-page black-and-white illustrations and statements by Warhol, on cheap paper and in vast quantities. The now legendary catalogue was handed over to customers in a shopping bag designed by the artist. Warhol's *Cow Wallpaper*, which was on view in my gallery the year before, decorated the entire facade of the museum. The exhibition's success—including long lines despite the freezing cold, a total of twenty-five thousand visitors, and many reviews—cemented the artist's position as the most famous representative of pop art in Europe. Four months after the opening, he was shot by Valerie Solanas, a visitor to the Factory and founder of the Society for Cutting Up Men (SCUM). So began the legend of Andy Warhol.

Many of the pop artists themselves, however, regarded museums with ambivalence. Claes Oldenburg, for instance, initially refused to exhibit in museums: "Anything but the museum. I'm taking to the street," he said. His first exhibition was called *The Street*, the second *The Store*. For him, it was clear: "I'm going to open a store and sell my art like a vendor in a supermarket." His goal was for his work to be as participatory as possible; high and low should be leveled. While Oldenburg regarded the museum as an "institution of death" for art, Warhol served both factions: the public and the elite collector circles. He no longer made a distinction between department store and museum.

In the United States, the success of pop art began only indirectly. Its popularity in Europe, especially in Germany,

caused American museums to change their attitude toward this new form of art, from which they had previously distanced themselves as they—unlike the galleries—perceived it to be vulgar. The gallerists had celebrated the works of Warhol and Oldenburg as well as James Rosenquist, Tom Wesselmann, and Roy Lichtenstein much earlier. Art critics were in agreement about the importance of pop, at least in part, while the representatives of abstract expressionism and their collectors indignantly turned their backs on pop art. In 1962, the Sidney Janis Gallery, which represented both the École de Paris and pop art, caused a scandal. After the *International Exhibition of the New Realists*, organized as a survey exhibition of pop art and featuring works by fifty-four artists, Philip Guston, Adolph Gottlieb, Robert Motherwell, and Mark Rothko declared their resignation from the gallery. At a symposium on the subject of pop art at The Museum of Modern Art at the end of the same year, the opponents formed a lobby. In particular, the influence of the art critic Clement Greenberg, who dominated the scene, prevented a positive reception for pop. For Greenberg, Warhol, whose work he called "novelty art," was not an artist but merely the symptom of an era. What Greenberg disliked did not get through, at least not to museums. Also during this time, the gallerist Lawrence Rubin, who represented the abstract expressionists and the protagonists of color field painting propagated by Greenberg, presumably also exerted his influence on his oldest brother, William, who had been working as curator at The Museum of Modern Art since 1967.

Such a dogmatic attitude was far from my mind. As an art dealer, I didn't want to take sides but instead wanted to remain open. I represented both pop art and conceptual tendencies, especially minimalist art. In New York, I bought from dealers of both camps—pop art from Leo Castelli, and from Rubin and André Emmerich the color field painters championed by Greenberg. This broad spectrum later benefited me in my dealings with Peter Ludwig, because it also corresponded to his sensibilities as a collector active in various fields.

In 1963, when I traveled to the United States with the Düsseldorf Kunstverein and, with Alfred Schmela, took my first look around the New York galleries, there were already two large pop art collections: not museum or corporate collections, of course, but rather those of two social outsiders, the insurance broker Leon Kraushar and the taxi entrepreneur Robert Scull. Like the pop artists themselves, they were social climbers and art speculators. One of my most bizarre moments in New York was a visit to Scull's private apartment, on Fifth Avenue across the street from The Metropolitan Museum of Art, where he had invited me for lunch. Magnificent paintings by Warhol, Lichtenstein, and Rosenquist hung on the walls. But there was fake Chippendale furniture in the room, all covered with a cheap plastic film. The wine we drank was a so-called Spätlese, but it had more residual sugar than acid. A plastic film also stretched over the tablecloth. The contrast between the works of art and the domestic ambience could not have been greater. Outside, on the opposite side of the street, the artist James Lee Byars was standing on a box, constantly looking up at the windows of the apartment and reciting poems or texts that we could not understand. The then unknown artist presumably wanted to draw attention to himself in front of the home of the great collector.

The relatively early sales of the Kraushar and Scull collections at the end of the 1960s and the beginning of the 1970s, respectively, caused a great sensation at the time. The auctions fired up the reception of pop art not only in the United States but also in Germany, because the Kraushar works ended up going to Karl Ströher—the heir of the Wella hair care company in Darmstadt—who had previously collected postwar modernism and founded an art prize (named after himself) that honored, among others, Ernst Wilhelm Nay, Fritz Winter, and Heinz Trökes. Ströher's purchase of the Kraushar collection in the spring of 1968, its subsequent tour of Germany, and its placement two years later on long-term loan at the Hessisches Landesmuseum in

Darmstadt brought further recognition to pop artists, especially Warhol, who was represented in the collection with fifteen major works.

The acquisition itself was spectacular. During a visit to New York, the Munich-based gallerist Franz Dahlem had learned, rather by chance, through a conversation with the lawyer representing Leon Kraushar's widow that she wanted to sell the entire collection. Together with his partner, Heiner Friedrich, Dahlem then made Karl Ströher an offer to mediate the purchase of the collection for him for $425,000. In order to beat competitors in the United States, the sum was twenty-five percent higher than what the 188 artworks would have achieved individually on the market. Ströher, who wanted to restructure his postwar collection anyway, gave his approval solely on the basis of photographs of the works.

Ströher had to travel to New York to sign the contract. Shortly before the last signature with a notary public, he suddenly became hesitant and mentioned to his adviser a stamp collection that also interested him and that he had been offered for the same price. Dahlem succeeded in talking the militant nonsmoker out of purchasing the stamp collection by pointing out that the previous owner was a smoker and that the collection had therefore certainly suffered from all the smoke and nicotine. Arriving at the office of the notary public, Ströher hesitated once again. He asked Dahlem for a private conversation and demanded that he waive his commission, and in return, Ströher proposed to let the blindsided gallerist participate in the resale of individual pieces, from which the enormous sum of 1.7 million marks was to be recovered. Dahlem agreed to this in order not to jeopardize the deal. In the end, his fee for the mediation amounted to the ridiculous sum of 20,000 marks.

During these exciting days, an agitated Sonnabend called me during my ski vacation in Verbier, Switzerland, to ask, "Rudolf, did you hear? Ströher is buying the Kraushar collection!" I just said, "Yes. So what?" When the news got out, the German newspapers were in a frenzy. Under the headline

"Wella Pop" on March 11, 1968, *Der Spiegel* reported on the sale of the "world's largest pop collection." On March 15, *Die Zeit* ran the headline "Pop for Two Million," even though the correctly converted purchase price was much lower. Ströher's heirs, and in particular his son-in-law, then wanted to have the seventy-seven-year-old declared legally incompetent. After Dahlem later succeeded in persuading Peter Ludwig to purchase from the group of works for twice the price paid, the litigation was called off and the business acumen of the head of the family was no longer questioned.

Having arrived in Germany, the sensational collection went on tour under the rather sober title *Collection 1968: Karl Ströher*, first to the Neue Pinakothek in Munich, then to the Kunstverein in Hamburg, the Neue Nationalgalerie in Berlin, the Kunsthalle Düsseldorf, and, finally, to the Kunsthalle Bern. Also integrated into the exhibitions were works by Beuys, pieces by younger German artists such as Georg Baselitz, Markus Lüpertz, and Hanne Darboven, and examples of American minimalist art by the likes of Donald Judd, Walter De Maria, and Robert Ryman. During the exhibition's run, individual works from the collection were already being resold. As a result, a new catalogue had to be printed for each venue, and in many cases the illustrated works were no longer in Ströher's possession—as a shrewd businessman, he wanted to market parts of the collection from the very beginning and exploited the museums as sales floors. Heiner Friedrich and Franz Dahlem also took the opportunity to add their own gallery inventory, despite the fact that everything was exhibited under the "Ströher Collection" label. Rauschenberg, Warhol, and Lichtenstein served as their engine, followed in tow by Baselitz, Blinky Palermo, and Gerhard Richter. The strategy was by all means successful: the young German artists were ennobled, and the reception of German art also began to change abroad.

At the same time, German dealers were now receiving more attention in America. "American Pop Really Turns On German Art-Lovers" read a headline in *The New York Times*

on November 27, 1970, following an auction at the Parke-
Bernet Galleries. My bids in particular aroused suspicion:
One bidder attracted more noticeable attention and
awakened more curiosity than anyone else in the over-
crowded hall. He is Rudolf Zwirner, a 37-year-old, blond,
blue-eyed German dealer from Cologne who soars to
the staggering height of 7 feet. He is also the man who,
after furious to-and-fro bidding, walked off with two of
the landmark sale's prize pieces: a huge "Brushstroke"
painting of Roy Lichtenstein and a Claus [*sic*] Olden-
burg "soft sculpture" of kitchenware innocently called
"Stove." He also purchased the Andy Warhol "Liz" and
another Lichtenstein "Spray." For the Lichtenstein
"Brushstroke," Zwirner paid an astronomical $75,000,
as much as has ever been paid at an auction for the
work of a living American artist, and a steep $45,000
for the Oldenburg, the most the work of a living Amer-
ican sculptor has ever brought at an auction. . . . "Con-
temporary American art is one of the hottest things
in Germany," said Mr. Zwirner. . . . As a result of the
American artistic success in Germany, "things are in
a bad way on the American art scene," lamented Leo
Castelli whose gallery represents Lichtenstein. "Amer-
icans never should have let important pieces like the
Lichtensteins and Oldenburgs slip out of their hands."
But it was too late for that now. The auction marked a turning
point. Previously, works had been brought in and out indi-
vidually by white-glove porters; in 1970, however, Sotheby's
Parke-Bernet introduced a revolving platform. Five or six
paintings and sculptures were placed on it simultaneously
and brought into position in front of the audience. When the
stage turned to reveal Oldenburg's *Stove* (1962) (p. 170), an
old enamel kitchen appliance with vegetables molded from
plaster and muslin on top, there was resounding laughter
in the auction room. His sculpture was mistaken for a (bad)
joke. As a result, the work was almost bought in; there was
no other bidder besides me. Today, it is worth millions. No

American dealer bid on Lichtenstein's *Brushstroke* (1965) (now known as *Big Painting No. 6*) either, so that I was able to take it with me to Germany for the Kunstsammlung Nordrhein-Westfalen.

After the auction, the artists complained to their gallerists for not protecting their markets. When Oldenburg learned that his gallerist Sidney Janis hadn't lifted a finger, Janis called me that very same night with an obviously guilty conscience: "You were the one who bought the great Oldenburg. Could we swap? I have two Klaphecks which you can have in exchange for the Oldenburg." Lichtenstein also complained to Castelli that he was to blame for the fact that his

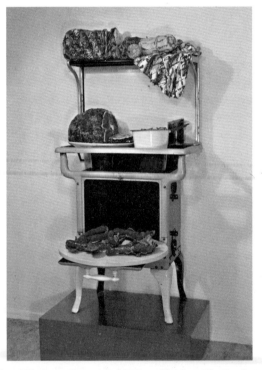

Claes Oldenburg, *Stove*, 1962. Muslin and burlap soaked in plaster, painted with enamel, utensils, and stove, 57½ × 28⅜ × 27½ inches | 146 × 72 × 70 cm. Kunstmuseum Basel, on deposit from the Peter and Irene Ludwig Foundation, Aachen

Brushstroke was going to a provincial town in Germany instead of Washington, DC; Los Angeles; or The Museum of Modern Art. With this auction, the interest in pop art in the United States became livelier than ever; and from then on, prices soared. Soon, American museums also began to enter the market.

Three years later, the auction of Robert Scull's collection benefited from this. It was the first time that an entire pop art collection was offered as a whole, and together with works by abstract expressionists. It was a test of the market. Nobody really believed it would work. Not even Peter Ludwig, who, to be on the safe side, left the bidding to me. Although many works were bought in, the auction was still a success. The total result for Sotheby's was more than $2.2 million, to which I had proudly contributed. For Jasper Johns's *Painted Bronze*, two Ballantine beer cans on a small plate, I successfully bid $90,000: a world record for a sculpture by a living American artist. Ten years earlier, the taxi entrepreneur had paid only $960 for it.

As a result of the Scull sale, auction house clientele had changed. The dignified atmosphere became a thing of the past. At Sotheby's, Scull's wife wore an ordinary T-shirt with the inscription "Scull's Angel." Suddenly, there were trend-setting socialites, such as Lee Radziwill, the sister of Jacqueline Kennedy, with her entourage. It also became louder in other respects. Rauschenberg stood farther back in the auction room with other artists and made a ruckus. At the top of his voice, he badmouthed Scull as a "vulgar capitalist" who, as he saw it, was gleaning profit from his work. Whereas in the United States pop art was initially the art of social climbers who boasted of their collections and successful resales—such as Kraushar in a report in the July 1965 issue of *Life* ("These pictures are like IBM stock")—the new pop art collectors in Germany represented a completely different type. They aimed to bring their collections into the museum—for reasons of prestige, but also to make the art accessible to a wider public.

It was thus a visit to a museum exhibition that eventually led Peter Ludwig to become the largest pop art collector in the country. Even before the fourth Documenta exhibition and the Ströher Collection's tour of Germany, Wolfgang Hahn—also in the decisive year 1968—presented his own collection, including works of nouveau réalisme, Fluxus, pop art, Beuys, and Richter, in the Wallraf Richartz Museum in Cologne. The show was accompanied by a comprehensive catalogue. All this caught the attention of Ludwig, who had had a look around at Kunstmarkt Köln the year before. He himself had been collecting modern art for years and had hardly received any public response, not even with the very expensive works of the École de Paris that he had acquired for the Suermondt Museum in Aachen, which was renamed the Suermondt Ludwig Museum in 1977 after Ludwig and his wife, Irene, donated 193 works of art from the Middle Ages and modern times. In contrast, Hahn, a midlevel museum employee with a modest salary, had managed to compile a notable collection that ended up causing a sensation in Cologne's most important museum.

The works by artists such as Nam June Paik, Daniel Spoerri, and Jean Tinguely, which many had previously considered "rubbish," suddenly made a new impact. The same could be said of works by Rauschenberg and Lichtenstein. And even Beuys, ever the strategist, had smuggled himself into the exhibition shortly before the opening by giving Hahn a work of his own: the door of his former studio in the Heerdt district of Düsseldorf, charred after a fire, with rabbit ears and a heron skull, which is now in the mumok – Museum moderner Kunst Stiftung Ludwig Wien in Vienna. For Ludwig, this must have been something like a hunting call: art that, up to then, had been widely viewed with suspicion had now been given the museum's blessing. And he decided he would be the winner in this field. That same year, he appeared on the scene as a bulk buyer of pop art and, as a result, also began to play an important role in my own life. Within a few months, he acquired works by Lichtenstein, Oldenburg, Warhol, and

Rauschenberg. As early as mid-November, Cologne's head of cultural affairs and the director of the Wallraf Richartz Museum were able to announce that the Aachen-based chocolate manufacturer had chosen the city for a permanent loan of seventy works by American, English, French, and German artists of postwar painting and sculpture, which were handed over the following year.

11

Peter Ludwig

Shortly after the opening of the exhibition of Wolfgang Hahn's collection at the Wallraf Richartz Museum, Peter Ludwig visited me in my gallery for the first time. I did not yet know of him and was astonished by his large stature, at more than six feet tall, and his ability to dominate a room with his authority. I immediately sensed he was used to making decisions. I had not yet caught sight of his Mercedes with a chauffeur directly in front of the door. Ludwig examined the pictures one by one and asked: "Who made this?" "Warhol." "How much is it?" "Four thousand marks." The next one: "Who made this?" "Lichtenstein." "How much is it?" "Eight thousand marks." "And who made this one?" "Rosenquist." Then he said goodbye without any further commentary. Full of optimism, I assured my astonished wife, "He'll come back." Perhaps this anonymous visitor already knew what was hanging on the walls. Only much later did I learn that, at that time, Ludwig was already a customer of Ileana Sonnabend's, from whom he acquired works of a completely different caliber. It is quite possible that he planned to visit her in Paris to compare prices.

And indeed, Ludwig returned about two weeks later.

In the meantime, I had made inquiries about him and found out who he was: the proprietor of a chocolate manufacturing empire based in Aachen that included the Trumpf

and Lindt brands. He was also a trained art historian who had written his doctoral thesis on Picasso's image of man, and a passionate collector with a wide range of preferences. Ludwig was equally interested in antique sculpture and medieval stained glass, porcelain, and ceramics as he was in the École de Paris and contemporary American painting. He shared a passion for art with his wife, Irene, whose family business he joined as a young man after they married. The two met while studying art history in Mainz. The desire to create their own museum was perhaps also due to the fact that they did not have any children, and Ludwig wanted to leave something behind. Through his acquaintance with Hermann Schnitzler, the director of the Museum Schnütgen in Cologne, he had already placed works of medieval art and handicrafts from his expansive collection on permanent loan in a Cologne institution. The Suermondt Museum, in his hometown of Aachen, also benefited from Ludwig's generous gifts. Ludwig had, however, thus far not received public recognition, such as that which Wolfgang Hahn enjoyed with the exhibition of his collection at the Wallraf Richartz Museum.

On his second visit to the gallery, Ludwig began playing the same game: "Who made this?" "Warhol." "How much is it?" "Five thousand marks." He was taken aback. "What? Last time, you said four thousand marks." This continued with the other works: the prices had all gone up. And Ludwig had remembered every single one. When he asked me indignantly why the prices had increased over such a short time, I simply replied: "Because I said so. And because it costs me more and more to buy new works." This was in keeping with the facts, as since the Kunstmarkt Köln the year prior prices had developed dynamically. Nevertheless, the prices were still moderate. For most artists, they were around $10,000, for more famous artists, $20,000, and for Jasper Johns and Roy Lichtenstein, they were far above that. Only Jackson Pollock was beyond my reach. Ludwig grumbled, but then he said, "Okay. I'll take this one, and that one as well." They were rather weak paintings,

including the small Warhol portrait of Jackie Kennedy—but
that evaluation would change in the future. Being the busi-
nessman that he was, Ludwig naturally also demanded a
generous discount. And thus began our mutually fruitful
working relationship.

As part of our first deal, I was to deliver the pictures to
him personally on the following Wednesday at four o'clock in
the afternoon. "Be on time!" There was, of course, an accident
on the autobahn between Cologne and Aachen, and I was fif-
teen minutes late. As a welcome, Ludwig explained the rules
to me: "Mr. Zwirner, if you want to continue working with
me, you must be punctual. I do not like delays." He did not
accept my reasoning for the delay and suggested that, next
time, I come to Aachen the night before and stay overnight
at a hotel, just to be on the safe side. I then understood how
he ticked and how I had to deal with him. I never stayed in
a hotel in Aachen, but rather left an hour earlier on my next
visits and, if I arrived too early, had a cup of coffee in the city.

When we began working together, Ludwig had already
conceived and developed his plan to collect on a grand scale
for the Wallraf Richartz Museum. And with his foresight,
he had recognized the beginning of a new era and was con-
vinced that pop art would one day become as important as
the modernist styles of cubism, expressionism, and surreal-
ism. Pop art appealed to him because it corresponded to his
own entrepreneurial thinking: one of his guiding principles
was, "It's the packaging that counts, not the content." This
also applied to pop art: it was not about intellectual content
but about perception—as loud, colorful, and garish as possi-
ble. Commercially adept, he also foresaw that this art would
become not only more important but also more expensive,
because the United States—with a completely different pur-
chasing power—was behind it. With his fortune as a choco-
late manufacturer, he wanted to participate.

I later experienced during our visit to Lichtenstein's
studio in New York how deliberately Ludwig proceeded and
with what determination. There, Ludwig was particularly

interested in an early portrait of a girl hanging on one wall (below). The artist declined Ludwig's offer to purchase it, saying, "This particular painting is not for sale. It belongs to my wife as a kind of life insurance for when I die." To which Ludwig replied, "That's a very clever idea. Instead of paying $200,000 for it, I'll offer you $400,000 and will invest the money for you in Switzerland." Ludwig acted as if he were a ruthless politician. Not only did he take Lichtenstein and his wife by surprise, he set the price himself. He knew the market value and simply doubled it.

When we went outside, I said to him, "Mr. Ludwig, you're completely disrupting the market. It's not good for you to double prices." He replied, "From today on, not only Lichtenstein but all other pop art artists will achieve double prices. I assure you, Mr. Zwirner, we are not three steps away from the studio yet, and Lichtenstein is already calling Warhol and Rauschenberg to tell them about it." And that's

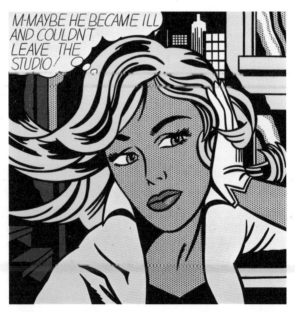

Roy Lichtenstein, *M-Maybe (A Girl's Picture)*, 1965. Magna on canvas, 60 × 60 inches | 152 × 152 cm. Museum Ludwig, Cologne

exactly what happened. A little later, the prices of the other painters doubled as well. We walked on to Rockefeller Center, over the entrance to which the adage was written, in capital letters: WISDOM AND KNOWLEDGE SHALL BE THE STABILITY OF THY TIMES. We talked about the Rockefellers' claim to architectural power in downtown New York, but he came back to the topic of Lichtenstein: "Mr. Zwirner, listen carefully to what I am telling you now. Less than ten years from today, the paintings will cost a million, because it is American art, and America will buy its own art. After all, they are American artists who will one day be as respected as these founding fathers here." He was right. Today, the paintings are worth well over $50 million each.

Soon after his first visit to the gallery, Ludwig and I formed a finely tuned team. The chocolate manufacturer chose me as his preferred art dealer because I offered important works of art, was fast, gave discounts, and acted dynamically on the market, all of which was in keeping with his own temperament. He appreciated my independence of thought and my taste, and especially my commercial acumen: I bought, priced, delivered, and framed. I not only procured the pictures but placed them in an art-historical context. In this, I differed from other gallerists, such as Alfred Schmela, who, as a former artist, argued rather emotionally and convinced his collectors through such emphasis. In bringing in my knowledge of art history, I could establish connections among artists, such as between Warhol and Duchamp, and was often, derisively, called Herr Professor by my colleagues. Wolfgang Hahn, whom Ludwig appreciated as a connoisseur, may also have played a role in Ludwig's choosing me as his adviser. Hahn would call Ludwig when he thought he had discovered something interesting for him in my gallery, which quickly reinforced the relationship between Ludwig and my gallery. The number of his acquisitions far exceeded the capacity of his private rooms, as he always bought works with a public institution in mind. In his villa in Aachen hung paintings by Léger and Picasso, and other classic works; there

was furniture from the Gothic period to the present. Ludwig wanted to fill entire exhibition halls with his bulk purchases of pop art. I therefore advised him not only on individual acquisitions but also on how to raise the profile of his collection.

Through my connections, I acquired a great number of artworks for him on the secondary market. And, in turn, my connection to Ludwig contributed to the many attractive offers I received. After all, the largest pop art collector in Germany was behind me, and he was making plans for a museum. The New York–based gallerist Ivan Karp advised me to contact the costume jewelry manufacturer and collector Victor Ganz. He owned two Rauschenbergs that might be a good fit for Ludwig. Ganz and his wife, Sally, were best known as great Picasso collectors. Their "love affair with Picasso," as Ganz called it, had begun in 1941 with the purchase of *Le rêve* (1932) for $7,000; after Sally's death in 1997, it was auctioned at Christie's for $48.4 million. In March 2013, it sold to the hedge fund manager and collector Steven A. Cohen for $155 million.

The next time I traveled to New York, I paid a visit to the Ganzes in their impressive duplex apartment in Manhattan overlooking the East River. In addition to works by Rauschenberg and Picasso, I saw pieces by Eva Hesse, whom they had begun to collect after Picasso and pop art became too expensive for them. At the time, I still had no feeling for Hesse's art, but I immediately recognized the two pieces by Rauschenberg—the sculpture *Odalisk* (1955–1958) (p. 182) and the painting *Black Market* (1961) (p. 162, bottom)—as major works, each worth $100,000. They would become groundbreaking references for later artists, such as the sculptor Gary Kuehn, who took up the mix of materials and the combination of hard and soft. With *Odalisk*, Rauschenberg quotes the famous painting by Jean Auguste Dominique Ingres, *La grande odalisque* from 1814. Rauschenberg's sculpture was full of sexual allusions—the cushion at the bottom is all but penetrated by a table leg topped by a makeshift box, the inside of which is illuminated by four light bulbs, flashing on

and off in white and blue; the crowning glory is a stuffed white-feathered rooster.

Ganz told me that he was selling the two Rauschenbergs to pay his debt to the Parisian dealer Daniel-Henry Kahnweiler for his Picassos—and then he told the whole story: A few years earlier, he had wanted to buy a painting from the series *Women of Algiers*. But Kahnweiler had said this series could be purchased only as a whole. Ganz then bought the series under the condition that he would be allowed to visit the artist in his studio and pay off the paintings over the course of several years. During his meeting with Picasso, Ganz confessed to the artist that he was only able to acquire the entire series with considerable financial difficulties, and that he had initially been interested only in one painting. In response, Picasso laughed and said, "That just goes to show you what a sly dog Kahnweiler is." It would, of course, have been possible to purchase individual paintings from the series.

And now Ganz had to part with his Rauschenbergs. I asked him not to offer the works to anyone else; I would convince Ludwig. Ludwig was pleased, but at the same time reacted cautiously, as he always did: "Yes, that might interest me. See that you get it." And thus began my dilemma: Which of the two works should I choose? And if I bought both, who would take the second?

I tried to win Ganz over by arguing that his Rauschenbergs would in all likelihood end up in a museum, although I couldn't guarantee this; in any event, I would indeed be able to do something for Rauschenberg. The risk of the transaction rested solely on my shoulders. I conducted the negotiations, acquired the works, and had them delivered to my gallery—only then did Ludwig give his consent. Today, *Odalisk* and *Black Market* are in the Museum Ludwig.

As proof that the price was indeed fair, Ludwig would typically demand that someone else pay this sum first. This was a comfortable starting position for him. He just sat back, gave me a small commission for mediating the deal, and had a guarantee for the quality of the work, demonstrating rich

people's fear of being taken advantage of. Ludwig never bid at auctions either; nor did he give me any guidance with regard to how far I could go with bids for him. The fact that I did not cultivate collectors apart from him would prove fatal for me after our collaboration eventually came to an end.

But my disillusionment was still to come. In the first year of our working relationship, Ludwig bought rapidly: every day one painting, every week he came to see me, and once a month he flew to New York to make purchases from Leo Castelli as well. "I had to make purchases there, so that I could get first choice," he explained to me afterward. "'Mr. More' is coming," it was soon said in New York when Ludwig went shopping in galleries and studios. He asked me to mediate a purchase for him at the fourth Documenta, somewhat nonchalantly: "Try to get something from Kenneth

Robert Rauschenberg, *Odalisk*, 1955–1958. Mixed media on wood structure mounted on four casters, 83 × 25¼ × 25⅛ inches | 210.8 × 64.1 × 63.8 cm. Museum Ludwig, Cologne

Noland." I would never have acquired the American color field painter's giant format for my gallery, but I was happy to satisfy Ludwig's hunger for pictures. Just one year later, on February 19, 1969, he gave one hundred works to the Wallraf Richartz Museum on permanent loan. The catalogue, designed by the German Fluxus artist Wolf Vostell and published by DuMont, had a large print run—by 1971, a total of thirty-three thousand copies sold—and made an enormous impact in the United States, where dealers and collectors passed it around. From then on, Ludwig was regarded as an authority by American museum curators, who saw him less as a chocolate manufacturer than as an art historian and colleague. Through Ludwig's commitment, pop art was further appreciated in the country of its origin.

Ludwig made many adventurous purchases. In 1968, for instance, I learned through Ivan Karp that Henry Geldzahler, the curator for twentieth-century American art at The Metropolitan Museum of Art and a friend of Warhol's, wanted to part with a painting by the artist. It was, however, no ordinary painting: *129 Die in Jet! (Plane Crash)* from 1962 (p. 184, top) was the last picture Warhol painted by hand before he switched to silkscreen printing. In his later works, it was no longer possible to clearly distinguish what part Warhol played in them versus what work had been done by the employees of his Factory. Through Geldzahler, *129 Die in Jet!*, the first of Warhol's disaster paintings featuring car crashes, electric chairs, tragedies, and catastrophes, also had an excellent provenance. When I went to visit the Metropolitan's curator in his tiny apartment, he was not at home, but I was allowed to look at the painting alone: the contemporary icon hung over Geldzahler's rumpled bed. I bought it from his bedroom, and Ludwig took it immediately.

With Jasper Johns's *Passage* from 1962 (p. 184, bottom), Ludwig made me wait longer and repeatedly tried to undercut my price. The circumstances under which I was able to acquire the painting were interesting in and of themselves. In 1974, at a Sotheby's auction, the Swiss gallerist Georges Marci

Andy Warhol, *129 Die in Jet! (Plane Crash)*, 1962. Acrylic and pencil on canvas,
100 × 72 inches | 254 × 183 cm. Museum Ludwig, Cologne

Jasper Johns, *Passage*, 1962. Encaustic and collage on canvas with objects,
54⅜ × 40 inches | 138 × 102 cm. Museum Ludwig, Cologne

de Saqqarah offered me the painting for 160,000 marks. I flew to Gstaad to view the major work on site and bought it immediately. Johns, the most intellectual of the pop artists, for whom content and form were inextricably linked, had condensed his entire project in one work, *Passage*, the title of which is to be understood literally. In the painting, he interweaves the most diverse references within his own oeuvre as well as references to works by other artists. I agreed with Marci that I would pay as soon as I had proof that the painting had been delivered to a forwarding agent. A few days later, my forwarding agent in Cologne received the news that the Johns had been sent on its way by a Swiss company. I then gave my bank the order to transfer the amount. That day, however, a customs officer at the airport in Frankfurt am Main discovered that the crate was empty. My immediate phone call to the gallerist was initially fruitless, since Marci had allegedly traveled to Tokyo. Fortunately, I reached the bank before the amount was withdrawn. Shortly thereafter, the gallerist called from Gstaad and demanded an explanation as to why the money had not been transferred. When she heard about the empty crate, she was surprised and promised to clear up the incident. We agreed that payment would now be made only after a carrier of our trust had taken delivery of the painting.

But when the costly work finally arrived in Cologne, Ludwig wanted to pay only the purchase price and not my asking price of 200,000 marks. The stalemate lasted for months. Time and again, Ludwig asked to see the painting but would still not accept the price I was asking for it, knowing full well that I was dependent on him as a buyer. Since I urgently needed the invested money to buy new works, I considered another strategy. I used the summer break to prepare an art-historical lecture on Johns's *Passage*, and in September I invited a select circle of guests to my presentation. Positioned on an easel, the painting was the only artwork in the otherwise empty space. Ludwig appeared fifteen minutes before the lecture began and again offered the purchase price of 160,000 marks. I then told him that my asking price of 200,000 marks

would be valid only before the lecture, and after it would rise to 250,000 marks, since the significance and thus the value of the painting would be obvious to everyone in attendance.

The gallery space began to fill up as Wolfgang Hahn and other collectors arrived one after the other. Just when I was getting ready to greet the guests and start my presentation, Ludwig walked up to me and whispered discreetly, "The painting has been bought. For 200,000 marks." No sooner had the lecture ended—the guests were still standing together with glasses of sparkling wine in their hands—than Ludwig walked over to his latest acquisition and explained in detail to Hahn and his wife what he had heard during the presentation. The painting now belonged to him, and the knowledge he had gained from my lecture seemed to belong to him as well.

I employed a similar strategy with Salvador Dalí's *La gare de Perpignan* (1965) (below), which, at 600,000 marks, was even more expensive and would not have found any other buyer. I had purchased it from the Parisian dealer André-François Petit, a specialist in surrealism who had acquired it

Salvador Dalí, *La gare de Perpignan*, 1965. Oil on canvas, 116⅛ × 159⅞ inches | 295 × 406 cm. Museum Ludwig, Cologne

from an estate. This time, I invited only Irene and Peter Ludwig, as well as Ludwig's best friend, a urologist from Aachen, and his wife to a small dinner in the gallery. The enormous painting, roughly ten by thirteen feet, hung on the wall, and the table set for the five of us was positioned directly in front of it. There were oysters and champagne.

This key work, which today is one of the most popular pictures in the Museum Ludwig, is not only full of art-historical, christological, and geographical references but also contains barely veiled erotic, even pornographic allusions. In my lecture this time, I referred in particular to the latter, since Ludwig enjoyed such delicacies. Irene writhed with every detail, such as the references to the fork and the sack. Her husband, however, was clearly won over. The next day, he called to tell me, "Mr. Zwirner, it's bought." Alongside Kazimir Malevich's *Suprematism No. 38* (1916), which I purchased from the American collector and oil magnate Armand Hammer, Dalí's *La gare de Perpignan* became Ludwig's most expensive acquisition through my gallery.

Ludwig, who otherwise lived a rather reclusive life, enjoyed attending social events at my gallery, including lectures, concerts, and dinners, which he liked to attend with his wife. He once traveled from Aachen to Cologne for a chamber concert with an excellent violinist and pianist, followed by a seated dinner for one hundred guests. He was so enthusiastic about the violinist that he wanted to meet her personally. During intermission, he came to me and demanded that I declare the concert finished and begin serving dinner so that he could speak to her right away. I told him that this was not possible: the program was printed and would be carried out as planned. He replied, very seriously, that it would not get any better after the break, and that Karajan also played only two pieces. But I remained firm. Ludwig the power-monger strove to exert his rule even in my own gallery, but alas, in vain. This was my territory.

I reached my limit, however, when Ludwig unexpectedly visited the gallery one afternoon and came to see me in my

private rooms on the upper floor. Hanging on the wall there was a cubist still life by Picasso: *Au bon marché* from 1913 (below), which was not for sale because, for me, it represented a bridge to pop art, and I had a special association with it. Picasso had integrated advertising lettering into the collage, linking high and low with each other in a way that many representatives of pop art would later do. I discovered the picture in an exhibition organized by the New York–based art dealer and collector Eugene Thaw. When I asked the gallerist, he confirmed that it was for sale; the widow of the previous owner wanted to part with it. When I expressed my interest, Thaw simply said, "Take it with you." Despite the fact that I had neither a checkbook with me nor insurance, Thaw insisted that nothing would happen. I took the painting with me on the plane back to Cologne in a large suitcase. When Ludwig discovered it by chance in my private rooms, he wanted to buy it immediately. He would not accept no for an answer. "You're a dealer," he argued and threatened me in no uncertain terms: "If you don't sell me the painting, we're through. This will be the last time I come here." I had

Pablo Picasso, *Au bon marché*, 1913. Oil and paper on cardboard, 9¼ × 12¼ inches | 23.5 × 31 cm. Ludwig Collection, Aachen

no choice but to give in. Ludwig had clarified the balance of power between us.

I was more dependent on Ludwig than he was on me—that was obvious. I again experienced the danger of relying too much on one collector during my mediation of the important "Beuys Block" from the Ströher Collection, which comprised almost all of the artist's early work. The heirs had chosen me as their adviser and gave me ninety days to sell this major group of works, which had been in the Hessisches Landesmuseum in Darmstadt since the artist personally installed it. There was one stipulation, however: the buyer had to be a public collection. Of course, I immediately thought of the new museum building in Cologne by Peter Busmann and Godfrid Haberer, which was to be built right next to the cathedral and house both the Wallraf Richartz Museum and the Ludwig Collection under one roof. Irene and Peter Ludwig had provided the foundation for the new building in 1976 with their donation of 350 works, mainly of pop art. The double museum was to open almost a decade later.

To me, the juxtaposition of American art of the 1960s with such a significant body of work from the same period by a European artist seemed ideal. The concept for the museum could still be amended to accommodate this change. Beuys agreed, not least of all because of the Roman foundations beneath the museum, which anchored both American and European culture. At that time, I had no idea that Ludwig no longer had the means to pay the sum demanded by the Ströher heirs. I relied on him and had conversations with Beuys instead of entering into negotiations with other museums, such as the Kunstmuseum Basel. I promptly experienced my Waterloo in the Hotel InterContinental near my gallery, where the final decision to purchase the works was supposed to take place. I took Wolfgang Hahn with me as my second. Ludwig was accompanied by his wife, which gave me an inkling of the difficulties I was about to face. I explained to Ludwig the concept of integrating the Beuys Block into the museum once again and made the purchase palatable to him

by saying that the drawings alone were worth millions, and the artist would allow them to be resold. Irene then joined in the conversation: "Mr. Zwirner, why does it always have to be Peter? Peter, Peter, Peter. Can't you sell to someone else? You just want to make money." I replied, "Madam, you will pay the heirs the price I mentioned. I'll make nothing if I don't get a commission from your husband. But that's not at issue here. It's the importance of the work and a great opportunity." Now Ludwig took the floor: "Mr. Zwirner, my wife is right. Beuys is a member of the Green Party, and no public museum will buy this collection." All I could say was, "Mr. Ludwig, we obviously operate on different levels. It's not about party affiliation but about the spirituality of a collection. You'll see, the Beuys Block is going to a museum."

And that's exactly what happened. The state of Hesse paid the sum, plus more, to keep the Beuys Block in Darmstadt. But I was crushed. I thought it quite possible that this was some sort of payback for an insult that I had inflicted on Irene during another negotiation in my gallery. She had mocked a painting by David Hockney and said, "My daughter could do that too." I quickly replied with a statement that I had heard so often from others: "Your daughter couldn't do that, because you don't have one." This hurt her deeply, and she said to her husband, "Peter, we're leaving." Their car and chauffeur were right outside the gallery. In the doorway, Ludwig turned around and said without further ado: "Bought." Many years later, I spoke to Irene about this incident and begged her to forgive me. She graciously accepted my apology.

In fact, Irene's intervention during the Beuys negotiations had to do with her husband's financial problems. He was overextended. How he managed to afford such enormous acquisitions had long been questioned even by fellow collectors, especially Bernhard Sprengel, who, although he was not a pop art customer, did buy works by Sam Francis. Sprengel once said to me: "Mr. Zwirner, I am also a chocolate manufacturer. How does Ludwig finance all this? Chocolate

doesn't yield profits that big." I muttered something about family fortunes and land, but I knew better. Ludwig made his money with futures on the stock exchange. Together with a cousin in Toronto, who also owned a chocolate factory, and a third party in another city, the three speculated on the commodity exchange for cocoa and bet on bull and bear markets. Since they were buyers themselves, they could stockpile entire harvests and thus determine the price trend. If the price fell, they bought in bulk for their own production, and if it rose, they sold it again at a profit.

The millions earned in this way poured into the collection, not into the business. Ludwig ran his company with an iron fist and, at times, demanded social sacrifices from his employees, allegedly to avoid having to move jobs abroad. I experienced Ludwig's quick reaction to movements on the stock exchange firsthand one early morning when he rang me out of bed at six o'clock. Out of the blue, he inquired again about the price of a painting he had been interested in. It was priced at 40,000 marks. He then asked, "I have French francs. How much is it then?" Half asleep, I converted for him. Then he demanded to hear the dollar price of the painting. As soon as I uttered it, he shouted: "Bought." I didn't understand his behavior until I got a look at the day's newspaper: "The Dollar Plummets." Ludwig, an early riser, had of course seen it, surprised me with the morning phone call, distracted me with the question of the price in francs, and then struck the deal. The picture now belonged to him at a much lower price.

The failed Beuys deal marked a turning point in our working relationship. Ludwig was already reorienting himself—to Cuba, China, and the Soviet Union—where he discovered other forms of realism and got more for less money and could buy in huge quantities. In order to pay off his loans and thus pacify the increasingly impatient bankers, he had to sell something from his vast holdings and asked me, with discretion, for an appraisal of his collection of pre-Columbian artifacts, which had been on long-term loan to the Rautenstrauch Joest Museum in Cologne since 1967. I

hired a young man to take on this task and, under the seal of secrecy, make inquiries about the prices. When I handed the list over to Ludwig, I pointed out that there were obviously forgeries among the collection, that dates were not correct and could be easily clarified by tests. In view of the estimated total sum in the millions, Ludwig played down the situation: he said it didn't matter to him, that I shouldn't get upset, and that he still intended to sell, perhaps to the J. Paul Getty Museum in Los Angeles. "There's another problem," I told him. "The provenance." That changed things for him in a flash; he obviously knew that parts of his collection were from uncertain sources, and perhaps looted. If the collection were to be taken from the safe sanctuary of the museum and put on the market, all this might become public. So, when I mentioned the word "provenance," Ludwig looked at me only briefly and then said coolly, "The matter is settled. Forget it." Ludwig obviously didn't want to face this problem, in addition to the foreseeable controversy around removing the collection from the Rautenstrauch Joest Museum and offering it for sale. The subject was never mentioned again between us; he didn't even ask about my expenses.

A short time later, the Ludwigs announced the donation of their collection of pre-Columbian artifacts to the Rautenstrauch Joest Museum, where it is still housed to this day. The most recent exhibition of the collection, on view in 2012 to 2013, addressed the issue of forgeries, as the museum's own investigation identified nineteen objects from the collection, which comprises 219 pieces total, that were not authentic. The precise sources of the questionable items remain unclear. The official statement is that "the museum is currently in the conception phase for its provenance research." Since some of the Mesoamerican objects in the Ludwig Collection were acquired from the New York–based art dealer Robert Stolper, whose dubious sales had already brought provenance researchers to the Ethnologisches Museum in Berlin, the Denver Art Museum, and The Mint Museum in Charlotte, North Carolina, there is a need for further research here.

Instead of his pre-Columbian holdings, Ludwig sold his manuscript collection, which had been on long-term loan to the Museum Schnütgen in Cologne. In the spring of 1983, the spectacular sale of the entire collection for 96 million marks to the J. Paul Getty Museum was announced: it included 144 illuminated manuscripts from the seventh to the sixteenth centuries, which had been researched and catalogued by the curators of the museum over the course of many years and which had already been published in three volumes of a four-volume collection catalogue. This naturally provoked a huge outcry, and not only in Cologne. "A Patron Shirks His Responsibility" read the headline of *Die Zeit*, but the transfer was legally unobjectionable. The snubbed city, however, had to find a way to come to amicable terms with its patron, who had handed over millions of dollars' worth of twentieth-century art for the planned museum that was to bear his name (although he would shoulder no responsibility for operating costs). The official transfer of the collection of pre-Columbian artifacts to the city of Cologne took place, however, on the morning of the topping-out ceremony of the new museum for modern and contemporary art in October 1983 to cool down the situation surrounding the lost manuscripts.

During many years of controversy over the new museum building, I stood by Ludwig's side, despite accusations that he wanted to create a monument to himself and govern the cultural policy of the city. In my opinion, the museum was a great deal—given his pop art collection and the Picassos. Unlike Karl Ströher, Ludwig never considered reselling individual pieces from his collection. His acquisitions were intended to be permanent. To build bridges for the project, I invited Günter Herterich, the faction leader of the Social Democratic Party of Germany in Cologne, and Ludwig to a dinner at my home. Ludwig's personality immediately impressed Herterich, who let himself be won over to the cause, and indeed became the driving force for the project, which was controversial within his party. Since Kurt Hackenberg, Cologne's head of cultural affairs, no longer played a decisive

role in the process, Ludwig and Herterich were in constant contact with each other. At the time, there was also a fierce public debate about the building's architecture. Shortly before planning began, the Centre Georges Pompidou in Paris opened, with its flexible rooms, visible pipes and tubes, and an external escalator—a possible model for Cologne, some people thought. The architectural team of Busmann and Haberer, however, developed a completely different concept, which I liked better, with a large entrance hall and a classic open staircase. In the end, though, I was not convinced by it, since there were no large halls or magnificent entrance stairs, the kind we know from castles. With Busmann and Haberer, the visitor is led from the large hall into another corridor, where the galleries branch off to the right and left. Today, the former Wallraf Richartz Museum designed by Rudolf Schwarz, which now houses the Museum of Applied Arts, remains the better building.

Peter Ludwig in front of the former building of the Wallraf Richartz Museum
(now the MAKK – Museum of Applied Arts) and Museum Ludwig,
Cologne, 1980s

I did not participate in the hanging of the works in the museum; my task was done, my role a different one. To this day, however, it fills me with gratitude to see my part in it when I visit. In 1986, when the new building opened as a "double museum" to house the Wallraf Richartz Museum and the Museum Ludwig, it was a highlight for Cologne as a city of culture, for Ludwig the apotheosis of his collecting activities, and for me the culmination of my activity as an art dealer. I helped him to compile the collection, seeking out what had museum status: not only American pop art but also British pop art, represented by David Hockney, Richard Hamilton, and Peter Blake, the German contemporaries Sigmar Polke, Gerhard Richter, and Georg Baselitz, as well as the Italians Lucio Fontana and Piero Manzoni. Suddenly, the paintings that we had acquired over the years were visible, together, to a wide audience. At the same time, however, a weak spot in the Wallraf Richartz Museum's Haubrich collection of classical modern art became apparent. It was overshadowed by the Ludwig Collection, which dominated the new museum. When Peter and Irene Ludwig raised the prospect of further substantial donations, it became clear there would not be enough space for such an expansion. In 1994, the city commissioned Oswald Mathias Ungers to design a new building for the Wallraf Richartz Museum, which was inaugurated in 2001, and the Museum Ludwig then took sole possession of the entire building behind the Cologne Cathedral.

Ludwig had achieved what had perhaps always been his motivation: to inscribe himself in the history of the city, in the history of art. This desire for recognition also drove him to establish the other museums that followed—whether in Vienna, Budapest, Havana, Beijing, Saint Petersburg, Koblenz, Oberhausen, or Saarlouis. But that was not enough for him. His vanity was so great that he asked me to obtain awards and decorations for him. At the Vienna Opera Ball, he discovered the Federal Cross of Merit, identifiable by a shoulder ribbon. That was exactly what he wanted to have, and thanks to my relationship with the then German president,

Walter Scheel, seven years after being decorated with the Grand Cross of Merit in 1976, Ludwig received the corresponding upgrade. But even that was not enough: a few years later, Ludwig wanted to receive the Légion d'honneur, the highest distinction in France; he was, after all, the lender of important works by Warhol in the Centre Pompidou. Through my relationship with Galerie Karl Flinker in Paris, which maintained good contacts with the president's wife, Danielle Mitterrand, the wish was passed on to the Élysée Palace. But there, Ludwig was made to understand that he would have to do a little more for such recognition. Pontus Hultén, the director of the Centre Pompidou, suggested the donation of a work by Kurt Schwitters, which Ludwig then acquired at the next Cologne art fair. In this way, Ludwig also received his visible merits in the neighboring country, and the Musée national d'art moderne received the work of an important German artist.

Although I did not like them, as Ludwig's closest adviser, such activities were also my responsibility. My ambition as a gallerist to achieve only the best for him proved to be a commercial error for me and my business in general. Other collectors believed that they would be offered only what Ludwig declined—that is to say, second choice. I was considered his "purveyor to the court." In the end, however, it was all justified: as difficult as Ludwig was as a person, as much as his bargaining down to the point of free framing pushed me at times to my financial limits, it was still an incredible experience to place works in the museum.

Our paths diverged when Ludwig began to buy en masse; I could not and would not follow him in this. Others now took care of him. We also diverged when it came to the content of the works he wished to acquire. For example, I did not share Ludwig's new enthusiasm for the photorealists, with two exceptions: the Americans Richard Estes and Wayne Thiebaud. Estes in particular appealed to me because of his unusual meticulousness and refined color palette. In his painting *Food Shop* from 1967 (opposite, top), the colors

Richard Estes, *Food Shop*, 1967. Oil on canvas, 65⅜ × 48⅝ inches |
166 × 123.5 cm. Museum Ludwig, Cologne

Wayne Thiebaud, *Cake Counter*, 1963. Oil on canvas, 36¼ × 72 inches |
92 × 183 cm. Museum Ludwig, Cologne

are well balanced in an incredibly subtle way, and the three menu boards framed by bouquets appear in the snack bar display window with absolute precision. This painterly exaltation elevates Estes above all others working in the field of photorealism. Unfortunately, other collectors also discovered his qualities, so that Estes quickly became as expensive as the pop artists. Thiebaud's works are less subtle than those of Estes, but he convinced me with his constructive compositions, as in his *Cake Counter* from 1963 (p. 197, bottom). The wedding cakes on the top shelf and the smaller round cakes below are arranged geometrically, which lends the work an almost minimalist touch and distracts from the realism of the imagery. Ludwig acquired both paintings through me, and they are now both part of the permanent collection of the Museum Ludwig. During one of his last visits to my gallery, Ludwig tried to explain to me that Marcel Broodthaers was not an artist. I was not surprised by his judgment, because Broodthaers's art manifests itself on a linguistic, intellectual level, which is not easily accessible to a viewer such as Ludwig, for whom form and packaging are most important.

The break between us came when I responded publicly to a remark Ludwig had made to a journalist, that I was simply "jumping on his bandwagon," that I was positioning myself in his collection catalogues in order to resell works under the "Ludwig hallmark." When confronted by the journalist with this statement, I replied that if this were true, then what was on display in my gallery before Ludwig was inconceivable, as was the fact that pop art had found its way into the Hahn collection. Ludwig read this in the newspaper, saw it as an affront, and never let himself be seen in my gallery again.

And that was that. I had had my best years as a gallerist with Ludwig as my client. At that point, the recession was approaching. I decided to take a break in 1976 and move to New York with my family to be closer to my artists and the American market, and to think about how things could move on from here.

12

The New York Connection

With New York, I made a second attempt to go abroad, at least temporarily—not necessarily to open a new gallery there, but to take a kind of sabbatical. The oil crisis of 1973 had a strong impact on the art market, which ultimately collapsed. Although this crisis was eventually overcome, the time of the so-called economic miracle in West Germany was over. In 1975, the unemployment numbers there had exceeded one million for the first time. Instead of 8 percent, the gross national product increased by only 1.9 percent. The United States seemed more promising. Ursula and I had just gotten a divorce, and I married Ursula Weidemann, and we were expecting a baby. I thought it was time for a fresh start for all of us. Esther and David, my children from my first marriage, made the move with me in 1976. In the second marriage, our sons Titus and Maximilian were born. Titus experienced New York as a baby, Maximilian was born three years later back in Germany.

Since my first trip to New York thirteen years earlier, in 1963, I had returned regularly to the United States on business. I went there at least every three months with artists, gallerists, and collectors. In terms of activity as an art dealer,

this was the most successful time for me, when pop art was not yet recognized in the United States but already had collectors in Germany—until the Scull auction in 1973, when prices began to rise in the United States as well.

During this phase, I never traveled with Peter Ludwig; he wanted to move about independently of me in New York and make his own appointments with other dealers. If we happened to be in the city at the same time, we visited studios together only at his request. On Thanksgiving in 1969, the Munich-based photographer Guido Mangold accompanied us for a reportage for the magazine *Twen*. We met him at Duane Hanson's studio, where Ludwig bought the sculptural ensemble *Football Vignette* (1969), consisting of three hyperrealistic football players at the moment of their collision (opposite, top). As he later told us, Mangold was most impressed by Ludwig's rapid decision between two large-format paintings by Morris Louis in André Emmerich's gallery: the process lasted only five minutes. The successful day, which also included a visit to John De Andrea's studio, was celebrated rather spartanly in the evening with a visit to Horn & Hardart's coffee shop, where Ludwig invited us for donuts and coffee. Afterward, we once again parted ways. Ludwig was staying at the Hilton in Times Square, and I was staying at the Alden, on Central Park, in an apartment owned by Hertha Vogelstein, an old friend of my parents'. By chance, Ludwig and I had booked the same return flight to Germany, where he was in business class and I was in economy.

Among the most memorable studio visits in New York were the appointments at Warhol's Factory, in a more than three-thousand-square-foot loft in Manhattan. When I first came to see Warhol, around 1966, there were about a dozen young men and women running all over the loft, all well dressed. Warhol greeted me with a Polaroid camera in his hand and immediately photographed me as if I were a star. This irritated me, of course, until I noticed that he received all the other guests in the same way. I was nothing special.

Rudolf Zwirner with Duane Hanson's *Football Vignette* (1969),
New York, 1969

Rudolf Zwirner with a work by John De Andrea, New York, 1969

Peter Ludwig with an untitled 1977 work by John De Andrea,
Museum Ludwig, Cologne, 1990s

Peter Ludwig and Rudolf Zwirner in a coffee shop, New York, 1969

After this greeting, I was left to myself and was able to look around in peace at the legendary studio. There was no hierarchy in the Factory; everyone made his or her own contribution. Both finished and unfinished pictures were piled up along the walls. Two young men operated a printing press, with Warhol joining in from time to time to correct the colors. In the middle of a large room with ladders and cameras along the walls was a huge sofa: the famous red couch, on which Warhol filmed his friend Henry Geldzahler for close to two torturous hours, and on which numerous actors— including the writers Allen Ginsberg and Jack Kerouac— had sex in front of the camera for the film *Couch* (1964). In another room, there was a jukebox that was always playing music. Everyone was busy, and everyone was constantly high; only Warhol was not on drugs—he basically didn't take any. Instead, he closely observed everything going on around him. He needed the hustle and bustle so that he would not feel lonely and could concentrate on his work. Toward the evening, more and more visitors came, including Nico, the Cologne-born singer of the Velvet Underground, to gather before going out together to a club. Warhol invited me to come along, but I did not want to be part of his entourage and politely declined.

I once made an appointment with Ludwig, Ileana Sonnabend, and Leo Castelli at the Factory. We were asked to take a seat on the giant sofa in the "silver salon," the walls of which were sprayed with silver paint and the windows covered with shiny foil. There, we were shown the three-and-a-half-hour film *The Chelsea Girls* (1966), in which residents, visitors, and friends of the Factory play themselves and become increasingly aggressive. With this work, Warhol gained importance as an experimental filmmaker. My visits usually took place in the afternoon, when the hustle and bustle began. One time, as I was riding up in the elevator, I was told that Marlene Dietrich had just been there; another time, I had apparently just missed Duchamp, whom Warhol also immortalized in a film. Dalí also came to the Factory with

his wife and had himself photographed. They, too, wanted to become part of the star cult around the master and participate in the media event of Warhol, although they were well-known celebrities themselves. Later, in 1977, I saw the artist's "oxidation paintings," for which he invited people to his studio and gave them plenty to drink so they would urinate on the canvas, triggering a chemical reaction. During my first visits, I spoke directly with Warhol; later, I made the appointments with his assistant Gerard Malanga, from whom I purchased print portfolios, including the *Marilyn Monroe* series. The phase during which Warhol painted himself had already ended at this point. To obtain works from that period, I had to track them down on the secondary market.

Whenever I was in New York, I also tried to meet with Richard Lindner, who was born in Hamburg and immigrated to New York via Paris in 1941. I could speak to him in German. During our conversations, he told me a lot about his time in Munich, where he experienced the persecution of Jews by the Nazis. I had first met him at the Cordier & Ekstrom gallery on Madison Avenue, where he regularly exhibited and invited me to his studio after our first meeting. Lindner had a very critical view of his own work, and I was always surprised that he did not see himself among the top tier of American artists of the time. His highly unique style, which he developed parallel to pop art, had its roots in the new objectivity of the 1920s in Germany, which he exaggerated to grotesque caricature. Lindner was successful because he was mistakenly seen as a pop artist, although—in my eyes—he was actually an important surrealist.

My New York itinerary included visits to other colleagues. Harold Diamond, one of the most successful private art dealers, received me in his large bourgeois apartment on Central Park West. A rotating selection of paintings from the 1920s and 1930s was always on view. I was able to acquire important works of surrealism and classical modernism from him—pieces by Max Ernst, Yves Tanguy, and Joan Miró, which I was able to take home with me. Diamond was

the perfect art dealer for widows—mostly elderly European immigrants—whom he was able to charm into selling him their works of art. His wife, Hester, worked as an interior designer for New York high society and in this way provided her husband with access to collectors. When I moved to New York for a year in 1976, they advised me to enroll my children Esther and David in the private Walden School on Central Park West, which their son Michael attended; he later cofounded the band Beastie Boys as Mike D.

For me, the most important gallerist in New York was Sidney Janis, who was a generation above me and sold works by the great Europeans from the 1920s and 1930s. He and his wife, Harriet, an art historian, collected paintings by Piet Mondrian in particular. In 1967, a few years after his wife's death, he bequeathed those along with works by Picasso, Paul Klee, and Umberto Boccioni to The Museum of Modern Art. His 1962 exhibition *International Exhibition of the New Realists*, featuring artists including the Americans Roy

Richard Lindner, *Leopard Lilly*, 1966. Oil on canvas, 70 × 60 inches | 177.8 × 152.4 cm. Museum Ludwig, Cologne

Lichtenstein, Claes Oldenburg, Jim Dine, Robert Indiana, James Rosenquist, Tom Wesselmann, George Segal, and Warhol, as well as the Europeans Arman, Daniel Spoerri, Christo, Jean Tinguely, Yves Klein, Mimmo Rotella, Peter Blake, and Öyvind Fahlström, all of whom were also important to me, caused a sensation in the art world. I was also impressed by Janis's personality. On his visits to Cologne, he always wanted to go dancing in the evening, but only to bars or clubs with live music. One time, when I had finally found a suitable place for him, I had to go out and buy a necktie to get in. Janis was a gifted dancer and was immediately surrounded by ladies. Well over eighty years old, he traveled to Kassel to visit Documenta with his much younger girlfriend and danced there until well after midnight. When I danced with his girlfriend, the young woman spoke enthusiastically about Sidney as the most wonderful lover she had ever had. From then on, I had even more personal insight into the gallerist.

One of my New York colleagues I appreciated most was Richard Bellamy, who was also a close friend; we both had vacation homes in Provincetown on Cape Cod and met there regularly. Dick was six years older than me and was considered the New York "eye for the '60s." He was an extraordinarily kind, versatile, and immensely interesting gallerist, though he was less skilled when it came to the commercial side of the business. He was one of those great gallerists who saw their work artistically and only sold works by artists with whom they were also friends. In his gallery, he was the first to show Segal, Richard Stankiewicz, and Mark di Suvero. A milestone was the exhibition of Oldenburg's *The Store* in 1962. Between 1960 and 1965, his Green Gallery was financially backed by the taxi entrepreneur and art collector Robert Scull, who hoped to gain access to important works by his artists.

Through Dick, I met the abstract steel sculptor di Suvero, who then invited me to his studio. When I arrived, he was sitting up in the rafters like a bird. Despite being physically disabled, he climbed down again with unusual skill to

greet me. He had become disabled after riding on the roof of an elevator while moving lumber and getting pinned between the elevator and the ceiling. We quickly became friends, but the exhibition we planned together, which we talked about a lot, never materialized, due to a lack of funds.

One of di Suvero's most important collectors was Emily Tremaine, who perused all the galleries in the city. She and her husband, Burton Tremaine, owned a spacious apartment on Park Avenue and a large house on Long Island, where early works by Rosenquist, Lichtenstein, and Warhol hung. One particular visit to the Tremaines early on was a revelation for me. I saw a late *Boogie Woogie* painting by Mondrian and an early *Flag* by Jasper Johns hanging side by side. The works reinforced each other in their quality, and suddenly, the art-historical interconnections became evident. The white stripes on a red background and the blue field with stars in Johns's *Flag* were directly related to Mondrian's geometric constructions. Such art-historical relevance would henceforth be the benchmark for my own acquisitions.

While with Janis I discovered both European modernism and contemporary art from New York, the galleries of Bellamy, Castelli, and Emmerich as well as Klaus Kertess and Paula Cooper were important for me in learning about current developments. I did not yet recognize the significance of many of the young artists of that time. Later, I could not acquire their works because their prices had become prohibitive. This is especially true for Agnes Martin and Brice Marden. Fortunately, I learned to appreciate other artists earlier, including Dan Flavin, Donald Judd, Larry Bell, John McCracken, Doug Wheeler, and Richard Tuttle, the sculptors Paul Thek and Jonathan Borofsky, as well as Joan Mitchell and Nancy Spero.

I thus already knew New York quite well when I decided to move there temporarily with my family. I was attracted to the city not only because of the business opportunities, but also for its cultural climate. At that time, the nineteenth-century industrial buildings that housed the textile industry

Dan Flavin, *"monument" 7 for V. Tatlin*, 1965. Cool white fluorescent light, height: 120 inches | 305 cm. Museum Ludwig, Cologne

Donald Judd, untitled, 1966–1968. Steel; eight units, overall: 47¼ × 123¼ × 125⅛ inches | 120 × 313 × 318 cm. Museum Ludwig, Cologne

Larry Bell, *Untitled (Cubus)*, 1969. Tinted Plexiglas and aluminum, 18⅛ × 18⅛ × 18⅛ inches | 46 × 46 × 46 cm. Museum Ludwig, Cologne

Richard Tuttle, *Wheel*, c. 1964. Wood, 31⅛ × 30⅛ × 8 inches | 79 × 76.5 × 20.5 cm. Museum Ludwig, Cologne

Joan Mitchell, *Straw*, 1976. Oil on canvas, 108¼ × 77¾ inches | 274.9 × 197.4 cm. Private collection

Paul Thek, *Untitled* (from the *Technological Reliquaries* series), 1967. Wax, metal, paint, butterfly wings, and Plexiglas, 9 × 34½ × 9 inches | 23 × 87.5 × 23 cm. Museum Ludwig, Cologne

in SoHo were gradually being transformed into living spaces, and I rented a loft for us. I already knew of the converted factory buildings from my visits during the 1960s. They stood empty for a long time after the industry had resettled outside the city for tax reasons. The first people to move in were artists, who set up their studios there. To get to the higher floors, you had to set the industrial elevators in motion yourself by pulling a rope. Since there were no doorbells, I used to shout "Picasso! Picasso!" from the street to announce that I had arrived. Someone would then come down and pick me up. Certain floors were nearly eleven thousand square feet in size: enormous, ice-cold spaces, often with sheetrock walls at the back, behind which were beds and makeshift kitchens, living spaces hidden from view. This was all illegal in the 1960s; nobody was actually allowed to live in the lofts, because the buildings were considered industrial facilities, and there was no residential infrastructure. But as more and more artists moved in and refused to be evicted, the city administration capitulated, and the owners began to rent or sell the floors for small amounts. That was the final signal of SoHo's transformation into an artists' district—they came in droves and were soon followed by the galleries.

One example: The building at the corner of West Broadway and Spring Street with four or five floors had a ridiculously low price. The Berlin-based gallerist René Block occupied two floors and paid a total of $900. In May 1974, the Beuys performance *I Like America and America Likes Me* took place there with the participation of a coyote. It was, however, not quite as extreme as it appeared to the outside world. Beuys did not spend seventy-two hours, day and night, with the coyote in a separate room but withdrew to René Block's private floor as soon as the gallery closed its doors to the public. Moreover, the coyote was not wild but a tamed animal that Block had borrowed from a zoo in New Jersey. The performance was seen mostly by other artists; few people actually witnessed the event. I recommended it to Ileana Sonnabend, but this was in vain.

Many people seized the opportunity and bought empty factory buildings in SoHo, with which they later made millions. But I did not want to own real estate at that time nor deal with all the formalities and details; I just wanted to live in a loft. I found two floors on Broadway between Prince and Spring Streets and rented them for ten years for the symbolic sum of one dollar. But I only got the naked space and had to do everything myself. My former secretary Birgit Riedel's husband, who was in the United States, took care of the renovation. He was a designer and had contacts with various craftsmen. I bought the furniture secondhand and then settled down with my family. When we moved out again after a year, I made the two floors available as a studio to the Cologne municipal department of culture, which gave certain artists—including the sculptor Heinz Breloh, whom I later exhibited—scholarships. Peter Nestler, who had succeeded Kurt Hackenberg as head of cultural affairs in 1979, saw in it an opportunity to do something for the artists of the city, for whom it was much more attractive to spend a year in New York than in the Villa Massimo or the Villa Romana in Italy. Later, my son David lived there while studying music and then trying his luck as a drummer in a jazz band, before opening his own gallery, which is now one of the largest in the world.

A few years after my return to Cologne, I had the opportunity to transfer the New York model of the studio loft to the Rhine, at least on a small scale, by acquiring an abandoned cardboard factory in the city's so-called Belgian Quarter in 1982. In Gerhard Richter's case, having an entire floor for his large-format paintings was the decisive factor in moving from Düsseldorf to Cologne. He later had his own studio built in the Hahnwald district in the south of Cologne, but his wife, Sabine Moritz, continues to use the floor at Bismarckstrasse 50 as a studio. When I bought it, Deutsche Bank refused me any credit. They didn't understand the signs of the times, so I brought Paul Maenz and his gallery and the frame-maker Martin Laska with me in the deal. I myself maintained a branch of my gallery in the building, which I

later made available to my former intern Daniel Buchholz
so that he could try out his own program there.

The move to New York in 1976 was an adventure. From
my father-in-law, a high-ranking military man who repre-
sented the German army in the United States, I had inherited
a large Buick that he had taken with him when he returned to
Germany. I loaded it up to the roof with clothing and dishes
and had my brother-in-law, a Lufthansa pilot, send it on a
cargo plane to New York. I myself followed on a scheduled
flight and picked up the loaded car in the hangar at John F.
Kennedy Airport. After I had filled it up with enough fuel
to drive into the city, I had to make a stop at customs again,
where officials were especially interested in the wine boxes
in my luggage. My explanation that it was diabetic wine, and
that I was ill, was enough for them. I was allowed to drive on
and left them a bottle to sample. After arriving on Broadway
and unpacking, I found a gas station just around the corner,
where I would always get my gas and park—an important
factor in times of fuel shortages.

I did not really have any concrete plans for our year in
New York. In my gallery, I had never taken the time to talk
more intensively with my artists from the United States, who
had been our guests. Now I wanted to make up for that and,
above all, to get to know new ones. When artists such as
Dan Flavin, Donald Judd, or Neil Jenney stayed with us for
eight to ten days above the gallery while preparing for their
exhibitions, the conversations were usually only about or-
ganizational matters: purchase and sales prices, transport
costs, catalogues. The fact that there were no conversations
in greater depth was due also to the language barrier, as my
English schooling from the postwar period was quite poor.
I discussed a lot with Dan Graham, who also lived with us
during his exhibition setup, but hardly understood him. A
plane ticket and a place to stay within our own four walls—
that's what German gallerists were able to offer New York art-
ists in the 1960s, in addition to selling their works, of course.
None of us had any capital, and we could not afford to sign

them worldwide and guarantee them a monthly minimum of $2,000 to $4,000 like Leo Castelli, for instance. If a work sold, they got their share. Flavin, who was also very interested in art history, let me pay him with art—he was happy to take prints by El Lissitzky and László Moholy-Nagy from their famous *Prouns* and *Constructions* portfolios, published in 1923 by the Kestnergesellschaft in Hannover to supplement its budget. Individual prints from this portfolio occasionally appeared on the market.

When I moved to New York in the mid-1970s, the great era of pop art was over and the countermovement was well underway. The narrative art of the realists was followed by minimalism, land art, and conceptual art, before painting once again regained the upper hand in the 1980s. I was still able to follow right up to the beginnings of minimalism—but conceptual art was, in my eyes, overly intellectual, not sensual enough. I used my sabbatical to inform myself about new trends and visit artists I already knew, including the sculptors Gary Kuehn and George Segal, and the painter Robert Mangold, as well as Robert Kushner, the founder of so-called pattern art. Kuehn had his studio in New Jersey, on a farm in the immediate vicinity of Segal's. Both were able to maintain much larger storage facilities in the country than was possible in New York. Kuehn and Segal were friends and often visited each other. So it was common for a visit to Kuehn in the morning to end with Segal in the late afternoon. I have not forgotten my first visit to Segal's studio: the surprising moment of stepping into a large space in which life-size plaster figures appeared as though they were in action. It felt like a ghost town; each figure had its own sphere. I had up to that point known this form of surrealistic-realistic sculpture only from photographs.

During my year in New York, I discovered quite a few American outsider artists. At The Museum of Modern Art, I saw drawings by Agatha Wojciechowsky for the first time and inquired about her address. My visit to her small apartment in Brooklyn was extremely inspiring. As a spiritualist

Gary Kuehn, *Straw Pillow*, 1963. Plaster and straw, dimensions variable
with installation. Museum Ludwig, Cologne

George Segal, *Woman Washing Her Feet in a Sink*, 1964–1965.
Plaster, wood, metal, and porcelain, height: 62⅛ inches | 158 cm.
Museum Ludwig, Cologne

and medium, the artist held weekly séances. She believed she was in contact with the crews of the UFOs that were frequently sighted at the time. Her vivid descriptions of these mental encounters fascinated me as much as her drawings, which she was convinced were guided by her "spirit teacher," the physicist Isaac Newton. What appealed to me about Wojciechowsky's work was that she had no contact whatsoever with the contemporary art scene, and that her bizarre drawings—mostly of shoes and heads—were solely products of her imagination. She claimed that, in a previous life, I had been a prince. I later presented exhibitions of her works in my gallery in Cologne and invited her to stay with me in my home. In this way, I witnessed abilities that transcend the bounds of reason. The Berlin-based gallerist Rudolf Springer, with whom she also stayed for several weeks, was equally impressed with her work.

Agatha Wojciechowsky, *Untitled*, 1962. Watercolor on paper, 14¾ × 11 inches | 37.3 × 27.7 cm. The Museum of Modern Art, New York

Shortly after meeting Wojciechowsky, I met two other self-taught artists at the Phyllis Kind Gallery in Chicago, which specialized in outsider art: Henry Darger and Martín Ramírez, whom I later showed in my gallery as well. Roger Brown, Jim Nutt, and Ed Paschke, who I also brought to Cologne, followed as representatives of the Chicago Imagist school. Through Sidney Janis I also discovered paintings by Morris Hirshfield, another primitive painter from the United States. Unfortunately, my commitment to this wonderful, creative art was hardly commercially successful at the time. I had only one buyer for such art in Germany: Charlotte Zander, who later made a name for herself as a collector of self-taught artists. Since 1988, her daughter, Susanne Zander, has been running a gallery in Cologne that specializes in outsider art. Works by these artists are also now being collected by museums.

I had more success with as-yet-unknown sculptors from New York, whose works I exhibited in Cologne, including Tom Otterness, John Chamberlain, and Scott Burton, who died far too early. The latter became important to me through his furniture works, such as *Copper Pedestal Table* (1981–1983), which is both a table and a minimalist sculpture. Burton took part in three consecutive editions of Documenta, in 1977, 1982, and 1987. His works, including his marble benches, later helped me understand other artists such as Franz Erhard Walther, Franz West, Robert Wilson, and Siah Armajani, who worked in a similar way and created sculptures that were also functional. In 1981, I had a commercially disappointing exhibition with the sculptor Alan Saret, in which he attached his minimalist wire mesh sculptures to the walls like reliefs and placed others freestanding in the space. Fortunately, I had more success with another still unknown American sculptor, Jonathan Borofsky. When I exhibited him in Cologne in 1981, he lived in my house for a long time. I was able to sell a number of his works to American collectors who came to the Cologne art fair at the time and were surprised to meet this great artist from their home country at my gallery.

Henry Darger, *a) The Vivian girls nuded like child slaves*
b) Untitled (Sacred Heart) and At second battle of Marcocino also escape
from disasterous explosion during battle caused by glandelinians, n.d.
Watercolor and pencil on paper, 19 × 49 inches | 48.3 × 124.5 cm.
The Museum of Modern Art, New York

Morris Hirshfield, *Lion,* 1939. Oil on canvas, 28¼ × 40¼ inches | 71.5 × 102 cm.
The Museum of Modern Art, New York

Robert Wilson, *Parzival Sofa*, 1987. Stainless steel and maple wood,
34¼ × 27¼ × 80¾ inches | 86.9 × 69.2 × 205.1 cm

So, in the 1980s, I once again began exhibiting young American art. In retrospect, it was not only pop art that shaped my program but also the artists of the following generation, which I was also quite enthusiastic about. Among them were Deborah Butterfield and Susan Rothenberg, who had a difficult time in the United States. At the recommendation of a friend, I visited Butterfield in her studio in Bozeman, Montana, where I spent my fiftieth birthday. On a hike through the incredibly beautiful mountainous landscape, I found an exceptionally large, flawless porcini mushroom, which she prepared for my birthday dinner. Butterfield loved horses and created whimsical horse sculptures made of steel and wood. I had just bought a horse for my daughter and was interested in horses myself. Unlike Rothenberg, whose expressive paintings I first saw at 112 Greene Street in 1975, Butterfield was not successful in Europe. I exhibited Rothenberg at my gallery in Cologne in 1980, the year she was also featured

Alan Saret, *Forest Close*, 1969–1970. Vinyl coated netting, 70 × 48 × 32 inches | 177.8 × 121.9 × 81.3 cm. Herbert F. Johnson Museum of Art, Cornell University, Ithaca, New York

at the Venice Biennale. The following year, she had a solo ex-
hibition at the Kunsthalle Basel. At the 1982 *Zeitgeist* exhi-
bition in the Martin Gropius Bau in Berlin, she was the only
female artist among forty-six artists.

The painter William Copley was also among the art-
ists I met in New York at the time, and his studio amazed me.
There was a bar in the middle, above which glasses hung up-
side down in rows like in a professional restaurant. Copley
himself was its best guest. Before he had begun working as
a painter, he had been a gallerist, and as a collector he still
owned important works. When I visited him, he was present-
ing ten variations on Francis Picabia's painting *La nuit es-
pagnole* from 1922 (p. 225, bottom), a major work by the French
artist, which belonged to him. The charm of the painting lies
in the tension between the male flamenco dancer in black
silhouette against a white background and the passive
female nude held in white against a black background. I did
not know it by the original and became infatuated with it.
I offered Copley an exhibition of his pictures dedicated to
Picabia under the condition that I would also be permitted
to show the original. When, in 1978, I presented Copley's
variations with the famous original in my gallery, I noticed
how weak they were in comparison with Picabia's grandiose
work, which hung in the center. I decided shortly before the
opening to remove *La nuit espagnole* from the exhibition and
take it into my private rooms. There, Ludwig discovered it
and bought it immediately. Since then, I have developed a
rather ambivalent view of Copley's paintings. The juxtaposi-
tion of his works with one of the greats of recent art history
taught me once again that pictures in a museum must stand
up to comparison. Copley was unable to do so; unintention-
ally, he let Picabia put him in his place.

On one of my later trips to New York, I visited Jean-
Michel Basquiat in his studio, which was located in the base-
ment below his gallery. At that time, his great breakthrough
was still to come. I bought two paintings directly from his
studio, which I initially deposited with his gallerist. Shortly

afterward, I met Cy Twombly by chance on the street and told him about my latest acquisitions. Twombly just shook his head and said that he could not take Basquiat's art seriously. He was simply not convinced by his highly emotional painting. I, too, was skeptical and remained so. My reservation about this new, fierce painting also applied to the works of Julian Schnabel, a friend of Basquiat's.

I had Schnabel bring a dozen pictures to his New York gallery for two weeks on a trial basis, so that I could assess his art in peace and decide whether I wanted to show him at my gallery later. In the end, I decided against Schnabel, because the influence of Beuys in his drawings seemed too strong. This was a commercial mistake, as I soon discovered (though I continued to stick to my opinion) when the Swiss gallerist Bruno Bischofberger called me and enthusiastically announced, "Here we go! Saatchi just bought Schnabel." Acquisitions by the British advertising guru and collector Charles Saatchi were a clear signal to the market. Bischofberger offered to let me represent the painter in Germany, in particular to bring him to Cologne, the art metropolis of Germany. I politely declined. A little later, Basquiat and Schnabel were the new international painting stars that I had let slip through my fingers.

At the beginning of my year in New York, Peter and Irene Ludwig signed the contract providing for the donation of 350 works of modern and contemporary art from their collection and the construction of the museum bearing their name, the cost of which was to be borne by the city. No other museum in Europe dedicated to twentieth-century art has such treasures as the Museum Ludwig; nowhere else can European and American postwar art be seen in such a way. But, despite my affinity for New York and American painting, Ludwig's collection remained full of gaps. The history—the historical dimension of the artistic dialogue between the two continents—was not visible in his collection. Due to my lack of knowledge of art history, I had failed to provide him with examples of paintings from the beginning of the exchange,

Rudolf and Ursula Zwirner (née Weidemann) with Francis Picabia's
La nuit espagnole (1922), 1978

Francis Picabia, *La nuit espagnole*, 1922. Enamel paint and oil on canvas,
63 × 51⅛ inches | 160 × 130 cm. Museum Ludwig, Cologne

in the late nineteenth and early twentieth centuries, that reflects the influence Europeans who immigrated to the United States had on American painting, an influence that later went in the opposite direction. With Jean Dubuffet and Claes Oldenburg, I succeeded. One of my most daring acquisitions was the fifteen-piece ensemble *The Street* from 1960 by Oldenburg (opposite, bottom), which I acquired directly from the apartment of Robert Mapplethorpe's collector and partner, Samuel J. Wagstaff, near Washington Square. Wagstaff—then curator at the Wadsworth Atheneum in Hartford, Connecticut—had bought most of the pieces from *The Street* at Oldenburg's first exhibition with Dick Bellamy and distributed them throughout his home. Seeing the bizarre objects in a bourgeois apartment full of books surprised and fascinated me at the same time. Wagstaff wanted to part with the ensemble in order to focus on his collection of American photography. In 1984, he sold this collection to the J. Paul Getty Museum.

Oldenburg is a special example of the exchange between Europe and the United States. The son of a Swedish diplomat, he came to the States as a child. Between 1946 and 1950, he studied at Yale University in New Haven, after which he took evening classes at the Art Institute of Chicago until 1954. He may not have personally heard Dubuffet's lecture in December 1951 titled "Anticultural Positions," held on the occasion of his exhibition at the Arts Club of Chicago, but Oldenburg probably read the transcript, which circulated in artistic circles. It obviously had a strong influence on him. For *The Street*, Oldenburg transferred the principle of the naive imagery of art brut, taken directly from life, from the street, to simple cardboard boxes placed freely in space.

Overjoyed with this unusual, museum-quality purchase, I returned to Cologne, but there had to face the fact that the interest of the collectors did not come anywhere close to my own. Only when I drew Ludwig's attention to the connection between Dubuffet and Oldenburg, to the French painter's lecture in Chicago, did he decide to buy the environment from me. But I should have gone back even further, to the early

Jean Dubuffet, *Le chien sur la table*, 1953. Oil on canvas, 35⅜ × 45⅞ inches |
89.7 × 116.5 cm. Museum Ludwig, Cologne

Claes Oldenburg, *The Street*, 1960. Canvas, cardboard, fabric, cord, and casein
paint, dimensions variable with installation. Museum Ludwig, Cologne

1920s and 1930s, and looked for an Edward Hopper for the future Museum Ludwig; Hopper was still affordable at the time. Unfortunately, I did not buy works by Josef Albers or Stuart Davis, and today they are no longer affordable. The dealer André Emmerich offered me Hans Hofmann but I refused, since his work reminded me too much of the abstract expressionists. I was more interested in the present. I lacked the foresight of a museum director. My focus was on the 1960s, my own time: on pop art and realism.

Siegfried Gohr, the first director of the Museum Ludwig, recognized these deficits in the collection and filled the gaps with special exhibitions. In 1986, he presented the comprehensive exhibition *Europa/Amerika. Die Geschichte einer künstlerischen Faszination seit 1940* (Europe/America: The History of an Artistic Fascination since 1940), in which he juxtaposed the museum's holdings with a large number of international loans. His real love, however, was for the West German painters who were born and raised in the East: Georg Baselitz, Sigmar Polke, and Gerhard Richter, to whom I had also given many exhibitions in my gallery. In retrospect, my passionate commitment to these artists often recedes into the background. As Ludwig's preferred art dealer, I was often reduced to pop art.

13

Richter, Polke, Baselitz, and Co.

In the 1960s, I often attended the open studio days at the State Academy of Art in Düsseldorf, as a scene was forming there, and I was able to make discoveries. In Cologne, Fluxus was establishing itself as a new movement, with Nam June Paik, Karlheinz Stockhausen, and Carlheinz Caspari as its main figureheads. But it was still the older generation of painters, including Ernst Wilhelm Nay, Hann Trier, Joseph Fassbender, and Georg Meistermann, who set the tone. So in my search for new artists, I oriented myself toward Düsseldorf, where Joseph Beuys had been teaching at the academy since 1961 and attracted a great deal of attention with his "actions," as he called his performances. Blinky Palermo attended his sculpture class. Gerhard Richter, Sigmar Polke, and Franz Erhard Walther, who were studying under Karl Otto Götz, also piqued my interest, since they all did their own thing.

I wanted to collaborate with Richter for an extended period of time and—contrary to my principles as a gallerist—would have signed him on. But Richter shied away from an exclusive contract, since he did not want to offend Alfred Schmela and Heiner Friedrich, who had shown him in solo exhibitions before. In July 1968, I held a large exhibition of

his work in my gallery, which included the painting *Ema (Nude on a Staircase)* (1966) (opposite). I was able to convince Peter Ludwig to buy it, which was a coup—he had recently come to me as a new and important client. My work with Ludwig in the field of contemporary German art began with this piece. The painting, executed two years earlier, established a reference to Duchamp's key work *Nude Descending a Staircase, No. 2* (1912) through both its title and composition. The blurred contours of Ema, who was Richter's wife at the time, are reminiscent of the graphically depicted movements of the robot-like figure in Duchamp's painting, which in turn refers to the chronophotography of the photographic pioneers Étienne-Jules Marey and Eadweard Muybridge. Photography was essential for Richter. Time and again, he demonstratively used photographs as models to reflect on his own creative work as a painter.

With his reference to Duchamp, Richter positioned himself within art history and took up the baton. It was precisely the communicating of such connections to earlier art, the historical relevance, that I took to be my task as a gallerist. It was part of the educational work for the collectors, who should know exactly what they are buying. Today, this is often very different; art-historical lectures by gallerists are uncommon. The art business has changed, especially in the large international galleries, because of globalization, a different clientele, and a general increase in the speed and dissemination of information. Ludwig, however, was convinced by what I had to say about *Ema* and also purchased the large-format painting *Five Doors* (1967), measuring 92 by 216 inches, from Richter's exhibition, in which each door is opened at a progressive angle—with literally nothing behind it.

A few months later, in March 1969, Klaus Honnef, later the chief curator of the Rheinisches Landesmuseum in Bonn, organized a Richter exhibition at the Gegenverkehr Kunstverein in Aachen. It was Richter's first solo exhibition at a public institution, featuring paintings from the previous seven years and accompanied by a comprehensive catalogue.

Gerhard Richter, *Ema (Nude on a Staircase)*, 1966. Oil on canvas,
78¼ × 51⅛ inches | 200 × 130 cm. Museum Ludwig, Cologne

The show made me nervous, because Aachen was Ludwig's hometown. Its reception would be important for the future of Richter's career—whether he would be accused of being inconsistent because of the extreme diversity of his techniques and motifs, or whether this would instead be recognized as his greatest strength. I feared that Richter's stylistic inconsistency might displease Ludwig, which would also have had consequences for my business relations with him. But in the catalogue, Honnef resourcefully declared the stylistic break to be Richter's principle and thus set the most important standard for the future interpretation of his work. Ludwig remained interested in Richter and, with my help, acquired the artist's monumental piece for the 1972 Venice Biennale, *48 Portraits* (1971–1972), directly from the German Pavilion (below).

This transaction was another triumph. Dieter Honisch, the commissioner of the German Pavilion and the director of the Neue Nationalgalerie in Berlin, had selected Richter, who painted a series of forty-eight black-and-white portraits of philosophers, poets, musicians, mathematicians, physicists, and biologists in a photorealistic manner for the biennale. Richter's random selection of subjects from various encyclopedias presented a cultural and scientific panorama

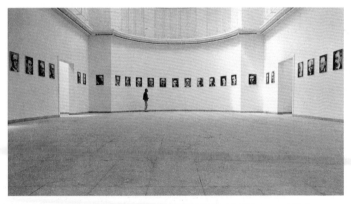

Installation view of Gerhard Richter's *48 Portraits* (1971–1972) in the
German Pavilion at the Venice Biennale, 1972

of the late nineteenth and early twentieth centuries, a frieze of heroes. During the course of the biennale, I succeeded in selling the work to Ludwig for the extremely low price of 48,000 marks. For Ludwig, it was a bargain; for Richter, it was a stroke of luck, because it meant that his monumental work, which would otherwise have been difficult to place, would end up in a museum.

In December of the same year, I showed a photo edition of the *48 Portraits* in my gallery, which Richter wanted to produce in an edition of six. Ludwig disliked the prospect that there would be an editioned photographic version of the painted version he had purchased. He asked the artist to give up his idea of producing an edition and purchased the extant version as a unique work for a larger sum. Two years after Ludwig's death, Richter finally created an edition of the *48 Portraits*. The London gallerist Anthony d'Offay published four copies and offered them in 1998 for $150,000 each.

While I remained friendly with Richter, my relationship with Sigmar Polke turned out to be more difficult. I was able to persuade him to move from Düsseldorf to Cologne; but as a loner, he always kept his distance from the gallerists. This actually suited me well, because I, too, valued mutual independence. I was thus able to show the contemporaries Baselitz, Polke, Richter, and A. R. Penck together with the historical greats Picasso, Magritte, Miró, and Tanguy, and tell visitors with a clear conscience: "You can buy this painting by Dubuffet for 120,000 marks or this work by Polke for 12,000 marks. It's the same quality, only a generation younger." For me, these artists were on equal footing. I was often the first to exhibit young artists, sell them well, and place them in important collections. Since I did not sign any contracts, they moved on after a while and found permanent galleries elsewhere. Dan Flavin left my gallery to show with Heiner Friedrich, who then looked after him until he moved on to Leo Castelli. For me, the collaboration with an artist was essentially terminated after I had purchased outright or taken works on commission, exhibited them, and paid out any

proceeds after the exhibition closed. After two or three years, there might—but not necessarily—be another exhibition.

In 1969, for example, I presented Polke's first solo exhibition in the ruins of a former bank building next door to my gallery—the bank had stood until the outbreak of the war. I used the space that remained after the building was bombed as a storage unit. A few months later, the Belgian artist Panamarenko exhibited there with one of his gigantic, imaginative flying objects, followed by erotic figures by the English pop artist Allen Jones. Parallel to Polke, Donald Judd exhibited in the gallery next door; this was Judd's first exhibition in Germany. I had become acquainted with his work and the work of Dan Flavin and Carl Andre in 1966 during the groundbreaking exhibition *Primary Structures* at the Jewish Museum in New York. I liked the contrast: the cool boxes of this mastermind of minimalist art were completely different from Polke's work. The difference between the two artists was intensified by the respective ambience in which they exhibited—the modern, new gallery space for Judd and the desolate main hall of a former bank for Polke. In a white cube, Polke's "stuff," as we playfully called his works, would have looked very different. But for me, this staging made perfect sense and was reminiscent of the first Documenta in the ruins of the Fridericianum in Kassel. From today's perspective, it was one of Polke's most important exhibitions, which included a pile of potatoes that soon grew sprouts, as well as his roughly thirteen-by-fifteen-foot *Das grosse Schimpftuch* (1968) (p. 238, top) full of handwritten abusive words and phrases, which the Cologne-based collector Reiner Speck later acquired.

On the official invitation to Judd's exhibition (p. 238, bottom), there was only the brief note: "In the warehouse, S. Polke exhibits and works for eight days beginning on June 4"—which annoyed Polke, since he would, of course, have liked to receive his own invitation card. To his satisfaction, however, the attention of the audience was directed more toward him at the joint opening. On the occasion of my appointment as an honorary professor at the Braunschweig University

Rudolf Zwirner and Sigmar Polke, 1969

Sigmar Polke, *Freundinnen I*, 1967. Offset print mounted on cardboard,
18⅞ × 23⅞ inches | 47.9 × 60.8 cm. Museum Ludwig, Cologne

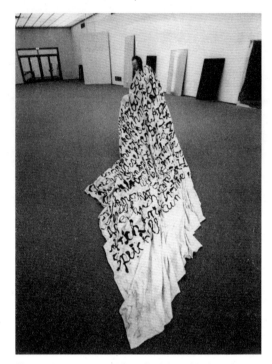

Sigmar Polke wearing *Das grosse Schimpftuch* (1968) in the Cologne Kunsthalle
during the installation of the exhibition *Jetzt: Künste in Deutschland heute*
(Now: Arts in Germany Today), 1970

Invitation card to the opening of the double exhibition of Donald Judd and
Sigmar Polke at Galerie Rudolf Zwirner, Cologne, on June 4, 1969

of Art in 2000, the sculptor Heinz-Günter Prager recalled this memorable opening: "That evening, most guests were not at Judd's show but were instead playing table tennis in the warehouse while Polke continued tinkering with the potato sculpture to the right of the main entrance." Polke later called the venue of this exhibition "Galerie Zwirner, Warehouse." I did not sell a single one of the paintings on view; I could not even convince Ludwig.

I would also have liked to have done more for Blinky Palermo, who died much too young, in 1977, at the age of thirty-three. But he was already under contract with Heiner Friedrich, who paid him a fixed monthly sum and thus had exclusive rights to his work. I warned Palermo not to give everything away and promised him that, through Ludwig, I would place certain works in the museum; but alas, he was already taken. Nevertheless, I did indeed succeed in brokering sales of individual pictures.

Heiner Friedrich in particular should be thanked for his clever promotion of young German art. With his business partner Franz Dahlem, he ensured that not only American pop art would be shown during the Ströher Collection's tour of Germany following the spectacular acquisition of the Kraushar collection in 1968, but that works by Richter, Baselitz, Markus Lüpertz, and Hanne Darboven, who had never before been exhibited in a museum, would also be on view. Through him, they became publicly respectable.

International acceptance of contemporary art from Germany was, however, still some way off. Beuys's programmatic statement "I like America and America likes me"— the title of his "action" in René Block's New York gallery in 1974—was pure wishful thinking. This mood persisted until the early 1980s. The American dealers and collectors were for the most part Jewish and, understandably, kept their distance. Only works by Egon Schiele, Oskar Kokoschka, Ernst Ludwig Kirchner, and Max Beckmann—German and Austrian painters who had been labeled "degenerate" by the Nazis—were bought, never pictures by contemporary artists.

For a long time, many of my American colleagues, with whom I was on quite friendly terms, refused to visit me in Germany— with the exception of Ileana Sonnabend. The memory and trauma of the Holocaust was still deeply lodged.

The turnaround for German artists was brought about by the seventh Documenta in 1982, which was curated by Rudi Fuchs, and the Anselm Kiefer exhibition two years later at The Israel Museum in Jerusalem. At Documenta, Fuchs gave the German neo-expressionists an international platform. By this time, pop art in the United States had also become unaffordable for most Americans, and the subsequent movements of body art, land art, conceptual art, and minimalism were overly intellectual or simply not for sale. With Fuchs's propagation of a new representationalism, there were finally attractive paintings that could be hung on the walls: the so-called Neue Wilde in Berlin, the Mülheimer Freiheit in Cologne, and the transavanguardia in Italy. But the final breakthrough for German art came with Kiefer's exhibition in Jerusalem. The Israel Museum granted absolution. From then on, it was not only possible for Jewish collectors to acquire German art, but galleries such as Pace in New York were now able to offer it for the first time. Only a few years earlier, Arnold Glimcher, the founder of Pace Gallery, had replied to my suggestion to exhibit Georg Baselitz, because he didn't yet have a gallery in the United States: "I can't expect that of my clients. If I show a single living German artist here, I'll lose my clientele."

I had met Baselitz in Berlin at Rudolf Springer's gallery in 1966. He exhibited his "Hero" paintings there under the title *The Great Friends*. The figures' fingers and feet were caught in hunting traps; the attributes of brush and palette further revealed them as the artist's alter ego. They were psychograms of a generation that had experienced the war and the postwar period in Germany as children. At first, I was shocked by these images, especially since I had just purchased the life-size silver Elvis Presley, *Elvis* (1963), from Warhol. Baselitz's expressionist protagonists with their disheveled

hair seemed like the greatest conceivable contrast to Warhol's Presley. On one hand, there was the downright dramatic image of a failed hero, yesterday's painting, and on the other hand, the multiplied, silkscreened, cool image of a media star. At the time, Baselitz seemed to me to be looking backward, and Germanic. It was not until six years later, when I got to know his early paintings at Galerie Tobiès & Silex in Cologne, that I recognized his painterly power. I bought *The Great Friends* (1965) (p. 242, top) and *The Big Night Down the Drain* (1962–1963) (p. 242, bottom), a painting of a boy masturbating, which caused a scandal at the Galerie Werner & Katz in Berlin in 1963 and was confiscated by the Berlin public prosecutor on charges of immorality.

I was able to convince Peter Ludwig that Baselitz did not paint "late expressionist" pictures, but that this was the further development of a style that had been interrupted by the political circumstances of 1933 and had not yet been exhausted. Through Baselitz, I discovered A. R. Penck's "Standard" pictures and Markus Lüpertz's "Dithyrambs," which I was also able to sell to Ludwig. Today, Penck's *Large World Picture* from 1965 (p. 243), a key work by the artist, is a highlight in the collection of the Museum Ludwig. With its elementary forms, including the frontal stick figures with raised hands, it is reminiscent of cave painting. The theme—as is so often the case with Penck, who was born and raised in Dresden—is the division of the world, or more precisely the division of Germany, for which he developed his own unique artistic language of ciphers. The divided country is also the leitmotif of the *Café Deutschland* series by Jörg Immendorff, who formed a West German–East German tandem with his colleague Penck. In the first picture of the series from 1977 to 1978, which is also one of the most popular works in the Museum Ludwig, the artist extends his hand toward the viewer through the small stone wall placed on a bar table, as an invitation to help overcome the division.

I took it as a special compliment when Siegfried Gohr, the first director of the Museum Ludwig, later said to me:

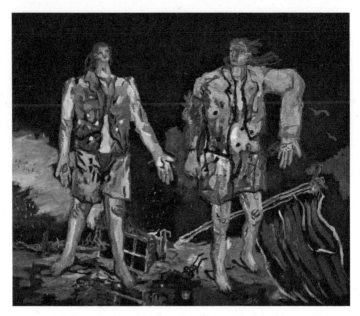

Georg Baselitz, *The Great Friends*, 1965. Oil on canvas, 98½ × 118⅛ inches |
250 × 300 cm. Museum Ludwig, Cologne

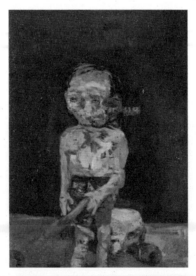

Georg Baselitz, *The Big Night Down the Drain*, 1962–1963. Oil on canvas,
98½ × 70⅞ inches | 250 × 180 cm. Museum Ludwig, Cologne

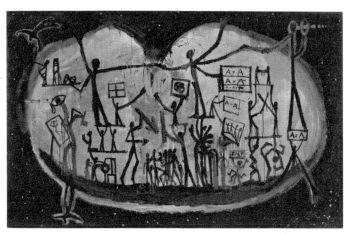

A. R. Penck, *Large World Picture*, 1965. Oil on fiberboard, 70⅞ × 102⅜ inches | 180 × 260 cm. Museum Ludwig, Cologne

"Mr. Zwirner, when I see the provenances of the paintings—most of what is really important here in the museum came through your gallery." From him, this comment had particular meaning for me because Gohr was closely connected to Michael Werner, with whom I was in constant conflict. Werner worked together with the "Big Five": Georg Baselitz, Jörg Immendorff, Markus Lüpertz, A. R. Penck, and Sigmar Polke. In 1968, he had moved from Berlin to Cologne and made every effort to gain a foothold in the Rhineland with his artists—above all, with Baselitz and Penck. This was why he called his first three Cologne exhibitions—titled *Avant-Garde 1–3*, in which he combined works by, among others, Warhol with Baselitz and Richter—his "integration program." During Gohr's tenure as director, Werner succeeded in placing numerous works by his artists in the Museum Ludwig.

While he was still in Berlin, I got into an argument with Werner over a sculpture by Alberto Giacometti, which he claimed to have purchased from the niece of Annette Giacometti, the artist's wife. I acquired the roughly twenty-two-inch-tall bronze for a great deal of money because of its excellent provenance. Since I had doubts about that same provenance, however, I enquired with Galerie Lelong, Giacometti's dealer in Paris, just to be on the safe side. There, it was confirmed that the figure, created in the 1950s, was indeed genuine because it was anchored to the plinth just like all authorized casts and did not deviate even a millimeter in size. It must have been cast from the original mold. In the case of a copy, the circumference of the body is reduced by the shrinking process. Since I was still not convinced, as the arms of the female figure depicting Annette seemed to me to be too close to the body, I traveled to the Kunsthaus Zürich, where the most extensive collection of Giacometti's works is located. When I placed my sculpture next to the one that the gallerist and collector Ernst Beyeler had sold to the Kunsthaus, my suspicion was confirmed: my "Annette" had to be a forgery, because, unlike the original, her forearms touched her hip. For further proof, I went to the Susse Frères foundry

in Paris, which produced eighty percent of Giacometti's sculptures. The foundryman took my figure in his hand, shook it a little so that some residue fell out, and told me plainly and straightly, "I did not cast this bronze." He couldn't articulate why but asked me to sit down and went into a shed next door, where there were more than one hundred Giacometti plasters, from which the casts were made. (Today, they are safely stored in an archive.) I waited and waited until, after twenty minutes, the foundryman returned and said, "The plaster is gone." It had obviously fallen into the hands of forgers. He then phoned Annette, who immediately demanded that the police be called to arrest me and confiscate the sculpture. I intervened, "Before you do that, first call Lelong and ask about me and why I am here. And you will by no means take the sculpture away from me; it has been officially imported and needs to officially leave the country again. Otherwise, I'll be charged with tax fraud."

Because of my inexperience in this field, I was not aware that the justice system would not accept my case. There is a fixed period of three months for purchases between dealers to return goods. This is done formally by a registered declaration of the buyer that he wishes to return the good. After the deadline has expired, however, nothing can be done.

I also came into conflict with Ludwig regarding a forgery. I had acquired a very beautiful work on paper by Matisse from a Swiss gallery, for which I received an alleged certificate from them with the signature of Matisse's daughter, Marguerite Duthuit. Shortly after I sold this late line drawing of a female model to Ludwig, he received a call from the Swiss criminal investigation department, which had tracked down a forger. They informed him that he had acquired a "Matisse" drawing from this forger's hand. Furious, Ludwig called me and could not be reassured that I myself had been cheated because I had believed the certificate was authentic. He did not accept my offer to return the drawing and to be refunded the amount paid. Ludwig did not want his money back at all, but instead demanded that I get him a new genuine drawing

by Matisse. He wanted to keep the fake one anyway. I didn't agree to this, nor could I grant his wish. Ludwig decided to drop the case. The drawing is still in the Ludwig Collection today but is marked as a forgery in the "safe deposit box" of his Aachen-based foundation.

I felt cheated by Michael Werner, and the relationship between us remained tense. Like me, in the 1980s, Werner tried to sell works by German artists in the United States, initially through collaborations with the New York–based galleries Ileana Sonnabend, Pace, Xavier Fourcade, and Marian Goodman. In 1984, he married the gallerist Mary Boone and thus had both personal and business connections across the Atlantic. In the mid-1980s, I also tried to gain a foothold in New York and cooperated with Barbara Gladstone for a few years, in whose gallery I maintained my own self-financed office space. It was not easy, though, because my American colleagues did not appreciate the German competition in their own country. I experienced this in 1986 at an exhibition of paintings by Richter, which I had organized at Gladstone's gallery. Goodman came in and said, in a way that was completely audible to everyone, "What a pity that not a single museum-quality painting is hanging in this exhibition." The result was that I sold only one of the paintings, to a collector friend of mine, although they were all major early works. The same thing happened in Chicago with Baselitz, where I showed important early paintings in Rhona Hoffman's future gallery space. This time, it was Sonnabend and Fourcade who publicly declared that they were second-rate paintings. To spare Baselitz the disappointment, I told him that I had sold well. In reality, however, I purchased the works myself and later sold them to Charles Saatchi. The Baselitz exhibition in Chicago and the Richter exhibition in New York taught me once again how intense the competition is in the American art market. I was accepted there by my colleagues as a collector, buyer, and consultant—not as a competitor.

But the Cologne–New York axis remained strong. In the 1980s, German artists experienced a boom in the United

States. American collectors now traveled to Germany, no longer just to discover the art of their fellow countrymen in the Cologne galleries but also to acquire paintings "made in Germany." One of them was the New York–based collector Elaine Dannheisser, who always stood out from the crowd during her gallery tours with her striking feathered hats. The American collectors were specially invited to Art Cologne in order to create excitement among them to buy. In addition, on the occasion of the art fair, the Friends of the Museum Ludwig, a group that I had initiated, held a dinner for the guests from the United States. In the States, I had learned how important it is to take care of American collectors, so I gave my dinner speech in English. There was a lot of energy concentrated in Cologne, which had its heyday as an art hub during this time.

Galleries set up shop in the city. Max Hetzler and Tanja Grunert moved to Cologne from Stuttgart, Gisela Capitain from Berlin, and Johnen and Schöttle from Munich. At the same time, new galleries were also established. In addition to Daniel Buchholz, who had made an initial start in my former warehouse, Sophia Ungers, Rafael Jablonka, and Monika Sprüth sought to establish themselves alongside elder gallerists such as Rolf Ricke, Paul Maenz, Michael Werner, and myself. What Cologne had experienced in the 1960s was repeated again twenty years later but on a much larger scale. For me, however, the 1980s proved to be less important artistically. As a gallerist, my best days were behind me. I continued to see to the organization of Art Cologne but the sensational exhibitions were taking place elsewhere. Robert Gober, Mike Kelley, Jeff Koons, and Martin Kippenberger exhibited with Hetzler; and Maenz presented Keith Haring, who on the evening of an opening painted a living model with his typical lines (p. 248). With the newly awakened interest in figurative painting in the 1980s, Maenz also reoriented himself and from then on became involved with the Cologne-based artist group Mülheimer Freiheit and the Italian transavanguardia. Monika Sprüth mainly showed works by women artists,

including Rosemarie Trockel, Jenny Holzer, Barbara Kruger, and Cindy Sherman. Through her, women artists also gained a greater presence in numerous other exhibitions throughout Germany. And at Art Cologne, an increasing number of works by young Americans were now being shown—artists such as Robert Longo and David Salle, who subsequently had solo exhibitions at galleries in Cologne. I presented works by John Ahearn and Tom Otterness. The new gallerists were vehemently committed to their artists, sought partners in the United States, as we had twenty years earlier, and cooperated with galleries in New York. Along with the new generation of gallerists, a new generation of German collectors also emerged, including the publisher Benedikt Taschen, the Grässlin family, and the fashion manufacturer Uli Knecht, all of whom were not buying from me.

Cologne had clearly become the center of contemporary art in Germany. The year 1986 marked the high point with the opening of the Museum Ludwig—appropriately enough with the exhibition *Europe/America: The History of an Artistic Fascination since 1940*. In the summer of the

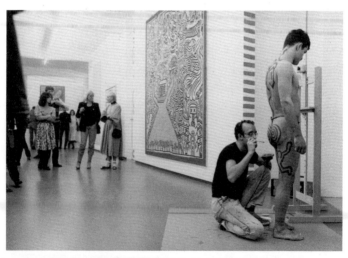

Keith Haring painting a live model during the opening of his exhibition
at Galerie Paul Maenz, Cologne, on May 3, 1984

following year, a particularly large number of American col-
lectors traveled to Germany, starting off in Kassel to attend
the eighth Documenta. From there, they moved on to Cologne
and finally to the open-air exhibition *Skulpturen Projekte* in
Münster, organized by Kasper König and Klaus Bussmann,
the director of the Westfälisches Landesmuseum. The sculp-
tures were scattered throughout the city and the surround-
ing area, and visitors had to search for them. This is when I
first met my New York–based colleague Barbara Gladstone,
accompanied by the collector Emily Spiegel and her hus-
band, Jerry. I invited all three of them for a drink in my little
cottage, which was located in the woods near Münster. Emily
Spiegel was so enthralled by the cottage that she sponta-
neously said to her husband, "This is exactly the kind of cot-
tage I want." Her husband, who had made a fortune as a real
estate developer after humble beginnings on his uncle's farm
on Long Island, replied dryly, "Emily, that's where we came
from. We don't want to go back."

With the close of the decade, my activity as a gallerist
also came to an end: 1988 was my last artistically important
year. Beuys died in 1986, Warhol in 1987, and a significant
generation of artists left the gallery. AIDS had cost many
young artists their lives, including the sculptor Scott Bur-
ton. The year 1989 brought a final break with the fall of the
Berlin Wall—for me as well as the city of Cologne. I was not
the only one who began to think about a change of location.
Paul Maenz was the first to close his gallery the following
year and prepare for his move to Berlin. He was followed by
Max Hetzler, who opened a new gallery in Berlin, later by
Jörg Johnen, and finally by Rafael Jablonka, Monika Sprüth,
and Daniel Buchholz, all with second galleries in the new
German capital.

14

From Art Dealer to Curator and Back

I have organized exhibitions all my life: more than three hundred as a gallerist between 1959 and 1992, and half a dozen as a curator at the invitation of public institutions. In retrospect, many of them were the first presentations of artists who later, after being shown in my gallery, had their big breakthrough. Of course, several of them were forgotten, but a large number of "my artists" now belong to the canon of recent art history. Although official recognition may be a long time coming for some of these artists, I have been friends with many of them for decades. When I look back on their individual developments, I can only marvel at how incalculable an artistic career ultimately is. But what seems even more important is the question as to how success or failure can be measured within their respective time. My admiration goes out to artists such as Astrid Klein and Gary Kuehn, who continued to work unwaveringly, even when times were tough.

Two things shaped my approach to art, and also determined my work as a gallerist: my rejection of any kind of

blind loyalty, as a counterreaction to the Third Reich, and my sense of the relationship between an artwork and its surrounding space, which I developed through my experience of the first two Documenta exhibitions. As a boy, I had witnessed the collapse of an entire system of values. After being indoctrinated with Nazi ideology during my childhood, inner independence became my program; that was true in working with artists as well. I never wanted long-term professional relationships; and I did not work with contracts, so that I would remain free in my choices. I purchased art like a collector, bought what I personally liked, but always remained a dealer. This also gave my arguments more weight when I negotiated with collectors and had to explain why my prices were in some cases higher than elsewhere. Peter Ludwig understood this principle. He could be sure to receive only important works of art from me. Even from the multifaceted Warhol, I facilitated sales of only important paintings.

In 1955, the first Documenta exhibition opened my eyes as a young man and awakened my enthusiasm for contemporary art. Its effect on me, standing in the ruins of the Fridericianum, was enormous. From then on, I knew that I wanted to have a career in art. But the second Documenta, which I organized four years later, taught me how to handle art, and my mentor and teacher was the Documenta founder Arnold Bode, whom I accompanied in his role as curator in the weeks and months before the opening. From him, I learned how to hang pictures, place sculptures, and stage spaces. As an artist, Bode worked intuitively. His motto "Every work of art seeks its place" might have been time-consuming in practice, if this or that piece found its place only after numerous trials, but the effort was always worth it. For example, shortly before the opening of the second Documenta, Bode demanded that an entire hall be made smaller and repainted, just to make sure the proportions were right, the atmosphere perfect. Everything had to be taken down, reworked, and reinstalled. As secretary general, I was nervous, but moving

the temporary wall, by about an inch, and changing the wall color only slightly, produced a different, much better result.

The harmonious interaction between art and the surrounding space became my own touchstone. It pains me when this interrelationship is not quite in sync, as is often the case with public art. Donatello and Michelangelo knew very well how to place their sculptures in public spaces. In contrast, Barnett Newman's *Broken Obelisk* (1963–1969), temporarily installed in front of the main entrance to the Neue Nationalgalerie, or Richard Serra's curved steel walls next to the philharmonic hall in Berlin seem as if they have been placed there randomly. Often, the artists themselves know how to present their works best. When Dan Flavin entered the gallery one morning during his exhibition with me, he froze and demanded to know who had been there before. When I answered, "No visitors yet, just the cleaning lady," he nodded and moved a fluorescent tube lying on the floor back about an inch. In the early years of his career, he insisted on knowing exactly who purchased his works and how they were to be presented in the respective collections. When I once complimented Ernst Beyeler on his superbly hung Mark Rothko exhibition, he told me that he had taken over the exhibition of the artist's work from Sidney Janis's gallery, where Rothko had installed the show himself—Beyeler had copied everything, from the selection of works to the height and distance between paintings on the wall. And it was perfect.

The long list of my gallery exhibitions may testify to a certain flightiness—something I have been accused of from time to time. Art brut, calligraphy, kinetic art, surrealism, new objectivity, modern classics, color field painting, pop art, arte povera, Fluxus, conceptual art, transavanguardia: all these movements were represented in my exhibition activities. This abundance arises from my temperament, my impulsiveness. I was able to get enthusiastic about both color field painting and pop art, which, for my American colleagues, were incompatible, even a taboo break. In the early 1960s, a French colleague and friend who mainly represented gestural European

abstraction asked me how I, as a serious art dealer, could deceive my customers like that—after all, as far as he was concerned, pop art was not art. "In fact, it is," I kept reiterating. I was attracted to works in which I could see new forms being tried out, where the artist was striving to realize his or her ideas in a new and different way. In this way, the pop artists Warhol, Robert Rauschenberg, Jasper Johns, Jim Dine, John Chamberlain, Claes Oldenburg, Allen Jones, and Richard Lindner, as well as representatives of color field painting such as Frank Stella, Morris Louis, and Kenneth Noland, could be reconciled with one another.

From the very beginning, I had a great affinity for art brut. Nowhere else is the impulsiveness of the artistic process as visually unbridled as in these works. Today, art brut has found its way into public collections; the Swedish spiritualist Hilma af Klint is now celebrated as a pioneer of abstract art, and I acquired an early "spirit drawing" by her British progenitor Georgiana Houghton, who is now also gaining belated recognition. But in the early 1960s, there were few exhibition opportunities for so-called outsider art. The Prinzhorn Collection opened my eyes to its significance, and I exhibited works by Louis Soutter, Henry Darger, Martín Ramírez, Agatha Wojciechowsky, Blalla W. Hallmann, and Morris Hirshfield. When Antonina Gmurzynska moved from Poland to Cologne in the mid-1960s, she brought with her a whole stack of watercolors by the naive painter Nikifor. I acquired more than two dozen of them from her and, in doing so, facilitated her start as a gallerist. Last but not least, I came across the Croatian folk artist Matija Skurjeni on a vacation in Yugoslavia and brought back various pictures by him.

Surrealism was also an important art movement for me. René Magritte, Max Ernst, Yves Tanguy, and Joan Miró were among the fixed stars of my gallery work, as were Salvador Dalí and Hans Bellmer. In contrast to cubism, this movement, which brought the subconscious into art, continues to exert an influence on contemporary art. In Germany, the works of the surrealists did not find recognition until very late, which

is why they were still affordable in the 1960s and 1970s. In addition to the exhibitions that I organized for surrealist artists, I also represented them at various art fairs.

I also brought back many of their works from the United States, such as the Ernst painting I acquired for the Von der Heydt Museum in Wuppertal during my first visit to New York. There, in galleries and private collections, I also tracked down other modern classics that American collectors had purchased in Paris before and after the Second World War, and brought them back to Europe. This activity as an art dealer, seeking specific works, formed the economic basis of my gallery in Cologne. In a way, I had two different but related professions: gallerist and art dealer. Since, unlike many of my gallery colleagues, I did not commit myself programmatically to a fixed stable of artists, I had enough time to research the market and make connections in the United States. As a gallerist, I was primarily committed to the avant-garde, while as an art dealer I worked with classic twentieth-century art.

The choice of artists, the decisions made in favor of a particular artistic movement, came about in very different ways. Tips from artists or critics were very important for me. My first wife drew my attention to Cy Twombly, whose work she had seen at the home of the art critic Albert Schulze-Vellinghausen; Benjamin Buchloh introduced me to Marcel Broodthaers; Kasper König also appreciated Nikifor. While visiting a framing workshop in Paris, I noticed a change in Dubuffet's style. I contacted him right away and arranged an exhibition of new works. I got to know Robert Wilson through the theater. His personality fascinated me immediately, so that I invited him to exhibit his chairs in my gallery.

Often, it was articles in art magazines that drew my attention to a particular artist—for example, a review in an American art magazine of the first exhibition of work by Richard Serra, who at that time worked with felt and ropes before turning to metal. On my next trip to the United States, I contacted him about making a studio visit and wanted to arrange an exhibition with him, but I was too late. The Cologne-based

gallerist Rolf Ricke had visited him the day before. Exhibitions also made me curious about artists and their work. For instance, in the exhibition *Primary Structures* at the Jewish Museum in New York in 1966, Carl Andre's line of red bricks laid across the space impressed me so much that I wanted to meet the minimalist artist personally and had the museum give me his telephone number. Unfortunately, an exhibition didn't take place because Andre asked for $10,000 just for thinking about what he might present at my gallery. That was clearly too much for my budget.

My first meeting with Donald Judd was a real experience. When I visited him in his studio, instead of standing to greet me, he remained seated in the middle of his cactus collection, looking out, undaunted, at the building opposite. With this self-dramatization, he immediately demonstrated his independent position—even to an art dealer who had come from Europe. As he sat there so focused, I followed his gaze and recognized the orderly structure of his sculptures in the clear line of the strip windows across the street. Judd not only presented urban architecture as a source of inspiration for minimalist art but also made the tension between sculpture and space visible. After Flavin and Judd, I later showed the West Coast minimalists Larry Bell, Robert Irwin, and James Turrell as well as the New York–based sculptor Scott Burton.

As a gallerist, I also paid close attention to the Danish-Belgian-Dutch artist group CoBrA, which strove to revive folk art with expressionist means, such as gestural abstraction. I gave one of my earliest exhibitions to Karel Appel. I was fascinated by Constant, who, along with Asger Jorn, also belonged to the core of CoBrA; his interest in the theory of *homo ludens*, the playing human being, captivated me. Through Constant, I got to know the situationists and their mastermind, Guy Debord. Constant believed that in the near future, through automation and rationalization, humans would no longer need to work and would play instead. To these ends, he developed utopian cities.

I was also committed to new objectivity. Otto Dix and George Grosz were well known, but artists such as Christian Schad, Gustav Wunderwald, Grethe Jürgens, Heinrich Maria Davringhausen, Karl Hubbuch, Franz Radziwill, Rudolf Schlichter, and Georg Schrimpf had long since all but fallen into oblivion, even after the rehabilitation of "degenerate" art. The National Socialists had discredited this style of realistic painting as a whole. Unlike today, the works of painters from the new objectivity movement could not be sold after the war.

I also showed calligraphy—for me, the highest form of abstraction—by Inoue Yūichi, Morita Shiryū, and Sesson Uno, as well as arte povera, which I had encountered at Ileana Sonnabend's gallery. Among the artists from this group who fascinated me most were Mario Merz, Jannis Kounellis, Michelangelo Pistoletto, Pier Paolo Calzolari, and Giulio Paolini. Their art, mostly installations, was characterized— as the name suggests—by "poor" materials: earth, wood, coal, broken glass, twine. The canvas cuts of Lucio Fontana, another Italian, greatly appealed to me; in them, I recognized the experience of war. What I did not exhibit was photography, with the exception of László Moholy-Nagy's photograms from the 1920s; I lacked an understanding of the medium. The photograms were a real discovery at the time, and the Hungarian artist's exhibition then traveled to the Bauhaus Archive in Berlin.

In the 1980s, like everyone else, I enthusiastically presented new painting: works by Werner Büttner, Walter Dahn, Jiří Dokoupil, Martin Kippenberger, and Albert and Markus Oehlen, as well as the transavanguardia artists, including Enzo Cucchi, Sandro Chia, and Francesco Clemente, who cultivated a preference for mythical themes in their expressive paintings. At that time, the collector and photographer Wilhelm Schürmann was one of the few customers to acquire a work from my first Kippenberger exhibition—a fourteenpart piece, which he later resold to my son David. From there, it came into the possession of the French collector François Pinault. In the final years of my gallery activity, I also showed

works by the painters René Daniëls, Helmut Federle, and Gustav Kluge, the sculptors Gary Kuehn, Olaf Metzel, Siah Armajani, and Jonathan Borofsky, and the Cologne-based artists Jürgen Klauke, C.O. Paeffgen, and Astrid Klein. Toward the very end of my time at Albertusstrasse 18, I showed Felix Droese, whom I had known for many years. I first made his acquaintance in Düsseldorf when he was a student of Joseph Beuys's; his thoughts and works were extremely political. As a special feature, he used the technique of paper cutting, which was more common in the nineteenth century. His sheets measured up to 120 or even 160 inches. The highlight of our collaboration was his exhibition as the official representative of the Federal Republic of Germany at the 1988 Venice Biennale, where he transformed the German Pavilion into a "House of Weaponlessness."

Parallel to my work as a gallerist and an art dealer, and even after I finally closed the gallery in Cologne in 1992, I was also active as a curator of public exhibitions. I came to this task rather unexpectedly in 1981 in order to supplement the *Westkunst* exhibition organized by Kasper König and Laszlo Glozer. Some years earlier, I had encouraged Kurt Hackenberg to organize a large exhibition of contemporary art as an extension of the art fair: "We in Cologne should also make a mark at the institutional level. The art market does not function in a vacuum here; support must also come from the public authorities." Hackenberg immediately agreed and asked me a little later about König as a possible candidate for the project; he had read in the newspaper about König's exhibition *12 Künstler zu Gast* (12 Artists as Guests) and an accompanying series of talks at the Museum of Ethnology in Munich in the spring of 1979, which generated some controversy.

The choice of König was typical of Hackenberg—to rely less on a recognized museum curator than on an outsider, indeed even a rowdy one, who he hoped would bring new energy to the city. As a local politician, he wanted to put Cologne on equal footing with the other metropolises in West Germany, after Stuttgart had presented its Hohenstaufen

exhibition shortly before, and given that Munich was plan-
ning a Wittelsbach show and preparations were underway
in Berlin for the Prussian anniversary. However, because the
Rhineland never had a ruling dynasty, Hackenberg wanted
the so-called second modern era to be honored as a great cul-
tural achievement after 1939. In keeping with this, *Westkunst*
was the ironically provocative exhibition title devised by
the curators, playing on the concept of "western art."

König, who at that time still lived with his family in
Munich, accepted the assignment, since he regularly came to
Cologne anyway, where he had founded the publishing house
Verlag Gebrüder König with his brother Walther in 1971. He
enlisted the services of the Munich-based art historian and
critic Laszlo Glozer, who procured excellent loans of works
by Picasso, Dubuffet, Paul Klee, Francis Bacon, and Hans
Hartung, as well as by Arshile Gorky, Hans Hofmann, and
Roberto Matta, a first-class selection of European and Amer-
ican art from the period during and immediately after the
Second World War. König and Glozer's exhibition concept did
not extend beyond 1968, and the 1970s and early 1980s were
completely missing. In light of the art fair, I urged Hackenberg
not to neglect this important period. I therefore intervened
with Peter Nestler, who succeeded Hackenberg in 1979 as
head of cultural affairs, and offered to set up a contemporary
section with the help of other gallerists.

I approached a total of fourteen galleries, from Am-
sterdam, Düsseldorf, Innsbruck, Naples, New York, Munich,
Rome, Vienna, and Zurich, who represented artists I wanted
to show. The budget for preparations, insurance, transpor-
tation, and the elaborate exhibition architecture by Oswald
Mathias Ungers in the Rheinhallen was quickly exhausted by
König and Glozer's exhibition, so the gallerists had to cover
the costs of shipping and insurance themselves; the city pro-
vided only the venue. Thirty-seven artists were presented
at the dealers' stands as if at an art fair—among them were
Isa Genzken, Jenny Holzer, Robert Longo, David Salle, and
Gerhard Merz. The programmatic title of the exhibition was

Heute (Today). Compared to the more than five-hundred-page catalogue for *Westkunst*, the small paperback catalogue for my exhibition looked rather modest, but contemporary art received necessary recognition in the city of Cologne one year before the next Documenta.

In 1988, I organized the exhibition *Köln sammelt* (Cologne Collects) at the Museum Ludwig, based on the 1964 show dedicated to showcasing twentieth-century works from private collections in Cologne, *Kunst des 20. Jahrhunderts in Kölner Privatbesitz* (Art of the Twentieth Century in Private Collections in Cologne), in the Hahnentorburg, one of the extant medieval gates to the city, on the occasion of the 125th anniversary of the Kölnischer Kunstverein. Occurring two years after the opening of the Museum Ludwig, the exhibition, featuring 180 works by fifteen artists, was a tribute to the many other collectors in Cologne in addition to the formidable figure of Peter Ludwig, such as Udo Brandhorst, Walter Neuerburg, Robert Rademacher, Jörg Rumpf, Reiner Speck, and Michael and Eleonore Stoffel. I wanted to show the gaps in the museum's collection—the lack of arte povera, the mythical painters, new materials such as light, the poetic work of Marcel Broodthaers. Each artist was given his or her own room, and for Lucio Fontana I had an octagon built as a special exhibition space. The art historian Dorothea Sieg, who later became my wife, edited the catalogue. Through *Cologne Collects*, she discovered Marcel Broodthaers for herself, who became the subject of her dissertation and the starting point for a later joint exhibition project in Austria: the presentation of the Speck Collection.

I had discussed the concept behind the exhibition *Cologne Collects* with Peter Ludwig, the secret director of the Museum Ludwig. He had his own office in the building, in which—at least temporarily—controversial bronze busts of him and his wife by Arno Breker, Hitler's favorite sculptor, stood. From this office, the great collector made his own decisions, including acquisitions for the museum collection, often over the head of the actual museum director, Siegfried Gohr.

During the preview of *Cologne Collects*, Ludwig acted com-
pletely surprised. He had not expected there to be so many
other important collectors in the city. Gohr remained on the
sidelines, not least because my selection did not take into ac-
count the artists represented by Galerie Michael Werner, who
were already well represented in the museum. With Gohr's
exhibition *Bilderstreit* (Iconoclasm) one year later, this con-
flict became a topic of public discussion: on the day of the
vernissage, an open letter protesting the one-sided selection
of artists by Gohr and his cocurator Johannes Gachnang was
published, signed by thirty-three gallerists. Despite the criti-
cism, Gohr remained in office until 1991, when he organized
the exhibition on the occasion of Max Ernst's one hundredth
birthday, which marked the end of his tenure as director. At
the center of the exhibition was Ernst's key work *Rendezvous
of Friends* from 1922.

 Cologne Collects was a success. Ludwig wasn't the only
one amazed at the treasures slumbering in the city's private
collections. The hope that artworks from my exhibition would
find a permanent home in the Museum Ludwig was, how-
ever, not fulfilled. Despite the praise it received, the exhibi-
tion did not achieve its actual purpose of opening the mu-
seum to other collectors. Much later, when Kasper König
became director of the Museum Ludwig, he took up the idea
again and called his very first exhibition, in 2001, *Museum
of Our Wishes*.

 An unfulfilled wish of his was the acquisition of the
Speck Collection. In 2008, it was purchased by the Rhein-
gold consortium, which was able to pay the formidable ask-
ing price in the eight-figure range. König would have liked
to have won for his museum the works of Beuys, Kippen-
berger, Oehlen, and Polke, which had in many cases found
their way into Speck's collection through me. His one con-
solation at the time was that, according to the statutes of
the consortium, the art investment fund set up by the
Düsseldorf-based art consultant Helge Achenbach, which reg-
ularly lends its holdings to museums in Cologne, Düsseldorf,

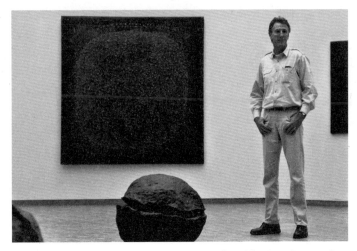

Rudolf Zwirner with works by Lucio Fontana in the exhibition *Köln sammelt*, Museum Ludwig, Cologne, 1988

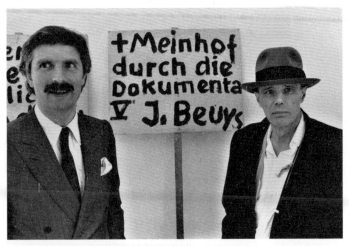

Reiner Speck (left) and Joseph Beuys at the Speck Collection exhibition *To the Happy Few*, Museum Haus Lange and Museum Haus Esters, Krefeld, 1983

Mönchengladbach, and Siegen, was not permitted to sell anything until 2022.

I deeply regretted the sale of the Speck Collection, which had been compiled with so much care and should have been preserved in a museum context. Speck came from a generation that did not regard collecting as an investment but rather pursued it with passion and the greatest knowledge. In addition to Wolfgang Hahn, he was always an important conversation partner and companion. He acquired his first drawing by Twombly from me. As a bibliophile and genuine bookworm who owned one of the largest collections of writings by Proust and Petrarch, he was also looking for a new location for his library of roughly forty thousand volumes, which he found in 2012 in the minimalist house built by Oswald Mathias Ungers in the Müngersdorf district of Cologne, the Haus ohne Eigenschaften (House without Qualities).

What I particularly appreciated about the Speck Collection were the drawings, which few people knew about at the time. Long before the Rheingold sales negotiations began, I asked Peter Weibel, who had been chief curator of the Neue Galerie Graz since 1992, whether he would like to show Speck's works on paper. At the time, my proposal didn't get much of a response in Cologne, where I obviously asked first, but Weibel immediately agreed. In 1994, under the title *Drawing-Room*, we presented a sequence of rooms with blocks of drawings by twenty artists, each accompanied by a sculpture. Along with works from the older generation, such as Andre, Beuys, Broodthaers, Kounellis, Merz, Polke, Twombly, and Bruce Nauman, groups of works by artists from the 1980s and 1990s were on view at the Joanneum for the first time, including Kippenberger, Günther Förg, Albert Oehlen, Georg Herold, Hubert Kiecol, Rosemarie Trockel, Jörg Schlick, and Raymond Pettibon. As with *Köln sammelt*, I worked together with my wife, Dorothea, who once again edited the catalogue. For Speck, it was a breakthrough in public perception. Two years later, the Museum Ludwig showed Speck's complete collection.

Also in 1994, along with the archivist Wilfried Dörstel, I presented the exhibition *Vergangenheit, Gegenwart, Zukunft* (Past, Present, Future) at the Bundeskunsthalle in Bonn, in which the Central Archive for German and International Art Trade (ZADIK) presented the work it had begun two years earlier. There, it was publicly revealed which archives of important gallerists, art dealers, collectors, and art critics were entrusted to ZADIK and how significant the researching and cataloguing of these archives was for recent art (market) history.

A short time later, Ulrich Eckhardt, the artistic director of the Berliner Festspiele, hired me, together with the art historian Eckhart Gillen, as cocurator of the exhibition

A portrait of Rudolf Zwirner by Raymond Pettibon with the text
"Dramatise It, Dramatise It!" (2008)

Deutschlandbilder (Images of Germany), which took place at the Martin Gropius Bau in Berlin in 1997. It was intended to provide a "diagnosis" in the field of the visual arts eight years after the Peaceful Revolution. Gillen was the expert for East German art, and I was responsible for art from West Germany. As the trusted adviser of numerous collectors, I was able to acquire important loans. The fact that I had proved to be open-minded toward the East may also have contributed to my being hired in the first place. In 1993, at the invitation of Hamburg's senator for culture, Christina Weiss, who later became federal commissioner for culture, I tried to revive Art Hamburg as a fair for Eastern European art. At that time, there was a sense of euphoria in the air: everyone from the West was traveling to Moscow, rediscovering the Russian avant-garde, and learning more about young art from Russia. I became acquainted with the Moscow conceptualists Pavel Pepperstein and Vadim Zakharov, with whom I later collaborated.

My vision of the Hanseatic city not only as a gateway to the North—and, in the future, likewise to the East—but also as a point of contact for Russian, Polish, Hungarian, and Czech galleries was not to be realized, however, because the art trade in these countries developed much more slowly than one had hoped. For the first edition of Art Hamburg, I found sponsors for the galleries from Eastern Europe. When the galleries had to pay their own fees for the next edition, they stayed away. A continuation of the Eastern European art fair was not feasible owing to lack of funds.

With *Images of Germany*, I finally returned for good to my hometown of Berlin. The exhibition reflected the development of the divided Germany up to the present day—beginning, however, not with the building of the Berlin Wall but with my birth year of 1933, when artists were driven into exile by the Nazis. For the signature image, we chose Ernst's raging *L'ange du foyer* from 1937, in which the painter was reacting directly to the Spanish Civil War and addressing his own situation as a persecuted artist. We selected a total of

five hundred works by ninety-one artists, and my wife, Dorothea, contributed to the catalogue as an author. The comprehensive exhibition was met with a great response. Ulrich Eckhardt immediately wanted to win me over for the next mammoth project, this time not limited to the East–West dialogue but rather intended to be global, going far beyond Europe. I turned him down, however: I lacked the standards to judge so-called world art, such as creative work from China or countries in Africa.

15

Finally Back Home in Berlin

Initially, I had no intention of closing my gallery permanently. I simply wanted to move it to Berlin. All my life, I had planned to return to my hometown as soon as it was possible to travel there by car or train without having to stop at checkpoints. I could not bear the controls at the border to East Germany; they evoked memories of the restrictions during the Third Reich. But the straw that broke the camel's back was a particular experience with East German officials, after they had discovered six leftover pork tenderloins in the trunk of my car. I had forgotten they were in a plastic bag behind the spare tire, where they had already started to rot. I was accused of wanting to smuggle in the spoiled meat and poison the citizens of the German Democratic Republic. The accusations, the subsequent interrogation in the barracks, the smell of a certain cleaning agent—all this was deeply engraved in my memory. I did not want to experience anything like that ever again, and from then would only fly between Cologne and Berlin. But the moment the Wall came down, I immediately traveled there with my wife to experience the celebration first-hand, knowing that the political shift would be a personal one for me as well. I was drawn back to Berlin.

It did not happen as quickly as I had hoped, although I soon found a suitable space for my gallery at the upper end of Kurfürstendamm. My plans were, however, thwarted by my managing director, Brigitte Ihsen, whom I had completely relied on for the move. She had no intention of leaving Cologne, which I had not expected. Brigitte, who had previously completed her training at Dieter Brusberg's gallery in Hannover, had worked for the gallery since the move to Albertusstrasse 18. At the openings, she stood at the door with me to greet the guests; everyone knew and respected her. She was an integral member of the company, had complete independence, and even determined her own salary. But she did not want to make a new start in Berlin. When I told her that I would have to give her notice, things got complicated. Her refusal to come with me to Berlin had taken the wind out of my sails; I needed a reliable gallery manager to get started in Berlin, because I wanted to spend more time with my young wife and our two small children, Julius and Louise. So I decided to close the gallery in Cologne after thirty years—I had always wanted to do other things, too, and had never seen myself as a businessman, only art dealer. And for me, the gallery also had a political side to it, with which I had been able to make an impact in the city. With the fall of the Berlin Wall, the new German capital once again acquired a cultural-political power that appealed to me. I wanted to be at the epicenter of the coming changes.

At the same time, I also felt increasingly estranged from the younger scene, which is not surprising, as I believe you can only fully understand, in all its depth, the art of your own generation. An infinite number of parallel experiences— music, film, literature, fashion, advertising—go into a work of art, and are not necessarily accessible to later generations. I could have shown only the art of my time, with artists such as Richard Hamilton, Andy Warhol, and Gerhard Richter. But I did not want that either. After all, I saw myself not as an art historian but rather as a mediator of contemporary art. I always wanted the now. I presented exhibitions with

works by Albert Oehlen, Martin Kippenberger, and Hubert Kiecol, but the distance between the new generation of artists and myself only grew, and I gradually lost contact with the present. My time was running out. Clueless, I turned to Astrid Klein, because I hoped, through her, to intensify my exchange with Sigmar Polke and, in turn, to continue the exchange with younger artists. But even she could not help me.

I lacked orientation; there were no more isms. When I began traveling to the United States in the 1960s, I regularly picked up catchphrases for particular artistic tendencies: after pop art, it was minimalism, conceptualism, land art, and pattern art—until, with postmodernism in the 1980s, everything got lost in a grand state of arbitrariness. Up until this point, art dealers, collectors, and museums tended to favor a particular style; they could define the focus of their collection and make targeted acquisitions. Today, artistic production is much more diverse, and museums have to buy whole groups of works to reflect the panorama of contemporary artistic production. Keeping up to date was now beyond my capabilities. This expanded concept of art is necessary, but it makes it much more difficult to assess new art. There are no longer any universally valid criteria; the standards have become relative.

As a young and successful gallerist, I was able to follow how art was the result of creative impulses in response to various crises, and how it developed from there. I experienced the triumphal procession of pop art as a reaction to abstract expressionism; in Europe, pop artists had their counterpart in the Nouveaux Réalistes, who emerged in reaction to the gestural abstraction of art informel. The economic crisis of the 1970s, in turn, brought about a more reflective, less opulent art. This phase was intellectually energizing and actually the most exciting, if not the most successful in terms of sales. The skyrocketing prices and the profit margins in the next decade altered our relationship to art: it became an object of speculation. Now a new group of buyers was primarily interested in the financial value of a work, not in the significance

of its content or even in the larger scope of art history. My goal was never purely financial success—through my (pre) occupation with art, I wanted to be stimulated.

Although I participated in the boom of the 1980s, I was no longer mentally involved in it. When the stock market went into crisis in 1987, and the prices for art began to tailspin, the end of the grand era of Cologne began. The unification of Germany soon after gave me the impetus to make a new start. It took another three years before my gallery finally closed, though, as the plans for shifting the business to Berlin were abandoned after the initial enthusiasm and there was a transitional period until Karsten Greve could seamlessly take over the space in Cologne. My former managing director, Brigitte, continued to work for him until she set up her own business on Sankt Apern Strasse, not far from my gallery, with the severance pay and some prints she received from me. Unfortunately, she was not able to keep up the business for long. In its last years, her gallery's sales diminished dramatically, as a difficult time began again for the art trade. At this point, Hein Stünke and I had already developed the idea of a central archive for the German art trade, and I made it my task to build it up after I stepped away from my gallery activities in 1993.

The date for the move was finally set when I realized how extensive the preparations would be for the exhibition *Images of Germany*. So, in 1996, one year before the opening, I finally moved with my family to Berlin. As I was responsible for the art representing West Germany, the large-scale exhibition of the Berliner Festspiele at the Martin Gropius Bau became something akin to a stocktaking of my own professional activity, at least on a national level. Otto Dix, Max Ernst, John Heartfield, Ernst Wilhelm Nay, Wols, Konrad Klapheck, Joseph Beuys, Georg Baselitz, Sigmar Polke, Gerhard Richter, Blinky Palermo, Franz Erhard Walther, Hans Haacke, Olaf Metzel, Werner Büttner, Martin Kippenberger, Astrid Klein—they were all there again. With this exhibition, a new phase in my life began.

Coincidence or not, at the very moment I finally gave up the gallery in Cologne, my son David decided to establish a new one in New York. It was fitting, because we could not have existed side by side. I did not want any competition within the family, especially in which I would inevitably be the loser. Dynastic thinking was far from my mind anyway; everyone had to go his or her own way. David's path had initially been music. The impulse for his shift toward art didn't come from me—certainly not his career choice as a gallerist. But David grew up with art; it had surrounded him ever since his childhood. So the decision came as no great surprise. Still, the beginning of 1993 seemed to be the worst possible time for such a new beginning—as a result of the economic crisis, galleries all around Manhattan had been forced to close down.

For my son, however, it was a stroke of good luck that he was starting out in a bear market, which meant he was able to work with international artists right away. Collectors trusted him: in New York, the Zwirner name meant something. In the early 1990s, David had a good starting position and was able to draw on holdings of unsold paintings in the United States and Europe. German art dealers, who found no buyers either in their own country or in the United States, gave their works to David on commission. Just as I had built on the art of my "fathers" and earned my money as an art dealer with the surrealists, new objectivity, and the modern classics, he sold Polke, Richter, and Klapheck to finance his gallery. In his physical gallery space, however, he exhibited artists of his own time.

In everything he does, David represents the next generation of artists and gallerists, a completely new era. While I could count on only ten or twelve collectors, at times relying almost entirely on Peter Ludwig, who then dictated the prices, David's gallery now looks after thousands of international collectors and has clients all over the world. Like all major international gallerists, he has branches in London and Hong Kong, and since October 2019 in Paris as well. In New

David Zwirner at the exhibition *Wie die Pop Art nach Deutschland kam*
(How Pop Art Came to Germany), organized by ZADIK, Art Cologne, 2015.
The black-and-white photograph at left shows a young David seated
in front of Andy Warhol's *Elvis* (1963) during the opening of the new gallery
at Albertusstrasse 18, Cologne, 1972.

York, he is having a new gallery space built by Renzo Piano; his son, Lucas, runs the in-house publishing company, and his daughter Marlene works with artists and estates. The gallery employs more than two hundred people, and well over two staff members are responsible for the personal care of each of his more than seventy artists and estates. In my time, the scope was very different. In Cologne, my gallery building was also designed by an avant-garde architect, my turnover was 10 to 12 million euros a year, and the team was manageable. Communication and the networking of the market worked differently. With the Japanese's new interest in impressionists and their entry into auctions in the 1980s, the globalization of art accelerated. Better flight connections, fax machines, and computers increased the pace. Today, the internet dominates business. Within fractions of a second, a selection of works can be emailed simultaneously to an infinite number of collectors, or it can be tailored to clients' individual preferences. The virtual marketing of art is still in its infancy, but apps and algorithms are already being developed to determine collector profiles and deliver individual offers to customers' cell phones. "I'm at the beginning of my career," as David puts it, to give a sense of what this next phase in the business might mean.

But this development of a virtual turbo art market began with the first contemporary art fair in Cologne in 1967. In view of what has unfolded since, I sometimes feel like the sorcerer's apprentice, whose very life was threatened by the forces he summoned. In the 1960s, young gallerists aggressively brought art to a veritable marketplace; inspired by Warhol, we blew up the exclusivity of the business in order to tap into new customer groups in a period of crisis. At the time, we could not have known that in doing so we would one day pull the rug out from under galleries as such. As the fairs became the more important forum for business, auction houses began trading in contemporary art, and trade in general migrated to the internet. And yet I continue to believe in the future of the physical gallery. The art world cannot

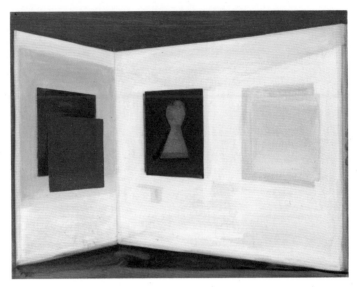

René Daniëls, *Lola de Balance*, 1987. Oil on canvas, 51⅛ × 66⅞ inches |
130 × 170 cm. Collection of Rudolf Zwirner

Jean Dubuffet, *Texturologie XXVI*, 1958. Oil on canvas, 45 × 57⅞ inches |
114.5 × 147 cm. Collection of Rudolf Zwirner

Helmut Federle, *Corner Field Painting XXXXII*, 1999. Oil and artificial resin on canvas, 19¼ × 23¼ inches | 49 × 59 cm. Collection of Rudolf Zwirner

survive without it; it's the expertise that counts. The gallery is where the real work of art is viewed and contemplated. This applies not least of all to museums, where artistic positions are evaluated to this day, determining whether certain works of art have a chance of entering the canon of art history. There, a work remains for eternity, so to speak—at least it should. Like a museum, the ideal private collector thinks not of reselling the work he has just acquired but rather of continuing his commitment in order to open up a particular artistic field for him or herself, as well as for posterity.

The future of the gallery lies especially in the realm of the analog, in smaller events on site, in personal conversations, the direct meeting between the artist and an audience in a defined space. I practice this today on a personal level, with visits to exhibitions and chamber concerts, or during evenings of animated discussions in my home. I still discover artists for myself, and follow and support them; some of note include Albrecht Schäfer, Bernd Ribbeck, Raphael Danke, Kathrin Sonntag, Natalie Czech, and, most recently, Jakob Mattner. And now, I keep the acquired works. Today I own a collection of antiques, contemporary works on paper, European drawings by the likes of Adolph Menzel, Victor Hugo, and Max Ernst, nineteenth-century paintings, works by contemporary artists such as Stan Douglas, Helmut Federle, and René Daniëls, and sculptures by Gary Kuehn and Franz West.

As in my days in Cologne, I continue to be active in cultural politics. When a former colleague recently asked me at Art Basel, "So, Zwirner, are you still getting into trouble?" I could answer heartily in the affirmative. When Germany's federal commissioner for culture launched the new Cultural Property Protection Act—which restricts certain cultural property from being exported—in 2016, I was one of the most vehement opponents, writing open letters and initiating advertising campaigns. Alas, this was in vain, as we were ultimately unable to prevent it. The whole industry will endure the consequences of this in the coming years. The trade in important works, the high-price segment, will increasingly

Louis Soutter, *Bouquet de fleurs dans un vase*, 1906. Watercolor on paper,
14⅜ × 12⅞ inches | 36.5 × 33 cm. Collection of Rudolf Zwirner

Vilhelm Hammershoi, *Frederiksborg Castle*, 1896. Oil on canvas, 17⅞ ×
14⅛ inches | 45.5 × 35.9 cm. Collection of Rudolf Zwirner

Rudolf Zwirner, seated on Franz West's *Liege (Doppelsitz)* (1989) under the work *Berlin Series* (1979) by Gary Kuehn, in his home in Berlin, 2020

shift abroad, out of concern that it will no longer be feasible to export art from Germany. Although this dispute made me angry, the tones have become quieter in general, because I no longer represent my own business. My mind is free. I pass on what I have experienced, and my assessment of the situation. In 2000, I was appointed an honorary professor at the Braunschweig University of Art, where I gave lectures on pop art and on the strategies of artists, collectors, and art dealers. To this day, I give lectures on the selling of modern art, the development of the art trade since 1945, the influence of major exhibitions such as Documenta in Kassel and the Venice Biennale on the reception of art, the consequences of auction trading for the market, and many other topics related to the business of art.

Following my childhood during the Third Reich and adolescence in the postwar period, I experienced the drive for reconstruction and the so-called economic miracle in Germany as an art dealer and a gallerist. This initial situation created deficits and advantages for the art trade. The lack of internationality after years of isolation enforced by the National Socialists heightened the need to catch up with the United States. The experience of the war, the knowledge of how easily everything can be lost, and the instability of the postwar period all still inform and impact my actions today. And my thinking: higher and higher prices is not the goal.

Since my beginnings in art more than fifty years ago, the trade has been revolutionized. But one thing has remained the same: It still revolves around works of art. Artists still produce works and need to be supported. As gallerists, we have to accept economic globalization. It is one side of the coin, but on the other side is local artistic production, which must be highlighted and championed. The virtual sphere may be shaping business today, but art itself must remain tangible. Galleries' opportunity lies in strengthening the analog even as they branch further into the digital; that is also true for the next generation of gallerists. And support for artists—and culture in general—is definitely worth fighting for.

Many people have suggested that I consider writing my own autobiography, but I never really wanted to do it any more than I wanted to be portrayed by an artist or start my own art collection. I always wanted the now, not to look back or become too preoccupied with my own life experiences. However, as I became more thoughtful with age, I wanted to play an active role in the telling of my story in the art world.

The decisive impetus for this project came from my friends Antje and Bernhard Kischk, who have heard my story, or rather stories, so often that they wanted to see a version of it between two book covers. However, since I am a man of the spoken word, it was necessary to find a suitable written form. With the financial support of the VivArte Foundation, the cultural journalist Christiane Hoffmans conducted initial interviews with me. Based on these conversations, Nicola Kuhn developed a concept for the autobiography. It included her own interviews with me as well as interviews already published by Regina Wyrwoll and Heinz Peter Schwerfel. It is thanks to her meticulous way of working, in which she repeatedly questioned and, as far as possible, checked all my stories, that my voice has found a readable form. For this, I owe her my deepest gratitude.

Like many, my life has been marked by coincidences, shifts, and quick decisions, with all the accompanying risks and opportunities. In helping me recount these many phases, I am thankful for conversations with my wife, Dorothea, and with companions and contemporary witnesses, in particular Kasper and Walther König, Gerhard Richter, Reiner Speck, and Wulf Herzogenrath. I would like to express my gratitude to Andreas Prinzing for not only transcribing interviews but also checking names and facts, and to Rosa Baumgartner of Wienand Verlag for her careful editing of the German edition.

As a cofounder of ZADIK, to which I have entrusted my gallery's archive, I am filled with gratitude that its former director, Günter Herzog, has helped with critical readings of the manuscript and the acquisition of images. My thanks also go to Dieter Beuermann, who accompanied the

project through all its phases. For supporting my autobiography, which is inseparably linked to the city of Cologne, I would like to thank Mayor Henriette Reker and the chief executive officer of Koelnmesse, Gerald Böse.

I would like to extend my thanks to Gérard Goodrow for his translation from the German and to Elizabeth Gordon for her work on the English edition. I am grateful to my son David for his enormous support of this publication and to my grandson Lucas for his engaged reading of the English edition. It is particularly meaningful that this project has found a home with David Zwirner Books.

Exhibitions and Happenings,
Galerie Rudolf Zwirner

*Exhibitions and Happenings
are listed chronologically by year
and also within each year.*

Kahrstrasse 54, Essen

1959
· *Eröffnungsausstellung: Moderne
Druckgrafik* (Inaugural Exhibition:
Modern Prints)

1960
· *Hann Trier: Aquarelle, Zeichnungen
und Druckgrafiken* (Watercolors,
Drawings, and Prints)
· *Victor Vasarely: Gouachen und
Editionen der Galerie Denise René*
(Gouaches and Editions from
Galerie Denise René)
· *Alan Davie*
· *Gerrit Benner: Gemälde, Gouachen
und Zeichnungen* (Paintings,
Gouaches, and Drawings)
· *E. W. Nay und Joseph Fassbender:
Aquarelle, Mischtechniken und
Grafiken* (Watercolors, Mixed-Media
Works, and Prints)
· *Karel Appel*

1961
· *Jesús Rafael Soto and Vassilakis Takis*
· *Japanische Kalligraphie* (Japanese
Calligraphy)
· *Antoni Tàpies*
· *HAP Grieshaber*
· *Rupprecht Geiger: Bilder und Grafiken*
(Paintings and Prints)
· *Cy Twombly: Gouachen und
Zeichnungen* (Gouaches and
Drawings)
· *Günter Ferdinand Ris: Bilder und
Zeichnungen* (Paintings and Drawings)
· *E. W. Nay and Joseph Fassbender*

1962
· *Konrad Klapheck*
· *Appel, Ernst, Geiger, Laurens, Picasso,
Riopelle, Twombly, Vasarely*
· *Antoni Tàpies: Bilder und Grafiken*
(Paintings and Prints)
· *Sesson Uno: Japanische Kalligraphien*
(Japanese Calligraphies)

Kolumbakirchhof 2, Cologne

1962
· *Eugène Dodeigne: Plastik und Zeichnung* (Sculptures and Drawings)
· *Inoue Yūichi: Kalligraphien* (Calligraphies)
· *Robert W. Munford: Bilder und Gouachen* (Paintings and Gouaches)

1963
· *Roel D'Haese: Bleistift- und Federzeichnungen* (Pencil and Pen Drawings)
· *Jacques-Charles Delahaye*
· *Cy Twombly*
· *Zeichnungen von Schimpansen und Gorillas* (Drawings by Chimpanzees and Gorillas)
· *Matija Skurjeni*
· *Jugoslawische Volksmaler* (Yugoslavian Folk Art Painters)
· *Maurice Wyckaert: Bilder* (Paintings)
· *Rupprecht Geiger: Bilder und Zeichnungen* (Paintings and Drawings)
· *Daniel Spoerri: ... bis das Ei hart gekocht ist* (... Until the Hard-Boiled Egg Is Finished)
· *Bruno Goller*
· *Konrad Klapheck*

1964
· *Antoni Tàpies: Collagen und Zeichnungen* (Collages and Drawings)
· *Jim Dine: Bilder, Aquarelle und Zeichnungen* (Paintings, Watercolors, and Drawings)
· *Bengt Lindström*
· *Daniel Spoerri und Robert Filliou: Wortfallen* (Word Traps)
· *Mark Brusse: Plastiken* (Sculptures)
· *Jean Tinguely: Métamécaniques und Wasserplastiken* (Metamechanics and Water Sculptures)
· *Wasserplastiken im Garten Wolfgang Hahn, Koppensteinstrasse 2, Köln* (Water Sculptures in the Garden of Wolfgang Hahn, Koppensteinstrasse 2, Cologne)
· *Bruno Goller*

· *Nikifor: Aquarelle* (Watercolors)
· *Bilder und Skulpturen: D'Arcangelo, Beuys, Dine, Dubuffet, Geiger, Goller, Jensen, Kampmann, King, Klapheck, Laing, Lichtenstein, Oldenburg, Rauschenberg, Spoerri, Tàpies, Tinguely, Twombly* (Paintings and Sculpture)
· *Jean Tinguely*

Albertusstrasse 16, Cologne

1964
· *Eröffnungsausstellung* (Inaugural Exhibition) (catalogue)
· *Konzert von Michael von Biel zur Einweihung der neuen Räume* (Concert by Michael von Biel on the occasion of the inauguration of the new gallery space)

1965
· *René Magritte: Bilder und Gouachen* (Paintings and Gouaches)
· *HAP Grieshaber: Entwürfe zur Entstehung eines Holzschnitts* (Drafts for the Creation of a Woodcut)
· *D'Arcangelo: Bilder – John Chamberlain: Plastiken* (D'Arcangelo: Paintings – John Chamberlain: Sculptures)
· *Konzert von Frederic Rzewski und Michael von Biel* (Concert by Frederic Rzewski and Michael von Biel)
· *Antoni Tàpies: Bilder* (Paintings) (catalogue)
· *Alan Davie: Bilder* (Paintings)
· *Konzert von Charlotte Moorman und Nam June Paik* (Concert by Charlotte Moorman and Nam June Paik)
· *Lesung von F. Achleitner, H.C. Artmann, G. Rühm aus der Wiener Gruppe sowie Gunter Falk aus Graz (Veranstalter Antiquariat Horst Nibbe)* (Readings by F. Achleitner, H.C. Artmann, and G. Rühm from the Vienna Group, as well as Gunter Falk from Graz [Presented by Antiquariat Horst Nibbe])

· *Inoue Yūichi: Kalligraphien*
(Calligraphies)
· *Jean Dubuffet: Bilder 1944–1964*
(Paintings 1944–1964) (catalogue)
· *Miró, Ernst, Dalí, Bellmer:*
Druckgrafik (Prints)
· *Matija Skurjeni, Ivan Lackovic:*
Bilder und Zeichnungen (Paintings
and Drawings) (catalogue)
· *Constant, Grosz, Goller (Accrochage)*
(from the gallery's holdings)

1966
· *Constant Anton Nieuwenhuys:*
Bilder, Gouachen und Plastiken
(Paintings, Gouaches, and Sculptures)
· *Ferdinand Spindel: Meditationsräume*
(Meditation Rooms) (catalogue)
· *Piero Dorazio*
· *Ay-O*
· *Neue Sachlichkeit: Bilder, Aquarelle*
und Zeichnungen (New Objectivity:
Paintings, Watercolors, and
Drawings) (catalogue)
· *Eugène Dodeigne: Plastiken und*
Zeichnungen (Sculptures and
Drawings) (catalogue)
· *Konkrete Kunst der Schweiz*
(Concrete Art from Switzerland)
· *Agatha Wojciechowsky: Aquarelle und*
Zeichnungen (Watercolors and
Drawings)
· *H.C. Artmann (Lesung)* (Reading)
· *Dan Flavin: Leuchtstoffröhren*
(Fluorescent Tubes) (catalogue)
· *Henri Michaux: Aquarelle, Frottagen*
und Zeichnungen von 1946–1966
(Watercolors, Frottages, and Drawings
1946–1966) (catalogue)

1967
· *Andy Warhol: Kühe und schwebende*
Kissen (Cows and Floating Pillows)
· *Asger Jorn: Radierungen, Lithografien*
und illustrierte Bücher von 1939–
1966 (Etchings, Lithographs, and
Illustrated Books, 1939–1966)
· *Twyla Tharp*

· *Gilardi, Klapheck, Lichtenstein,*
Louis, Noland, Oldenburg, Pistoletto,
Stella, Tàpies, Tinguely, Twombly:
Bilder und Plastiken (Accrochage)
(Paintings and Sculptures) (from the
gallery's holdings)
· *Helmut Heissenbüttel: Lesungen*
(Readings)
· *Jim Dine: Zeichnungen* (Drawings)
· *Michelangelo Pistoletto*
· *Piero Gilardi: Naturteppiche*
(Natural Carpets)
· *Andy Warhol: Most Wanted*
· *John Chamberlain: Skulpturen*
(Sculptures)
· *William Tucker: Skulpturen*
(Sculptures)
· *Matija Skurjeni und Ivan Lackovic:*
Bilder, Zeichnungen (Paintings
and Drawings)
· *Ten from Castelli*
· *K.H. Hödicke*
· *Michelangelo Pistoletto*

1968
· *Rauschenberg, Lichtenstein*
· *Dan Flavin*
· *Bilder, Zeichnungen, Skulpturen –*
Albers, Fontana ... (Paintings,
Drawings, and Sculptures) (catalogue)
· *Ed Ruscha: Self*
· *Gerhard Richter*
· *Neuerwerbungen* (Recent Acquisitions)
· *Neil Jenney*
· *Bernard Schulze, Franz Erhard*
Walther, Marcel Broodthaers, Jean
Tinguely (Accrochage) (from the
gallery's holdings)
· *Dieter Roth: Vergrösserte*
Kleinigkeiten (Enlarged Trifles)

1969
· *Cy Twombly*
· *George Brecht: The Book of the Tumbler*
on Fire, 20 Footnotes to Volume I
(catalogue)
· *James Turrell*

· *Neuerwerbungen von Arman,*
Dubuffet, Goller, Hacklin, Johns,
Klapheck, Morris, Louis, Nauman,
Nevelson, Noland, Richter, Segal,
Tinguely, Twombly, Warhol
(Recent Acquisitions)
· *Donald Judd: Skulpturen*
(Sculptures)
· *Sigmar Polke*
· *Eduardo Paolozzi*
· *Haus-Rucker-Co (Laurids, Zamp,*
Pinter) (catalogue)
· *Öyvind Fahlström* (catalogue)
· *Panamarenko: Das Flugzeug*
(The Airplane)

1970
· *Allen Jones: Skulpturen* (Sculptures)
(catalogue)
· *David Novros*
· *Blinky Palermo*
· *Neuerwerbungen* (Recent
Acquisitions)
· *Richard Tuttle*
· *Arbeiten von vier jungen Hamburger*
Künstlern: Heise, Rose, Schröder,
Voigt (Works by Four Young Artists
from Hamburg)
· *Almut Heise and Rolf Rose*
· *Larry Bell*
· *Larry Bell and William Stewart*
· *Max Ernst: Bilder* (Paintings)
· *Blinky Palermo: Bilder* (Paintings)

1971
· *Yves Klein and Cy Twombly*
· *Agatha Wojciechowsky*
· *Richard Lindner: Fun City* (Portfolio
with 14 Color Lithographs)
· *Konrad Klapheck*
· *László Moholy-Nagy: Fotogramme*
(Photograms) (catalogue)

1972
· *Accrochage* (From the Gallery's
Holdings)
· *Tom Phillips*
· *Neuerwerbungen* (Recent
Acquisitions)

Albertusstrasse 18, Cologne

1972
· *Amerikanische Künstler* (American
Artists)
· *Louis Soutter: Zeichnungen 1936–*
1942 (Drawings, 1936–1942)
· *Richard Tuttle: Drahtstücke 1971–*
1972 (Wire Pieces, 1971–1972)
· *Georg Baselitz*
· *Marcel Broodthaers: Peinture*
Littéraire 1972–1973
· *Film Analyse eines Bildes* (Film
Analysis of a Painting)
· *Gerhard Richter*
· *David Hockney: Photographische*
Bilder (Photographic Paintings)

1973
· *Bill Beckley*
· *Konzeptuelle Künstler, Konzeptuelle*
Kunst: Robert Barry, Art & Language
(Conceptual Artists, Conceptual Art)
· *John Wesley*
· *Barry Le Va*
· *Dan Graham*
· *John Wesley: Bilder* (Paintings)
· *Ausgewählte Grafik* (Selected Prints)
(catalogue)
· *Ben Vautier: Neue Bilder* (New
Paintings)

1974
· *Robert Graham: Skulpturen 1973–*
1974 (Sculptures, 1973–1974)
(catalogue)
· *Louis Cane: Objektbilder* (Object
Paintings) (catalogue, with a text by
Marcelin Pleynet)
· *Klaus Ritterbusch: Bilder, László*
Moholy-Nagy: Mappen mit
Fotografien, Fotogramme,
Fotoplastiken (Klaus Ritterbusch:
Paintings, László Moholy-Nagy:
Portfolios with Photographs,
Photograms, and Photo-sculptures)
· *Gerhard Richter: Farbfelder*
(Color Fields)

- *Michael von Biel: Akademische
 Landschaftszeichnungen und
 Collagen 1974* (Academic Landscape
 Drawings and Collages, 1974)
- *Sigmar Polke*
- *Robert Graham: Skulpturen 1973–74*
 (Sculptures, 1973–1974)
- *Asta Nielsen: Plakate, Fotografien,
 Filme* (Posters, Photographs, and
 Films)
- *Alfred Wallis, Elizabeth Allen, and
 Stathis Economou*
- *Sigmar Polke*
- *Jannis Kounellis*

1975
- *Robert Rauschenberg*
- *Frank Stella: Bilder* (Paintings)
- *L'Art brut und Kunst der
 Geisteskranken aus der Sammlung
 Arnulf Rainer* (Art Brut and Art
 of the Mentally Ill from the Collection
 of Arnulf Rainer)
- *Gustav Wimmer: Zeichnungen
 und farbige Blätter* (Drawings and
 Colored Works on Paper)
- *Giuseppe Penone*
- *Jannis Kounellis: Boulevard de la
 Solitude*
- *Accrochage* (From the Gallery's
 Holdings)

1976
- *Markus Lüpertz: Bilder 1972 bis 1976*
 (Paintings, 1972–1976) (catalogue,
 with a text by Reiner Speck)

1977
- *Jasper Johns: Radierungen zu Samuel
 Beckett* (Etchings on Samuel Beckett)
- *Konrad Klapheck: Zeichnungen
 und das gesamte druckgrafische
 Werk 1960–1977* (Drawings and the
 Complete Prints, 1960–1977)
 (catalogue)
- *Robert Rauschenberg: Arbeiten aus
 den Jahren 1976–1977* (Works from
 1976–1977)

- *Chamberlain, Cornell, Graham,
 Johns, Lichtenstein, Rauschenberg,
 Warhol, Wesselmann, Samaras,
 and Twombly (Accrochage)* (from the
 gallery's holdings)
- *Asger Jorn*
- *Jean Dubuffet: Théâtres de mémoire,
 Assemblagen 1976–1977*

1978
- *Bernhard Leitner: Ton-Raum*
 (Sound-Space)
- *Giuseppe Penone*
- *Salvador Dalí: La gare de
 Perpignan – Pop, Op, Yes-Yes Pompier,
 Les Chants de Maldoror*
- *Accrochage* (From the Gallery's
 Holdings)
- *Daniel Dezeuze: Neue Arbeiten*
 (New Works)
- *Agatha Wojciechowsky: Bilder und
 Zeichnungen 1952–1976* (Paintings
 and Drawings, 1952–1976) (catalogue)
- *Baselitz, Brus, Penck, Rainer:
 Handzeichnungen* (Drawings)
- *CPLY: Variationen über ein Thema
 von Francis Picabia* (CPLY: Variations
 on a Theme by Francis Picabia)
- *Agnes Martin*

1979
- *Robert Wilson: Skulpturen
 & Zeichnungen* (Sculptures and
 Drawings)
- *Arnulf Rainer: Totenmasken* (Death
 Masks)
- *Robert Zakanitch*
- *Hannes Jähn*
- *Robert Wilson: Möbel* (Furniture)

1980
- *Konrad Lueg: Bilder 1965–66*
 (Paintings, 1965–1966)
- *Jean Dubuffet: Kleine Bilder und
 Zeichnungen von 1979* (Small
 Paintings and Drawings from 1979)
 (catalogue)
- *Susan Rothenberg: Bilder und
 Gouachen* (Paintings and Gouaches)

· *Heinz Breloh: Fotografien und Plastiken* (Photographs and Sculptures) (catalogue)
· *L'Art brut: Arbeiten von Darber, Ramirez, Soutter* (Art Brut: Works by Darber, Ramirez, and Soutter)
· *Handzeichnungen des 20. Jahrhunderts mit Werken von Baselitz, Baumeister, Bellmer, Broodthaers, Christo, Dalí, Dix, Dubuffet, Ernst, Feininger, Francis, Grosz, Hockney, Immendorff, Kirchner, Klee, Kubin, Laurence, Leger, Magritte, Matisse, Nay, Penck, Schlemmer, Tanguy, Twombly* (Twentieth-Century Drawings)
· *Neuerwerbungen: Borofsky, Butterfield, Chia, Clemente, Cornell, Cucchi, Davis, Kelly, Kushner, Mariani, Paladino, Penone, Robbins, Rosenquist, Saret, Schapiro, Smyth, Stella, Sugarman, Wolf, Zakanitch* (Recent Acquisitions)
· *George Sugarman: Neue Arbeiten* (New Works)
· *Sigmar Polke*

1981
· *Alan Saret: Skulpturen und Zeichnungen* (Sculptures and Drawings)
· *Wolfgang Volz: Fotografien des Running Fence von Christo* (Photographs of Christo's Running Fence)
· *Miriam Schapiro: Neue Bilder* (New Paintings) (catalogue, with a text by Max Kozloff)
· *Jonathan Borofsky: Installationen, Zeichnungen, Bilder* (Installations, Drawings, and Paintings)
· *Kim MacConnel*
· *Deborah Butterfield: Skulpturen von 1980* (Sculptures from 1980)
· *De Andrea, Balla, Beuys, Dalí, and Fautrier*

· *Herbin, Klee, Magritte, Matta, Picabia, Picasso, Rauschenberg, Tanguy, Twombly: Bilder, Skulpturen, Zeichnungen* (Paintings, Sculptures, and Drawings)
· *Cy Twombly: Bilder, Alan Saret: Skulpturen, Bruce Robbins, Kim MacConnel (Accrochage)* (Cy Twombly: Paintings, Alan Saret: Sculptures, Bruce Robbins and Kim MacConnel) (from the gallery's holdings)

1982
· *Ruven Levav*
· *Gloria Nardin: Fotografien* (Photographs)
· *Robert Kushner*
· *Felix Droese: Papierschnitte, Zeichnungen, Objekte* (Papercuts, Drawings, and Objects)
· *Salomé*
· *Jürgen Klauke (auf leisen Sohlen): Neue Foto-Arbeiten und Zeichnungen* ([Silent Footsteps]: New Photo Works and Drawings)
· *John Ahearn: Skulpturen* (Sculptures)
· *Krimhild Becker: Foto-Arbeiten* (Photo Works)
· *Robert Kushner*
· *Jürgen Klauke*
· *Georg Baselitz: 16 Holzschnitte rot schwarz 1981–82* (16 Woodcuts Red Black, 1981–1982) (with Galerie Fred Jahn, Munich) (catalogue, copublished by Galerie Rudolf Zwirner, Cologne, and Fred Jahn, Munich; edited by Fred Jahn and Rudolf Zwirner; text by Per Kirkeby)

1983
· *Chicago School: Roger Brown, Jim Nutt, and Ed Paschke*
· *Per Kirkeby: 15 Tafeln von 1982* (15 Panels from 1982)
· *A. R. Penck: Zwei 14-teilige Arbeiten von 1977* (Two 14-Part Works from 1977)
· *Bruce Robbins: Neue Arbeiten 1982–1983* (New Works, 1982–1983)

- *Büttner, Dahn, Dokoupil,*
 Kippenberger, A. Oehlen, M. Oehlen:
 Neue Arbeiten (New Works)
- *Franz Hitzler: Bilder und Arbeiten auf*
 Papier (Paintings and Works on Paper)
- *Martin Kippenberger: Kennzeichen*
 eines Unschuldigen (83.07.24)
 (Signs of the Innocent One [83.07.24])
- *Arp, Baselitz, Clemente, Dubuffet,*
 Kandinsky, Kiefer, Klapheck, Nay,
 Oldenburg, Penone, Picasso, Richter,
 Soulage, Spoerri, Tàpies, and
 Twombly (Accrochage) (from the
 gallery's holdings)
- *Felix Droese, dort 1981–1983* (There,
 1981–1983)
- *Werner Büttner: Neue Bilder* (New
 Paintings)
- *Albert Oehlen: Die Feinde unserer*
 Feinde sind auch unsere Feinde
 (The Enemies of Our Enemies Are
 Also Our Enemies)
- *Ausstellungen auf dem Kunstmarkt,*
 in der Galerie und in der
 Bismarckstr. 50 (Exhibitions at
 the Kunstmarkt, in the Gallery and
 at Bismarckstrasse 50)
- *Felix Droese*
- *Bruce Robbins*

1984
- *Steve Keister*
- *Lee Quiñones*
- *Baselitz, Beuys, Droese, Immendorff,*
 Kiefer, Penck, and Polke: Pittura
 Tedesca Contemporanea (with Galerie
 Paolo Sprovieri, Rome) (catalogue,
 copublished by Galerie Rudolf
 Zwirner, Cologne, and Galleria Paolo
 Sprovieri, Rome)
- *Premierentage: Ernst, Dubuffet,*
 Magritte, Miró (Premiere Days)
- *Tom Otterness: Skulpturen 1982–1984*
 (Sculptures, 1982–1984)
- *Tom Otterness: Kings Parade–Königs*
 Haus (Buchhandlung Walther
 König, Albertusstrasse/Ehrenstrasse)
- *John Chamberlain: Skulpturen*
 1980–1983 (Sculptures, 1980–1983)
- *Sandro Chia*

1985
- *Thomas Schliesser*
- *Franz Hitzler: Neue Bilder und*
 Objekte (New Paintings and Objects)
- *Georg Baselitz*
- *Miquel Barceló: Neue Arbeiten*
 (New Works)
- *Karel Appel: New Yorker Bilder,*
 1984–1985 (New York Paintings,
 1984–1985) (catalogue)
- *Felix Droese: Keine Rätsel/Keine*
 Lösungen (No Puzzles/No Solutions)
- *Bilder, Zeichnungen und Plastiken*
 von Arman, Baumeister, Burri,
 de Chirico, Dubuffet, Ernst, Fautrier,
 Laurens, Miró, Nay, Picabia,
 Picasso (Paintings, Drawings, and
 Sculptures)
- *Arman, Baumeister, and Burri*
- *José Sicilia: Bilder* (Paintings)
- *John Chamberlain*

1986
- *Gary Kuehn: Skulpturen 1963–1985*
 (Sculptures, 1963–1985) (catalogue,
 with a text by Hayden Herrera)
- *Gustav Kluge: Bilder* (Paintings)
- *Arnulf Rainer: Totenmasken,*
 Serie 1978, Übermalungen (Death
 Masks, Series 1978, Over-Paintings)
- *Robert Kushner: Neue Arbeiten*
 (New Works)
- *Henri Laurens: Skulpturen*
 (Sculptures)
- *John Chamberlain: Oils 1970*
- *Joseph Beuys: Blitzschlag mit*
 Lichtschein auf Hirsch 1958–1986
 (Lightning with Stag in Its Glare,
 1958–1986) (catalogue)
- *Helmut Federle, Bilder 1977–1986*
 (Paintings, 1977–1986)

1987
- *René Daniëls*
- *Brandl, Danner, and Zitko*
- *Not Vital: Skulpturen* (Sculptures)
- *Siah Armajani: Skulpturen*
 (Sculptures)

· *Scott Burton: Skulpturen*
(Sculptures)
· *Nancy Spero: 43 Works on Paper,
Excerpts from the Writing of Antonin
Artaud* (catalogue, with texts by
Antonin Artaud and an interview
with Nancy Spero by Barbara Flynn)
· *Gerhard Richter: 20 Bilder* (20
Paintings) (catalogue)
· *Fabro, Fontana, Kounellis, Merz,
Pascali, and Paolini*

1988
· *Christopher Le Brun: Baumbilder*
(Tree Paintings)
· *Imi Knoebel: Bilder* (Paintings)
· *Gérard Garouste: Neue Bilder*
(New Paintings)
· *Hans Hartung: Pastelle 1935–1960*
(Pastels, 1935–1960) (catalogue,
copublished by Galerie Rudolf
Zwirner, Cologne, and Galerie Michael
Haas, Berlin)
· *Felix Droese: Malerei, Zeichnungen,
Objekte: Das Sichtbare des
Unsichtbaren* (Paintings, Drawings,
and Objects: The Visible of the
Invisible) (catalogue)

1989
· *Blalla W. Hallmann: 1987–1988*
· *Henri Michaux: Arbeiten 1943–1983*
(Works, 1943–1983)
· *Gustav Kluge: Bilder* (Paintings)
· *Olaf Metzel: Intelligence Service /
A.M.T.* (catalogue, with texts by
Hans Magnun Enzensberger and
Jonathan Cott)
· *Gerard Garouste: Les Indiennes,
1987–1989* (catalogue)
· *Philip Pearlstein: Bilder* (Paintings)
(catalogue)

1990
· *Pier Paolo Calzolari: Skulpturen*
(Sculptures)
· *Asger Jorn: Druckgrafik* (Prints)
· *C. O. Paeffgen: Die Ruhe der Steine*
(The Calm of the Stones)
· *Hans Hofmann* (catalogue)

· *Felix Droese: Der Zwischenträger,
Drucke und Objekte 1980–1990*
(The Talebearer, Prints and Objects,
1980–1990)
· *Volkmar Schulz-Rumpold: Bilder*
(Paintings) (catalogue)
· *Erik Dietman: Reflexions sur la
Sculpture* (Reflections on Sculpture)
· *Max Ernst: Bilder, Zeichnungen,
Collagen* (Paintings, Drawings, and
Collages) (catalogue)

1991
· *Franz Hitzler: Druckgrafik* (Prints)
· *Astrid Klein: Neue Foto-Arbeiten*
(New Photo Works) (catalogue,
with a text by Dorothea Zwirner)
· *Blalla W. Hallmann: Fenster*
(Windows)
· *Asger Jorn: Skulpturen, Bilder,
Arbeiten auf Papier* (Sculptures,
Paintings, and Works on Paper)
(with Galerie Michael Haas, Berlin)
(catalogue, copublished by Galerie
Rudolf Zwirner, Cologne, and
Michael Haas, Berlin)
· *Accrochage* (From the Gallery's
Holdings)
· *Felix Droese / Gustav Kluge, Arbeiten
auf Papier, Köln 1991* (Works on
Paper, Cologne, 1991) (catalogue)
· *Armajani, Artschwager, Burton,
Otterness: Bilder und Objekte, Arbeiten
auf Papier* (Paintings and Objects,
Works on Paper)
· *Siah Armajani*

1992
· *Sava Sekulić: 1902–1989*
· *C. O. Paeffgen: Handarbeiten*
(Handiwork) (catalogue)
· *Felix Droese: Das grosse Zeichen an
der Wand* (The Large Sign on the Wall)
· *Julia Scher: Zwirner's Verlies »Come
In«, Raymond Pettibon: Zeichnungen*
(Zwirner's Cell "Come In" –
Raymond Pettibon: Drawings)
· *Gustav Kluge*
· *Imi Knoebel, Luc Tuymans*

Gallery and Warehouse
Bismarckstrasse 50, Cologne

Director: Daniel Buchholz

1984
· *Geerd Moritz: Raum im Raum,
Fotoinstallation* (Room in Room,
Photo Installation)
· *Jörg Immendorff: Bilder und Arbeiten
auf Papier* (Paintings and Works
on Paper)

1985
· *Sandro Chia, Francesco Clemente,
Enzo Cucchi: Holzschnitte,
Lithografien, Radierungen*
(Woodcuts, Lithographs, Etchings)
· *Georg Baselitz: Arbeiten auf
Papier* (Works on Paper)
· *Iterativismus II: Armleder, Federle,
Rockenschaub, A. Schulze,
Schuyff, Taaffe* (Iterativeness II)
· *Hans-Jörg Meyer: Blitzen Vixen
& Harry*
· *Brian Eno: Video Installation,
Pictures from Venice, and Other Works*
· *John M. Armleder*

1986
· *Troels Wörsel*

Additional publications

· *Lagerkatalog* (Warehouse
Catalogue), 1970
· *Recent Acquisitions*, copublished
by Galerie Rudolf Zwirner, Cologne,
and Galleria Paolo Sprovieri,
Rome, 1984

Index

Page numbers in italics refer to illustrated artworks.

298

Nicola Kuhn is an art critic and a features editor of *Tages-spiegel*. She studied art history and modern history and has taught at the Free University and the University of the Arts in Berlin. In 2013, she was awarded the Critics' Prize from the hbs Cultural Foundation, Hannover. In 2016, she co-authored the biography *Hitler's Kunsthändler: Hildebrand Gurlitt, 1895–1956*. She became acquainted with Galerie Zwirner while studying in Cologne and met Rudolf Zwirner in her role as a journalist in Berlin.

Gérard A. Goodrow is a curator, an author, and a translator based in Cologne. He studied cultural anthropology and art history at Rutgers University, New Jersey; modern and contemporary art history at the City University of New York; and art history, German philology, and English literature at the University of Cologne. Goodrow immigrated to Germany in 1987. He has held positions at the New Museum of Contemporary Art, New York; Kunst-Station Sankt Peter, Cologne; Museum Ludwig, Cologne; Christie's, London; and Art Cologne and Cologne Fine Art. Over the past thirty years, he has curated more than one hundred contemporary art and photography exhibitions in Germany and abroad. He is the author of numerous texts and publications, including *Crossing China: The Land of the Rising Art Scene* (2012) and *Passages: Indian Art Today* (2014), and has taught and lectured extensively on international modern and contemporary art, photography, and the global art market.

Lucas Zwirner is Head of Content at David Zwirner. He oversees the editorial vision for the gallery, its publishing house, and its web and online platforms, deepening the conversation around the gallery's artists, exhibitions, and projects through books, podcasts, videos, web content, public programming, strategic partnerships, and online sales. Lucas serves as the editorial director of David Zwirner Books and has grown the program to more than thirty titles a year, ranging from criticism to poetry. He is also the host of *Dialogues: The David Zwirner Podcast*, a program about artists and the way they think. Lucas is also a writer and translator who has published pieces in the *Paris Review*, *The New York Review of Books*, and *The Drift*. He graduated summa cum laude from Yale with a BA in philosophy and literature.

Photography and Copyrights

Photography

Give Me the Now
An Autobiography
Rudolf Zwirner
Written with Nicola Kuhn

Translated from the German
by Gérard A. Goodrow

Published by
David Zwirner Books
529 West 20th Street, 2nd Floor
New York, New York 10011
+1 212 727 2070
davidzwirnerbooks.com

Managing Director: Doro Globus
Sales and Distribution Manager:
Molly Stein

Editor: Lucas Zwirner
Project Editor: Elizabeth Gordon
Copy Editor: Anna Drozda
Proofreader: Chris Peterson

Design: Mike Dyer / Remake
Production Manager: Jules Thomson
Color Separations: VeronaLibri,
Verona
Printing: VeronaLibri, Verona

Typefaces: Miller, Neutral
Paper: Holmen Book Cream, 80 gsm

Originally published in German
in 2019 by Wienand Verlag, Cologne,
as *Ich wollte immer Gegenwart*

Publication
© 2021 David Zwirner Books
Foreword
© 2021 Lucas Zwirner
English translation
© 2021 Gérard A. Goodrow

Distributed in the United States
and Canada by
Simon & Schuster, Inc.
1230 Avenue of the Americas
New York, New York 10020
simonandschuster.com

Distributed outside the United States
and Canada by
Thames & Hudson, Ltd.
181A High Holborn
London WC1V 7QX
thamesandhudson.com

ISBN 978-1-64423-055-8

LCCN 2020920016

Back cover: Rudolf Zwirner, 1951
Frontispiece: Rudolf Zwirner
with the painting *Pickup* by
Ralph Goings, New York, 1969

Printed in Italy